P9-DNS-572

IN THE VERNACULAR

In the Vernacular

*Interviews at Yale
with Sculptors of Culture*

Edited by

Melissa E. Biggs
of *The Yale Vernacular*

McFarland & Company, Inc., Publishers
Jefferson, North Carolina, and London

British Library Cataloguing-in-Publication data are available

Library of Congress Cataloguing-in-Publication Data

In the Vernacular : interviews at Yale with sculptors of culture /
edited by Melissa E. Biggs.
p. cm.
Includes index.
ISBN 0-89950-645-3 (lib. bdg. : 50# alk. paper) ∞

[Subject tracings are available]

I. Biggs, Melissa E., 1967– . II. Yale vernacular.

[LC & dc classifications are available] 91-52760
 CIP

Manufactured in the United States of America

McFarland & Company, Inc., Publishers
 Box 611, Jefferson, North Carolina 28640

*To the men and women
whose reflection
on the creative process
speaks to the artist
in us all.*

Table of Contents

Table of Contents

Introduction

The Yale Vernacular interviews began as a form of seduction. It was our intent to lure readers into our literary and arts magazine through interviews with popular artists and writers; the undergraduate stories and poetry would then lay siege to their minds. Our first issue featured an interview with Andy Warhol; and it was his eerie, bespectacled face which appeared on the cover. Two days after distribution, Warhol died. The seduction had begun.

The charge of getting interviews proved to be relatively easy. Many people gave us their consent immediately. Both the famous and the classic (Keith Haring, E. L. Doctorow, Eudora Welty, Arthur Miller) and the newer, secret favorites (Ashley Bickerton, Peter Sellars, and Susan Minot) all came aboard. We did, however, have our disappointments. John Updike sent me a postcard saying: "Thanks for thinking of me, but I don't like to be interviewed. Too many interviews rot the brain. Look what happened to Andy Warhol."

Updike may have had a point, yet the catchwords were "too many." For what may have begun as a seduction quickly took on an important role of its own. With each interview — a differing tone and new theme, each stressing personal artistic and social concerns — we realized the vital learning and wisdom of these exchanges.

The inextricable relationship between the artist's life and his works was first emphasized by the eighteenth century Romantics. By the 1940s, Jean-Paul Sartre still bemoaned the enduring division of the artist from his art. Sartre called for "a more conscious artist ... who, by reflecting on his art, would try to endow it with his conditions as a man." In his interview, Ashley Bickerton claims the division persists today. "To a lot of critics, artists are like pygmies," he says. "It's wonderful the resourceful ways they can track down and hunt animals and live a social and artistic life. But my God, any god, don't let them try and explain themselves! After all, we are the beholders of science and rationality; and, they are our laboratory experiment in blind passion."

1

The "blind passion" and the creative process are two themes widely discussed in these interviews. Politics and mentors, social contexts and routines appear frequently as do the inexplicable elements of art. "I think," says E.L. Doctorow, "that the act of writing confers a degree of perception on the writer that he or she doesn't ordinarily have." Or as artist Lindsay McCrum says: "There is a language of repeated truths, I think. If you look at great art, you can see that painters are always striving to hit on some universal truths."

The interview topics vary as do the lengths and styles of the interviews. Some interviewees asked general questions about art and culture, while others focused on the artists' particular area of art or their specific works. Hanif Kureishi, Toni Morrison, Calvin Trillin and Keith Haring visited Yale where they were either interviewed or introduced. Brigid Clark's interview with Molly Keane traveled the farthest distance, from Southern Ireland to New Haven. Brian Edwards' interview with Eudora Welty at her stately home in Jackson, Mississippi, was probably the furthest atmosphere-wise from New Haven. Whatever the distance or the method of interview, all of them speak. Some may ramble, others may hesitate, but all of the voices sound from the page.

A thread runs through the many voices and topics and talents. This thread William Kennedy identified in his interview. "These people," he said, "who become writers [or artists] are somehow imbued with what's going on in their age."

Many, such as Jules Feiffer, view this age dimly. "We're living in a very crowded place," he says, "in a very crowded time, with a very shaky economy and a very shaky social structure, and we're too easily moved from what we instinctively believe to what someone else pretends to believe." Arthur Miller talks about a social and political precariousness that he explores in his work and which exists in every age of civilization. "The feeling that civilization is pretty thin, yes. I think that's in everything I've ever written. That the violence is only a sliver, a thin piece away."

Politics also figure in many of the interviews. Peter Sellars and Keith Haring both speak of the unfortunate relationship between American politics and television. "In America, there are no politics," Sellars says. "There's no political discussion, it's totally collapsed. We have nothing but television shows. And prime time is in the White House."

There is a great diversity revealed in the ways the artists approach their audience. Many of the writers touched on the common idea of readers' growing impatience. William Kennedy spoke of novels evolving to rely less heavily on description as a result of the incredibly rich visual world of TV and movies. Doctorow talks about a skeptical audience that needs to be persuaded that fiction is "a kind of urgent truth," but this is a condition that has always existed for the author. However, he sees a new problem: "Modern psychology which codifies mental attitudes is a kind of industrialized fiction. So the serious writer of fiction tends to feel not as central to society as, perhaps, writers did in the first century."

Both Peter Sellars and Harold Brodkey expressed the interconnection between the artist's work and the audience's own experience. "I'm interested in awakening spaces in people," Sellars said, "but spaces where they themselves will be able to find and take something." Brodkey echoed the same principle: "What I then depend on . . . is the reader's sense of life. I don't care how conventional you personally are, you're more or less forced . . . to deal with experience, not with books." William Kennedy believes the writer's responsibility is not to his audience. "I think the writer's responsibility is chiefly to himself, to design himself in his work as something as truthful to human behavior as he can, as interesting as she can possibly be."

These artists' works are "imbued" with their age, just as their age shapes their work. The state of the arts at the end of the twentieth century is represented in these interviews. Art is no longer strictly confined to an elite domain as it was in the centuries preceding this one. Keith Haring bringing his work to the subways and the streets is merely one such illustration. Yet art has not blossomed into the proletarian tool that the early 1900s of the Armory Show and *The Masses* suggested it would. In the business culture of the past decade, the artist has become, in many ways, a professional. Andy Warhol first exploited the relationship between art and commercialism, and, despite their stylistic differences, Bickerton, McCrum and Haring all find themselves forced to grapple with his legacy in one fashion or another.

The development of publishing conglomerates and the resulting disappearance of small publishing houses have greatly affected the writer's job as well. Susan Minot and William Kennedy, despite vastly different experiences, are both products of this new literary world.

Susan Minot is one of the new young writers whose literary endeavors include night clubs and promotional tours. William Kennedy, on the other hand, spent years trying to interest publishers in his "unmarketable" novel, *Ironweed,* which eventually won the Pulitzer Prize.

Also represented in these interviews is the emergence of many multi-genre artists. Writers such as Feiffer, Doctorow, and Kennedy have moved into film, while Kureishi and Spalding Gray did the reverse, going from theater, film and performance art to novels.

Just as the artists, writers, poets and playwrights reflect a consumer shift in the art and literary worlds, so also do they reflect the endurance of that which motivated artists from the first day of "creation" — artistic passion.

Melissa Biggs

Founder and Editor,
1987–1989
The Yale Vernacular

Keith Haring

Mastering the Moment

Keith Haring burst into the 1980s as a new breed of Pop artist. His simple chalk drawings in New York City subway stations announced his artistic emergence. Drawing his radiant stick figures next to neo-colored graffiti tags, Haring quickly captured the city's imagination and then the art world's. His work was hailed as a needed return to the primordial by some and denounced as designer artwear by others.

Haring was born in 1958 in Kutztown, Pennsylvania Dutch country, not far from where his mentor Andy Warhol was born 30 years earlier. He spent much of his childhood doodling and watching television. In 1978, he enrolled in the School of Visual Arts in New York. Finding lectures on Abstract Expressionism "irrelevant," Haring took to the subway platforms with his chalk. Despite the many court summonses he received from the MTA police and one arrest for "criminal mischief," Haring continued adorning New York's "underground" with his "cave cartoons."

Haring's work was first shown in a gallery in the West Village in 1981. His primitive stick figures combined with TV sets and skyscrapers communicated technological doom and social protest. Haring attained international superstardom, in part because of the simple quality of his images. His radiant babies and barking dogs were born for mass production; T-shirts, buttons and posters spread Haring's conscience across the world. In 1989, Haring publicly announced that he had AIDS. He devoted the last nine months of his life to blurring ever further the distinction between his art and his social work.

In November 1986, Haring sat in on an art history lecture at Yale. He was in the area working on his sculptures. His foundry, Calder's too, was near New Haven. Sure, he'd give an interview. When Melissa Biggs and Jonathan Wright arrived at Haring Headquarters, they were told to wait. Keith was busy. He was with three kids, drawing on their skateboards. Haring was an artist whose personal image differed little from his artistic image.

Jonathan Wright: What were your early conceptions of being an artist?

Haring: The first drawings I have are from the time I was four or five years old. When I was a kid, I was not so much an artist by choice,

but because it was the only thing I was really good at doing; it was the one talent I had that I didn't have to force. It really started to form into something concrete when I was sixteen or seventeen. I was starting to think of myself more as an artist, as opposed to a cartoonist, because in the beginning I wanted to be a cartoonist.

J.W.: Could you talk about your formal artistic training?

Haring: Besides high school, which was the typical sort of public art education, there wasn't too much. I went to a horrible little school in Pittsburgh for six months and quit immediately. It was supposed to be a half fine arts and half commercial arts school, and I immediately realized that it wasn't doing anything for me. I didn't go to school again until I moved to New York and went to the School of Visual Arts for three years. In between, there was a lot of self-teaching. I hung out at Carnegie Mellon when I lived in Pittsburgh and sat in on classes, and I used their library and resources of other schools but nothing official. Most of my training came at an early age from my father, from him encouraging me to make cartoon characters.

Melissa Biggs: Was your father involved in the arts?

Haring: Well, he didn't do it to make a living, because he was being realistic. It was the fifties and you couldn't realistically make a living as an artist. He encouraged it. When I was really taking my art seriously and thinking about doing it for the rest of my life, they tried to guide me into commercial schools saying that was the only way I was going to make money. At a certain point when I really knew what I wanted to do, my parents doubted that it made sense because there was no financial security being an artist.

M.B.: Once you were in New York, how did you move from doing a lot of art on your own and in subway stations to actually showing with galleries?

Haring: It was a very gradual transition and the only difference was I was getting paid for it. I was showing in nightclubs and abandoned buildings and these other sort of "alternative spaces" in the city the whole time I was there. Then galleries started inviting me to be in group shows. The difference was I got paid for my drawings instead of just voluntarily putting them up in different places.

M.B.: So there wasn't any one dealer who discovered you?

Haring: Partly because of the way that I had approached the whole thing, no one really had the chance to discover me. By the time

that anyone would have had the chance to discover me, I had already played out their role. Everyone knew about me because I had already done the subways. Which also put me in a good position because I was able to choose who I wanted to show with because they knew that they needed me; I didn't need them. I never took slides to anyone. I started showing with Tony Shafrazi early on and partly because of our friendship and his interest in or loyalty to my work, we've grown together. He's been supportive, but he didn't discover me.

M.B.: How did you decide to do your first drawing at a subway stop?

Haring: It was sort of by accident. I was on my way to work, and I had to take the subway. I saw one of the empty black panels, and it seemed perfectly logical and easy to do, so I went and bought chalk and went back and did it. And it sort of had a snowball effect. The more I did the more I wanted to do because the more response and feedback I got. Then it became more of a responsibility. In the beginning the space was just there and it seemed right.

J.W.: What distinguishes a work in the subway from any other one?

Haring: Just the subway. The fact that the context is the subway and that it's not a signed work. First of all, I don't draw on the subway anymore, but many of the things that I drew there, especially in the last two years, were removed by people. Eventually that made me stop. It also means that the drawings are out there and are sold and resold, and eventually will come up for auction with a price. None of them were ever signed, and when people come to me to try to sell them, I tell them it's a stolen work and I don't want anything to do with it. I've only signed one or two after they've been taken as a favor for a friend or because of the way the drawing was obtained. People taking them defeated my reason for doing them.

M.B.: Do you still paint on walls, for instance, your Berlin Wall project?

Haring: Walls that cannot be taken apart. I did a public wall in Phoenix a couple of months ago in the downtown section with a bunch of high school kids. I'm doing a mural on a children's hospital in Paris in a couple of weeks. I'll do more murals in the summer in New York. I keep doing it but mostly in very public places. Right now, I'm trying to do more school walls.

J.W.: Do you see any problems with your artistic populism especially when put to political use? I'm thinking of an example at Yale, where the medium of your anti-apartheid post was criticized for being out of line with its message.

Haring: Speaking on that exact thing, I've had more criticism from the opposite side, people saying that it was too negative because there's this huge black figure crushing this white person. I don't think it's too violent, though. I think it's the reality of what is going to have to happen. The white minority, in refusing peaceful terms, is pushing people to the other extreme. I think in some ways you have to use extremes to get the point across. I don't think the figures are too playful. In a way, the neutrality of the image, because it's been filtered through my iconography, allows people to call it playful. But in a way that has a neutralizing effect, because you can deal with violence when it's translated into those terms. It can be dealt with as pure information. It's not like a photograph of a black stamping on a white where you see the blood and guts. The information is directly conveyed from the image to the mind and is not over-sensationalized.

M.B.: Do you feel that the thrust of your art is diluted as it becomes increasingly mass mediated, increasingly accessible?

Haring: First of all, I don't even know if it's true that it is becoming more accessible. I think sometimes it appears that way, but there are a lot of people trying to pull it back into the safety of the elitist art world, so I don't know if it ever will. The continuous attack I get is an example of it. A lot of people resent the fact that anyone would take my art seriously. Just because art is popular to a lot of people means that it's frivolous or trendy. It's been a real uphill struggle to have it respected in some circles as being legitimate or serious art with a capital "A." That's a continuous thing; I don't think it'll ever change. There will always be resistance.

J.W.: How do you answer those criticisms? Or do you just ignore them and continue your work?

Haring: A little bit of both. I don't waste too much time answering things that I think are irrelevant, but I think the best rebuttal is to try to be even stronger and to try to prove the point over and over again. I think the best way to prove the point is just by trying to maintain the strength of the work with the same attitude and philosophy. In the end, it becomes much clearer. If people knew the amount of commercial

things I am proposed and I turn down, they might understand better. I think as time passes people will realize how intentional my artistic direction is.

J.W.: What makes you decide to do something like the Absolut ad or open the Pop Shop? Are you making a subtle comment that all art is commodity?

Haring: No, not at all. That's something that maybe Andy [Warhol] would say. Choosing Absolut out of all of the proposals I have had for ad campaigns was an artistic choice with artistic integrity. The only reason I did Absolut was because Andy did it first. It was first Absolut Warhol. Andy introduced me to the project, and because Andy had done it, it okayed it for me. If I had been the first one, I would not have done it, but to follow Absolut Warhol with Absolut Haring was totally cool with me.

And the Pop Shop is another thing that was a decision. Again, if I had said yes to all the proposed Pop Shops, small versions of it could exist in Macy's and other department stores. People have offered to make Pop Shops in Texas, California, all over, but I continue to turn them down because I'm not a shopkeeper. The things I have done I've done with choice. I knew that it was going to offend some people, but in a way that's the best reason to do it. The people that are offended by it in the art world are the people I want to say "Fuck you" to anyway. Opening the Pop Shop was a multi-faceted thing. In a way, I didn't even feel I had a choice to do it or not. At that point I had to decide whether I wanted to play a creative role in the entrance or whether I would let the second generation rip-offs of it be what people assumed was me. Because I get credit for fakes whether I do them or not. People still think it's a Keith Haring.

The other reason concerns the graphic quality of the work itself. Because the aesthetic image can be reduced to a series of lines it has a strength that can be shrunk down to two by two inches or blown up to ninety by ninety feet and still hold the same kind of power. The lines have a graphic strength and ideology that can translate into many things and this goes with breaking down the limits of art. In a way it would have been more unfair and greedy to say: "No, this is art and it should remain in the intellectual elitist realm of Art. It's too good to put in shops." Andy was really the one who pushed me to open the store. I knew that I should, but I also know the art world, and I knew what kind

of feedback I would get because I was already getting it. Especially with the climate of the art world, now, with the hype that has surrounded it in the last ten years. It was a risk, and Andy helped convince me that I should do it.

M.B.: I've read over and over that your work is very spontaneous, of a moment, without mistakes. How much of this is your view and how much the critics'?

Haring: One thing that is really important to me is the spontaneous, immediate essence that happens while I'm creating. Nothing is done with preplanned sketches or pencil lines. It's all directly out of the head and the hand. It's the element of chance and instantaneous response that emerges. To me, that's the ultimate act of creation. That's really the main thing that has separated me from Andy. I don't take an image that already exists and utilize it. It's the active invention of an image, with a big hand of it being chance, that has been the core of my work.

J.W.: Since you just mentioned instantaneous, how influential were the early Abstract Expressionists to your work?

Haring: They're some of my favorite American artists definitely . . . Jackson Pollock and Stuart Davis before that. Being a child growing up in the fifties and sixties, that was the kind of art I was seeing when I was going to museums. Chance has always played a very, very big role in my life and consequently in my art. It's also something I've always been hyper-aware of, almost obsessed with. It's what drew me to writers like William Burroughs and the sort of Beat poets of the fifties and sixties. Chance is one of the strongest factors in anything that happens. There is some kind of destiny. There have been too many so-called coincidences that have happened to me to be coincidences. If you're in tune with your insides and your mind, you see these things even more. Things happen to me periodically, that let me know that I am in tune with myself and the world, little mundane things. Like the other day when I left the studio and I saw this little kid who was riding a bike and almost hit an old lady. He was about eight years old and totally oblivious to it. Then two hours later, I had walked all over the Village, and I was about forty blocks away and the little kid rode right in front of me. To run into the same kid in New York twice, that I had had some kind of thought about, things like that happen enough that I know I'm in the right place at the right time.

M.B.: Do you subscribe to a particular philosophy or ideology? That sounds rather spiritual.

Haring: I was bombarded with Christian ideology as a child because that was how I was raised, not Catholicism, but Protestantism. I was forced to go to Sunday school and church. But also, for awhile, when I was about thirteen and was trying to figure out for myself who I was, I got involved in the Jesus movement and absorbed all of it at a very impressionable age. I absorbed it enough that I could see through parts of it and didn't believe everything. I got information from it, but I didn't stay with it. And right around that time I discovered drugs as another outlet which took me out of religion but made me aware of other things I wasn't aware of like taking LSD which has also had a lasting impression. Sometimes I still experiment with hallucinogenics, and I think I will for the rest of my life.

J.W.: For artistic purposes?

Haring: For life purposes, for reprogramming. It's reflected in my art, but I never do art on drugs. It has enabled me to see things in a much bigger way, and encompass a bigger scope of things.

J.W.: Let's get back to your art. It seems to me that in your work, you're trying to capture what German essayist Walter Benjamin called the ritual value of primitive art. When an image is mass produced it naturally loses that aura. How do you reconcile this artistic tension?

Haring: Well, it depends. I'm not so much trying to capture a ritual of primitive life or art, but more the ritual of life itself in a way that it's not an assimilation or an appropriation, but a contemporary and honest method that's taken from my time and myself. I think that it's imperative to deal realistically with the present culture and times. Artists should feel free to use technological means like the printing media, photographs, and television, but there is a kind of attitude and understanding of the ritual of life and of the painting process or the painting process as a ritual, that allows you to be able to deal with any of those things. There's more strength or power in an object that you actually endow or embody with the marks themselves than in a reproduction. But the whole idea that something can be reproduced is something the artist has to deal with now, too. I am not a primitive person. I am not trying to capitalize on ideas of primitive people or things which were important to them, their culture or their spirits. It's been a much more natural thing. The work itself took me to look at those

11

things. I was interested in Aztec images because they looked like my drawings and I would see the reflection of me in them. The things I put out are genuine, because they're coming honestly from me, but they have an affinity with these other cultures because it's a genuine affinity of spirit and intention.

M.B.: Many Abstract Expressionists were influenced by Jung, and critics have cited their work as reflecting the first stage of Jung's collective unconscious as they brought prehistoric art into their works.

Haring: Well, a lot of the first Modernists like Picasso, Brancusi and Braques started collecting African masks and discovering all of these things in African masks. It seems to me it was more appropriation than bringing something to the actual work. You can see the exact same thing and they got credit for it. With the Abstract Expressionists, I think it was a much less conscious thing, though they were still really influenced by Picasso. When Mark Toby was really starting to do automatic writing things, they were finally starting to find something that was inside. It was then starting to be it's own thing.

M.B.: I know you show a fair amount in Europe. Once American and European artists had very different experiences that influenced each other. I was wondering if you see definite changes now that an international art world is developing.

Haring: That's true, but I think there are a lot of people who would like to believe that there are still big differences between Americans and Europeans. There is a lot of ridiculous nationalism, especially between "German painters" and "Italian painters." But to me it's a ridiculous idea living in an era with photographs, cameras and telefaxes travelling at the speed of light. Everyone knows what everyone else is doing all over the world. One of the things my art has done is to break that down as much as possible because it is universal in that way. That's why a lot of Germans hated it in the beginning, because they wanted the divisions of German painting maintained. Now Germany is coming around to appreciate me for the first time.

J.W.: Could you talk for a minute about the underside of your art. I know a lot of people perceive it as "Hey Keith Haring, fun!" but then you paint snakes coming out of people's heads and women giving birth. Are destruction and regeneration among the major themes of your work?

Haring: Again, if I'm being at all honest to myself or to anybody,

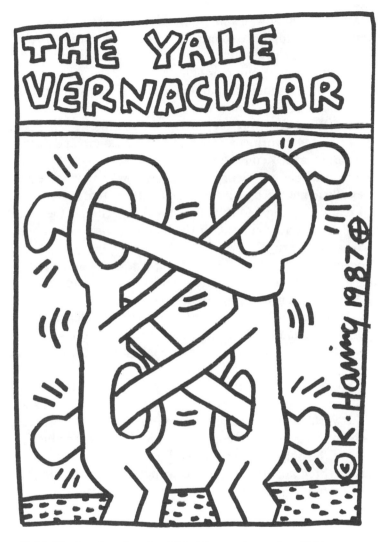

Keith Haring drawing for *Yale Vernacular* spring 1987 cover.

that's the world. My art is a kind of a mirror to what I see and what happens. The dark side is as real, if not more real, than the other side. There's only so much optimism you can have without being unrealistic.

M.B.: Do you see yourself as a part of a new artistic tradition of the eighties?

13

Haring: Right now, it's so totally confusing. I would hate to be the one who had to lump it together and say what it is or isn't. At the rate of change and this new thing, New-Geo, is that eighties art? I don't know if I can really be put in another whole category either. As much as possible I like to stand as separate from it. That's what art historians are for. I think in time things will sort themselves out.

M.B.: What contemporary artists do you like?

Haring: My favorite painters are George Condo and Jean-Michel Basquiat and maybe Kenny Sharf, which is pretty much the same group I was put into before. George paints in a way that is very similar ideologically to me. Because it's more about the actual meat of the painting, of really painting and thinking. It's the spirit and the feeling.

J.W.: What do you think of the Simulationists, who are now, or were recently, the rage?

Haring: Well, I like Jeff Koons' thing at the Whitney, the rabbit. I think it's cool. There are different levels on which to respect something. I mean the only reason I like Peter Halley's paintings is because of how thick they are. I think he's obviously very intelligent in knowing how to play the game well. I mean if you're going to try to make big, expensive-looking Minimal canvases, then he knows the right way to do it; they're four inches thick. He obviously studied Frank Stella and learned how to make them the right thickness, but as far as the information . . . I mean there's room for all kinds of art and all kinds of thinking in the world, and that's a certain kind of sterile, cold intellectualism that is interesting to some people, but I don't really get much from it. In the end, the only thing that gives it any kind of power or content, is what's written about it. It fits the corporate identity and the value-oriented, commodity-oriented idea of art and trends.

M.B.: What do you see as the greatest force changing contemporary art?

Haring: The death of Andy Warhol. He was influential to a lot of people in a lot of different ways. I mean Julian [Schnabel] says how much he influenced him. All kinds of people got information from him. For me, he was a friend and a mentor at the same time. Andy kept going in the direction that Pop Art started when all the other Pop artists stopped and went back to the canvas and took the canvas back to the art galleries. Andy was really the only Pop artist, who was about what he was supposed to be about: Pop and breaking down the barriers be-

tween art and life, and obliterating the boundaries between the two things. In the beginning, Pop Art really did that, but not for long. I mean now you have Jasper Johns paintings for four million dollars and it's back in the bank. Andy honestly lived his whole life toward this idea. His whole life was art. Everything was a metaphor for something else. Everything was art in a way. Andy was the person who really set a precedent for what I'm doing in a way that gave it a legitimacy and integrity. And he actively supported it. He also taught me about the whole phenomenon of being an artist and a star, of having your life be your work.

J.W.: Wouldn't you just call that being famous?

Haring: No, because Andy wasn't only famous, he was an artist. There were ways that Andy did things that made it art. I mean again it comes back to choices. He made people see things in different ways. He made you see little things with the aesthetic insight of someone else.

M.B.: But he once said that art couldn't change life, so what do you think he meant by that?

Haring: I don't know what he meant exactly, but art never changes life really. I mean it didn't stop him from dying. It can change ideas, but it's never really going to change actual things. But again everything he said could be read in so many ways. You could make it mean maybe even more than he meant it to when he said it.

J.W.: I just wanted to know what you watched on TV when you were a kid.

Haring: I don't know probably the same things as you. How old are you?

J.W.: I'm twenty.

Haring: Maybe not the same things, because I'm twenty-eight. But mostly sit-coms and comedies, like *Batman and Robin, My Favorite Martian, Mr. Ed, Ed Sullivan, The Jetsons, I Dream of Jeannie, That Girl.* That was when television wasn't taking itself too seriously. It was being what it was supposed to be, an illusion, entertainment. I think now TV is trying to take itself too seriously. There are no more talking horses, talking cars, martians, or genies in bottles; now we have *Dynasty* and these sit-coms based on real life. It's gotten so demented that we have a president that used to be an actor. That's how confused people are with reality.

E.L. Doctorow
An Urgent Truth

He has mythologized Bad Men from Bodie and good guys in the Bronx, ordinary people and historical figures, children and actresses, activists and families, and once two colossal aliens. An explorer of genres, he has written his books in the forms of the science fiction novel, the western, the historical novel and the novella. With a motley crew of characters and a multitude of genres, E.L. Doctorow has cast the twentieth century before his readers' eyes.

Doctorow was born in the Bronx in 1931. He attended the Bronx High School of Science and graduated from Kenyon College in 1952. His job as a staff reader at Columbia Pictures inspired his first novel, Welcome to Hard Times. *"I had to suffer one lousy western after another," he once explained in an interview, "and it occurred to me that I could lie about the West in a much more interesting way than any of these people were lying." Critics greeted the novel with tremendous acclaim.*

Doctorow's subsequent books tackled the science fiction genre and the Depression era, the turpitudes of turn-of-the-century America and the violent attitudes of the red-scared 1950s. In varied styles and settings, Doctorow has struggled to define good and evil in the modern world. His resulting works have crystallized the historical and the imagined into a unique and urgent vision of America. Doctorow's vision has earned him the National Book Award, the National Book Critics Circle Award and the John Simon Guggenheim Fellowship, among others.

In the winter of 1987, Liesl Schillinger went to Doctorow's pied-à-terre in the East Village for what Doctorow later called "a very ambitious interview." Schillingers' aims were to find out how Doctorow categorizes himself, as he defies the term novelist and spurns the title of historian, and to discover why he writes what he writes.

Liesl Schillinger: You once said that much of modern fiction "takes an act of will to read." Do you think there is a crisis in modern fiction?

Doctorow: I think I was talking about the condition of reading now, which is self-conscious, as compared to putting a tape on the

VCR, or listening to a record. So I was not speaking of the quality of modern fiction but of the contemporary consciousness. There is after all a history we all have now — eighty or a hundred years of optical technology and that has changed the way people read, and has changed our capacity for patience. And altered our interest in discourse.

L.S.: It must be hard to write in order to sustain the attention of the impatient reader.

Doctorow: Novelists have always had to persuade their readers that what they were reading was not fiction, but a kind of urgent truth. And, at least temporarily, to break down the distinction between fiction and non-fiction in the reader's mind. Defoe pretended to be the editor of *Robinson Crusoe,* rather than the author. Cervantes claimed at one point to have found this manuscript (*Don Quixote*) in an Arabian bazaar where he bought it for six reals and had it translated. Authors have always had to accommodate the skepticism or resistance of the reader. So do we today except that the overall conditions are different. In our time, fiction doesn't come only in the form of novels and stories; we have films, television, songs, news magazines, and the social sciences, which do a kind of fiction. They employ fictional techniques. Modern psychology which codifies mental attitudes is a kind of industrialized fiction. So the serious writer of fiction tends to feel not as central to society as, perhaps, writers did in the last century.

L.S.: You often address American society as a whole in your books — in *Ragtime,* for example, you portray a lot of disparate political and social figures, and expose many twentieth century injustices. Is there a "central" message to be found there?

Doctorow: There was an old time movie-producer named Sam Goldwyn, and he came out with a film and someone asked him what its message was. He said, "If you want a message, go to Western Union." The word "message" to me is a dirty word. A message is something that can be delivered briefly and concisely in a few words, and if I thought anything in my book could be reduced to that, then I wouldn't have written the book.

As a writer, you avoid bringing any calculated, thematic political or social intention to the book, because, if you do, you're in grave danger of becoming didactic. I think that the act of writing confers a degree of perception on the writer that he or she doesn't ordinarily have. The presumption of any art is that ordinary messages are insufficient.

17

L.S.: You mentioned that there are many different media, as well as genres, available in the twentieth century. Have you ever written for film or for television?

Doctorow: I've never written for television. I've written the film version of *Book of Daniel.* I've written screenplays for *Loon Lake* and for *Ragtime,* but those screenplays did not get produced.

L.S.: The movie *Ragtime;* was not based on your screenplay?

Doctorow: No. That was based on a screenplay by the director and another writer. I suggested some changes, but it was largely their work.

L.S.: I know that you weren't pleased with the film version of *Welcome to Hard Times,* you said it was the "second worst film ever made." Were you pleased with the film versions of *Ragtime* and *Book of Daniel?*

Doctorow: *Ragtime* is a highly-polished film, and there are some wonderful scenes in it. I just don't think it has much to do with my book. *Daniel,* of the three films, is the most faithful. *Daniel* is a novel-film; it has a certain novelistic structure to it. And since I wrote the screenplay to it, I think it's reasonably faithful to the book, probably the most faithful of the three films. While we made some critical mistakes, I like that film very much.

L.S.: About the idea that it takes an act of will to read in this very fast-paced society: Do you think that literature has been impoverished to any extent because the writer can't count on a very great attention span, or patience in the reader?

Doctorow: Not impoverished, no. The writers have changed along with the readers. So, for example, we don't do exposition as we used to. We explain less. We like to cut — just in the way of film. We chop up time, and space. Discontinuity is now a reasonable aesthetic principle. We're less innocent, all of us, than we used to be. We know reality is construed. It's something we all fight to create. None of that necessarily makes for impoverished.

L.S.: Your novella in *Lives of the Poets* seems to reflect the malaise of the times, in a way your earlier works haven't. Do you think that *Lives of the Poets* is noticeably different in structure and in general effect than your other writing?

Doctorow: I rely on readers and critics to make determinations like that. I just want to do them.

L.S.: One critic said that the personal malaise you describe in *Lives of the Poets* stands for a general malaise that you feel is gripping the country. Is that true?

Doctorow: If you're doing a piece about your character's life and no one else's, then it's of no value. It doesn't come off the page. There has to be truth in it so that people recognize it for their own lives. It is true that the hero of *Lives of the Poets* is falling apart. It is also true that falling apart is a national predilection.

L.S.: One of the interesting things about *Ragtime* is that there's almost no dialogue—it's almost as if you were recounting a history. Did you mean for that to be understood as a history?

Doctorow: *Ragtime* uses the mode of the chronicle. Historical chronicle is a kind of fiction that is not history, but it's not personal, intimate writing either. It's somewhere in the middle between history and the intimacy of the average contemporary novel. But it's still fiction. My use of historical chronicle was very much inspired by Kleist, the great German writer of the early nineteenth century. The character Coalhouse Walker, for example, derives from a figure of German literary legend that Kleist used, a man named Michael Kohlhaus, who was a horse dealer stopped on the road one day and forced to pay a toll. One thing led to another, and all hell broke loose.

L.S.: Some of your other books are chronicles as well. With a large canvas you've chronicled in different ways early-century western life, mid-century urban life, and on through the eighties. In any way do you see yourself as a historian or chronicler of this century in America?

Doctorow: No. Someone showed me that it is possible to put together four of my novels and get a unitary vision of the last hundred years of American life. That you can start with *Welcome to Hard Times,* then read *Ragtime,* and then *Loan Lake* and then the *Book of Daniel,* and then you have it. But if that's true it didn't come of any plan or scheme on my part.

L.S.: Which of the authors we see on the shelves today are your especial friends?

Doctorow: Many of the authors who live on the east coast in the New York area are friends or acquaintances. It just happens we run into each other. In our time, there are two schools of literature in the United States: the school that summers on eastern Long Island, and the school that summers in the Vineyard.

L.S.: When I was reading *Lives of the Poets,* the novella specifically, it seemed to me that there was a more direct feminism than I had seen before in your books. Still, you've always had strong female characters. In *Welcome to Hard Times,* for example, there's so little shame attached to prostitution, and you don't romanticize or trivialize women. Do you have explicit feminist views, and are they changing?

Doctorow: To me, regardless of the particular events of political feminism, and the debate that goes on internally among feminists, feminism seems to me an indisputably important advance in human apprehension of what life is. It seems such a simple thing, that women are human beings. That's basically what's being said. On the one hand, it's discouraging that there's a struggle to push this simple idea into the institutions of society. On the other hand, it's happening and that's good. It should have happened a thousand years ago. As for my work, I don't think I've ever consciously written from an explicitly feminist point of view.

L.S.: This is sort of a nuts and bolts question, but how long did it take you to write *Ragtime;* and how much time does it generally take you to write a book?

Doctorow: *Ragtime* needed about two and a half years. *Loon Lake* about three. *World's Fair* was very fast, in under a year. *Lives of the Poets* a year.

L.W.: What about *World's Fair,* how autobiographical is it? Is it really ten years of your life? You do use your name.

Doctorow: Every book encodes your life, but the code changes from one book to another. In any case, you have to remember that something *cryptic* is going on. Either all the books are autobiographical, or no one more than another. They're acts of composition. It's not what your material comes from but how you use it that matters.

L.S.: I've noticed that you always write about families; there has to be a family. One rises out of the dirt and somehow forces itself to exist in *Welcome to Hard Times.* In "The Writer in the Family," family dynamics is the theme, and of course, the family unit is crucial in *Ragtime* and *World's Fair.*

Doctorow: Well, life usually constructs itself familially. But you're right. *Book of Daniel* is about the destruction of the family, and in *Welcome to Hard Times,* Blue constructs a family out of disparate pieces of broken lives. I suppose there is a preoccupation with family

life. Certainly children figure prominently in just about every book. Someone said to me once that there are a lot of children in my books. And there are. But it's better for me to do these things and then move on, than to think too analytically about them when they're done.

L.S.: Do you plan to do more with short stories in the future?

Doctorow: I don't know. I'd like to, but I find them difficult. If you look at the stories in *Lives of the Poets*, they're not traditionally built, most of them. We may be leaving the era of the classic, modern short story. Anyway, if I'm to write more of them, I have to find out how they stand in my mind. How they're to be made. I'm not sure I know right now.

L.S.: Are you working on something now?

Doctorow: Yes.

L.S.: What is it?

Doctorow: I don't want to talk about work I'm doing. Makes me nervous.

Molly Keane

Something Old, Something New

Bedridden with tuberculosis and short of spending money, Molly Keane wrote and published her first novel at seventeen, under the pseudonym M.J. Farrell. Born in County Kildare in 1904 and now living in Southern Ireland, Keane hid her writing from her family and friends for years, for reasons that she explains in her interview.

Under her pen name, Keane published ten novels and a handful of plays. Throughout the twenties, thirties and forties, she traveled in England's rich literary and theatrical worlds. When her husband died in 1946, she stopped writing to focus on her family, and it was not until the 1980s that she resumed her writing career. In 1976, Virago Press, a London-based feminist publishing house, rediscovered and reissued Keane's earlier books. Inspired by the success of her books in the Virago Series, 80-year-old Keane, picked up her long-rested pen and wrote three more popular novels, Good Behavior, Time After Time *and* Queen Lear.

Keane's novels are set in the Anglo-Irish world of family estates and fox hunts. With great compassion and humor, she explores the gentility of the grand houses' well-appointed ballrooms and libraries as well as the darker intrigues of the kitchens, bedrooms and back stairwells. Though critics have faulted her for not departing from Ireland and the theme of decaying gentry, Keane's novels are consistently lauded for their tender insight and wit.

When Brigid Clark was in Ireland in the summer of 1986, she called Molly Keane to ask her for an interview. "You're perfectly welcome, Duckie, but it's an awful long way from Dublin," she said faintly, as coins clanked into the phone and wires crackled. On the strength of that "Duckie," Clark decided she had to at least meet Molly Keane.

Molly Keane lives in Ardmore, County Waterford, which is far away from almost everything. Two long bus rides, amounting to a day's time, took me from the caterwauling on O'Connell Street Bridge to the town of Ardmore, isolated and serene at the tip of a finger of land which points into St. George's Channel. Ardmore is so beautifully maintained, so gloriously gardened and so generously shuttered, that if it weren't for the overgrown ruins of a sixth century monastery on the High Road, and the dark, doorless round tower looming

over the spectacularly tidy town, its quality of idyllicness might have disturbed me.

Keane's house is beyond the ruins of the monastery and is set below the High Road, well into a bluff overlooking the bay. It was lashing rain the morning of our interview, and the owner of my bed-and-breakfast insisted on driving me up to Mrs. Keane's; he also pressed an umbrella into my hand. I leapt out of his car and examined the hedge which ran all along the road, obscuring the view of the bay. I had been advised to look for an iron gate in the hedge. When I found it, I wrenched it open, and began to descend the narrow stone steps behind the hedge. I picked my way down, using my umbrella for balance.

The steps led onto a flagstone patio full of flowers and wrought iron furniture, and to one side perched a substantial cottage with a bright blue door. Below, the surf rolled over the beach. The door of the house was one of those split ones; you can open the top half and leave the bottom half shut, to keep in babies and cats. After I knocked, the door swung open, and there stood a slight little woman with white hair and an animated face: Molly Keane.

Once inside Mrs. Keane took me into a tiny dark kitchen, where she made some coffee and chatted with me. Raised in a Protestant family, she struck me as more British than Irish, and her manner, though warm and genuine, seemed of another era. She was, in any case, the very soul of graciousness. We proceeded to her study, another small room where a coal fire was burning. The chairs were worn and soft. Mrs. Keane served me hot coffee with whisky in it, and handed me some sweet biscuits.

Brigid Clark: Did you read a great deal when you were young?

Keane: No, I didn't! No, I certainly didn't. I led a completely sort of outdoor life. The only thing that really mattered was to be good about hunting and riding and things like that. I did write though, when I was young, because I didn't have much money, or not nearly enough anyway — one was always given an allowance in those days — and it wasn't nearly enough for what I wanted to do ... something made me think, oh, I know; I was ill, after I left school, I had some sort of bug, that's all it was, but it turned into T.B. or something awful and the treatment was just to put you to bed —

B.C.: And how old were you?

Keane: I suppose I was seventeen. And I was in bed, and I thought, oh well, I'll write a book, and I sort of wrote it under the bedclothes because, you know, writing books wasn't terribly well thought of for most purposes back then...

B.C.: You mean people might think you were stuck up?

Keane: Oh, no, not stuck up, they would despise one, rather, from the sort of family and the kind of life I grew up in. But anyhow, I did.

I scribbled away under the bedclothes and I thought I was Mrs. Shakespeare! And then by some extraordinary miracle I sent it to some literary agent that I saw advertising in some *Times* literary something, I don't know how I got it. Well, my mother now, she was really, her generation was very well educated.

B.C.: And you were only seventeen or eighteen?

Keane: *(Laughs)* And I got something like, well, it wasn't as much as a hundred pounds. But that was then, what four hundred would be now.

B.C.: I had heard two stories; one that you had written for money for clothes, and one that you'd started in bed ill, now I see it's both. Was it all secret, to the very end, when you got published?

Keane: Yes, everything. I even put a pseudonym on it because it would never do if I was supposed to be a writer. I was just growing up, and I knew all those hunting-fishing-shooting fellows. What they'd think of someone who wrote, so I kept terribly quiet about it for quite a long time. But I wrote another book. I knew I could make money.

B.C.: So how long were you able to keep it secret?

Keane: I can't remember. Quite a long time, two or three books anyway.

B.C.: Even your family didn't know?

Keane: No, they didn't know; they were the last ones who knew.

B.C.: Did anyone?

Keane: I suppose. I can't tell you truthfully; it sort of broke just gradually, and I was sort of established by then. People liked me or didn't like me, so it didn't matter. And then, I wrote with a great friend of mine. I suppose I did the writing but he knew a bit about the theater so he gave me a bit of advice. I wrote this little play which was the most extraordinary success.

B.C.: I gather now it's a bit hard to get out of Ireland, as a writer.

Keane: It's so difficult, isn't it? That's why I say it's a sort of miracle to have done it. I think my earlier books always sold far more in England than in Ireland, actually. I think now there's a whole young generation in Ireland which reads and reads. And they're the generation whose mothers had very little education, and their grandmothers none. And they're growing up these bright young people. Whenever I meet them I'm absolutely surprised, but they've had jolly good educations at university and college. I'm sort of snobbish to say one's surprised; I'm not, I am surprised, because I feel they've done a big thing. There will

probably be some jolly great writers among them, much more so than were among the, what you called the sophisticated, educated classes. Educated! We weren't, clearly, educated.

B.C.: Where did the name M.J. Farrell come from?

Keane: Oh God, I just went the furthest away from my name as I could. Terribly Irish name, terribly Irish, you know. Then my agents had me go back to my own name, but they were absolutely right. When they had my books they said: "Now we know that your novels and your plays had pretty good success as things go, but it was nearly forty years ago, and we think if we're going to sell this book we're going to sell it almost as a first novel, and we'll do it under your own name." And that's why it became Molly Keane.

B.C.: What started you writing plays?

Keane: My friend John Perry; he was addicted to the theater. He used to say: "Moll, you ought to write a play," and I'd say: "Johnny, I can't possibly write a play, I'm not clear about the theater or anything else," and he'd say: "Well, write a play about your own life." So, more or less, I did. And he said: "If you do, I'll get John Gielgud to read it," because he was in the theater and he sort of did know John — John was at his zenith then. So that's what happened, and John did read it and liked it very much, and directed it, and no one thought it was going to do well at all. The actors practically didn't learn their lines. They thought it was going to drop.

B.C.: And then it became a huge hit.

Keane: A huge hit. It was the play that started Margaret Rutherford as a comedy actress. She'd done nothing before except small serious parts. If there'd been a National Theater, she probably would've been in little tiny roles, but there wasn't then.

B.C.: Have you thought of doing any more plays?

Keane: No, no I couldn't. No, I think the theater has changed so much. I think the plays one wrote were written, shall I say for the Establishment, do you know what I mean? There were so many more, I don't know, richer people, richer rich people. And they made this huge audience. It was the only audience I knew, the only kind of people I knew how to make jokes for. And now it's a totally, utterly different ball game. It wasn't the almost working class audience you get in the theater now. Will you have some more coffee? Would you like a drop more whisky? Sure?

B.C.: No, just coffee's fine, that's fine. Now you stopped writing for a number of years?

Keane: Yes, I did, after my husband died I stopped.

B.C.: Was that a decision or was it more circumstance?

Keane: No, it was just sort of an accident of life, I had so much more to do, you know—the children were very young, and one thing and another.

B.C.: Now you've begun again; I was wondering what prompted that?

Keane: The children were gone and married, and I was on my own. And also, money was pretty bad, and the children both needed some. And I said: "Well, I've been frightfully idle," you know.

B.C.: These new books have been very successful, haven't they? They've attracted lots of attention, even in the States where Irish writers aren't really talked about much.

Keane: Yes, extraordinary. It is quite a gift from above. I just don't understand it. And the old books, you know, that Penguin are doing, the Virago Penguin, they're doing jolly well.

B.C.: Did you find when the plays became successful that—

Keane: No, there was no publicity then. They wined and dined you privately, but there was none of this. There was no television and the radio was very boring. The only thing that you were asked to do, and which my publisher was very negative about, was to meet critics.

B.C.: Do you find that there are certain themes or concerns that you pursue, or do they just emerge naturally?

Keane: No, I just write about the people I know about, who are those kind of people. It's no good my saying I'm going to write a novel about something.

B.C.: Do you see much similarity between your novels, or do they seem very different to you?

Keane: I couldn't tell you, I never reread them. People ask me something about a character in a novel, and I have to ask them to tell me something about them before I can remember.

B.C.: Do you find you like writing from the points of view of particular kinds of characters, people who are unhappy, or—

Keane: I like people I can laugh at.

B.C.: Has it ever been very hard for you to write? Was it very hard to write with children?

Keane: It was when I was absolutely happy as a bird. Somehow one's whole mind was somewhere else. I didn't have those problems with children, not having written when they were young.

B.C.: What would you say has been your greatest achievement as a writer, or the success that you enjoyed most?

Keane: I would say my greatest surprise and extraordinary gratification, was when "Spring Meeting," the play that was done in nineteen thirty-eight, was such a success. That gave me the most amazement and pleasure.

B.C.: The books of yours I've read seem to focus on alienation within the family, the kind of curious antagonisms that come about . . .

Keane: I suppose that's what I know most about. I used to write about fox hunting; I don't now, because obviously I'm not hunting anymore.

B.C.: Was that part of the concern of the pseudonym, that you were afraid people would think you were writing about them?

Keane: I do have that annoyance and fear, because no matter what you do, someone says: "Oh, you put me in that book."

B.C.: Oh, what a collection of people in *Time After Time,* now where did that family come from?

Keane: There can be families like that!

B.C.: With each person in the house having some old memory rankling, some disability, caused or aggravated by someone else in the house?

Keane: I don't know, I pieced that together. I'm terribly bad on plot, that's my trouble, but I thought there must be some reason holding the family together; disability would do it.

B.C.: What person would you say has most influenced your writing, if that's possible to answer?

Keane: I don't think anything really did influence it. I remember, when I was terribly young, terrible books, I admired the most awful writers. There was a splendid gentleman, a real romance writer — God, was he — and I thought he was great! I mean I had no idea, I was so uneducated. No, I don't think anybody influenced me, for better or for worse. I made it out of my own silly head, my own observations, I'd say, more than experience.

B.C.: What would you say has been your biggest obstacle to writing?

Keane: Ordinary human life.

Lindsay McCrum
Hanging Out with the Old Masters

On Lindsay McCrum's canvases, comic-book heroes meet fallen apostles, and scenes of the Crucifixion join signs of the zodiac. Her mystical characters and haunting landscapes appear at once both sinister and celebratory. A magna cum laude graduate of Yale, McCrum has been living and painting in New York City since her graduation. She has shown her work at Ericson Gallery and Books & Company; both shows have sold out.

Art has been a lifelong passion for McCrum. Born in 1959, she spent her childhood in Connecticut and often traveled to New York to visit museums and later to attend art classes at Parsons School of Design. McCrum was an art major at Yale. During her senior year, she was chosen as one of a dozen seniors to be a Scholar of the House, an honor that frees the student of regular class meetings in order to pursue a specific field of interest. Upon graduation McCrum moved to New York to paint. Incorporating both the tricks of the old masters and the superheroes of popular culture in her paintings, McCrum seeks to illuminate "universal truths" on her canvases.

In the fall of 1987, Melissa Biggs spent an evening in McCrum's SoHo studio. As torrents of rain flooded the near-empty streets below, McCrum, set against her apocalyptic oils and watercolors, chatted about her days at Yale, her thoughts on education and ego, and how they affect the making of her art.

Melissa Biggs: What kind of response to your work do you hope to elicit from your audience, on an intellectual and emotional level?

McCrum: Well, I think there's a very intellectual part of my paintings, when you begin to interpret the Christian theology and iconography, but I think the objective of a painting is to communicate an idea and also to evoke some sort of emotional response. Hopefully, I get a mixture of the two; that's what I find most important.

M.B.: How did your artistic images evolve? When did you first start using the Christian iconography, for example?

McCrum: It began mostly from the point of view of a narrative. I liked the stories, and I really got involved with the idea of putting an

old story into a modern context. There's a whole tradition of masters learning from masters, and that's how it started for me. When I was at Yale at Norfolk, I started taking the narrative of Goya's *Lo que Aprecios* and updating it — that's what got me hooked. All of my favorite painters of that time — Piero della Francesca, Fra Angelico and Giotto — did Biblical paintings and so I started working with them also. I did a series of *The Seven Virtues and the Seven Vices*. That's how it all evolved; I always seem to gravitate toward the mythology, the Christianity. I loved telling the stories.

M.B.: What was the medium for those early pieces?

McCrum: I originally did a set of etchings, and then I started doing paintings of the same scenes from the etchings. I think one of them was *Nobody Knows Thyself*. It was an enormous painting that was very much influenced by Max Beckmann; it had faces with masks, and they were very caustic, very Beckmannic, influenced by the German Expressionists. That's how I began; it was my senior year, and that progression of media has been a constant ever since I graduated.

M.B.: Did you use any other media at Yale?

McCrum: I had always done printmaking, and then I also did paintings and collages — I've always loved collages. At Yale my work was literal and figurative, whereas now it's much more abstract. I think that when you're a young painter, you're constantly looking at great painters and appropriating their styles. That's how you learn. It's a great compliment to be told that your work is derivative, because it means you're doing your homework. Now, my paintings are still about stories, but the symbols and the images are my own. It's become my own language, as opposed to Beckmann's or Fra Angelico's. That's what you have to do: develop your own vocabulary. There is a language of repeated truths, I think. If you look at great art, you can see that painters are always striving to hit on some universal truths. All of my favorite painters were always aiming toward that goal.

M.B.: Modest aspirations.

McCrum: I think it's always good to aim high, because then you're always disappointed. I think the fuel that really drives most painters is that discontentment. I'm hard-pressed to think that very many artists whom I respect and think are very good, finish a painting and say, "Gosh, this is just great. I'm terrific." Although Julian Schnabel has a pretty high opinion of himself. I couldn't believe that he actually meant

it when he said that he was the best painter since Picasso, and then said, "No, since Leonardo." I think that's all bark; I don't believe any artist ever could mean it, because if you reached a point where you really did believe that, you would stop painting. Don't you think? If you wrote the perfect novel, why would you continue?

M.B.: It doesn't fit with the temperament required to paint or write. To put in the torturous hours it takes to create anything, you need a sort of insecurity, not unbounded arrogance.

McCrum: You really have to be a bit crazy, and you always have to be in that state. It's very unsettling, because as an artist, you're always trying to find something, and it's more of a journey than an arrival at a destination. Your use of "torturous" wasn't off the mark. I think that most creative people I know always have a destructive element. In order to create, you have to destroy. There are always the demons that are yapping at your heels. Or the whip of self-flagellation that Truman Capote spoke about in *Music for Chameleons*—he believed it came with his talent. I'm not so keen on the image, but there is that part which is always gnawing at you, and there is a sense of always reaching. The demons are always there, I guess; when you're actually involved in creating, the most you can hope for is to harness them.

M.B.: I think writers have a similar problem. Many writers who have had a really well-received first novel claim they have an impossible time writing a second.

McCrum: I think the catch is that you have to just shut up and do it. If you start to dwell on what you expect from something, it becomes so paralyzing that you can't work. The most important thing to do is to roll up your sleeves and say, "Okay, I'm going to do twenty really horrible paintings." And out of those, just by doing them, you'll find one with something you can grab onto.

M.B.: Have you found that showing your paintings has affected the way you work?

McCrum: I respond really well to deadlines. If I know it has to be done at a certain point, I just paint. If I know that I have to have a painting at a gallery by a specific date, that means I have to finish it. You don't think about having a better painting. You just do it. I think that it's a cyclic process. There are times you're really on a roll, doing paintings and it really hits, and then there are years when the key is just to

keep working; that's all you can do. Every artist, regardless of how great they were, went through periods where some paintings were really strong and some weren't as good.

M.B.: In a recent interview, you mentioned that you went through a period of self-doubt at Yale.

McCrum: That's a permanent fixture, the self-doubt. That never goes away.

M.B.: Did you consider not painting?

McCrum: No, never. Ever since I was four, I knew I wanted to be a painter. There was never any doubt. You are always questioning what you are doing. I have a standard shtick I haven't changed since college, I actually called it my "stockbroker mood" when I was at Yale. I would just say, "Things are so horrible, I'm just going to be a stockbroker." Of course, I never would because I'd get fired in a week, but the point is that you're always questioning yourself. A friend of mind is a writer, and we were on the same deadline last spring. One day I was talking to him and I said, "Do you ever just think that you're really not cut out for what you're doing, that you're clearly in the wrong profession?" He said, "Yes, every day."

M.B.: What sort of artistic training did you have?

McCrum: I had a really classical art training. When I was in high school, I had an extraordinary mentor, and she had us doing anatomy and perspective grids and figure drawing. I was fourteen, and I was really learning the craft, to the point of putting the paint out on the palette. We couldn't leave the studio until we'd showed her that we had cleaned our brushes correctly. In the summers in high school, I would commute into Parsons to take classes for college credit. So I really learned the craft. Also, when I was in high school I received a really solid background in history, literature, science and all of that. Those parts of education are absolutely key, because if you're going to be communicating things, you have to know what's going on around you; you have to be able to take all of these variables and synthesize them into some kind of vision.

M.B.: Don't you find that these days fewer artists are classically trained?

McCrum: There are a lot of people who aren't. There is a return to it now, or at least lip service. But there are artists whose work I really think is good who can't even draw. Being a draftsman is a skill; it's

knowing your craft. I think that if you have that knowledge, it frees you, whereas if you don't know how to do something, you have to paint it in a more stylized way, since you don't know how to do it in any other way.

M.B.: What do you think of your Yale education?

McCrum: Looking back, I took advantage of everything that was there, but I don't think I was nearly appreciative enough, because one of the great things about being an undergraduate at Yale is that you have all of the graduate professors teaching you. The Yale School of Art is top of the heap. If you look at the artists who are really on the scene today, you'll notice that a lot of them attended Yale. It really is an incredible facility. Senior year I was a Scholar of the House. I had no classes, so I was essentially a graduate student. I had a studio in the A&A building, and it was expected that I attend all of the lectures. They had the visiting artists program, and because of Yale's proximity to New York, there were always top artists coming in. It was wonderful. I basically had *carte blanche,* in that I could take any graduate courses I wanted to. I also enjoyed dealing with graduate students, who have taken several years off, holding down several jobs in order to support themselves as they paint, and now they're freed from all of those restrictions and can just paint. They're much more focused than the undergraduates, and create a wonderful environment.

M.B.: After graduation, did you find the transition from working in an academic environment to a non-academic environment difficult?

McCrum: It's an enormous adjustment. I think the hardest time is right after you get out of college. It's terrifying because you don't have the external structures of classes and assignments to support you, and you have to make your own. You really have to be disciplined. I think that if people are going to drop out of painting it's in the first year after college that they'll do it. It's a difficult time because for the most part you're working in a vacuum. At that point it is really important to hang out with other artists and get people to come and see your work and to take drawing classes, to do anything to keep you working. You lose the comfort of having a teacher behind you, and having other artists to compare your work to. You really have to develop resources in order to keep working, unless, of course, you go to graduate school.

M.B.: How active a role do you have to take in finding galleries to show your work?

McCrum: Pretty active. A lot of it is building a base: a gallery is not going to take you if you don't have a track record. They want to see that you're working, that your work is evolving. When you first arrive in New York, you just try to get into group shows. It's a catch-twenty-two, because regardless of how good your work is, most galleries want to know where you've been shown, where you've been reviewed, and clearly if you haven't been in the City for very long, you don't have any of those things. Then once you get enough shows under your belt, you can aim at second-tier galleries and invitational shows that get reviewed. Once you reach that level, the top galleries pick. But that's the long haul. So I just try to remind myself that compared to most artists I'm still very, very young. I'm really convinced that being successful in this racket has to do much more with tenacity and persistence than anything else. You get very adept at dealing with rejection, and you become immune to it. I think that for every acceptance, there have been perhaps twenty rejections. And it's very difficult, because it's something you have created. You find gallery owners who hold your slide tray upside-down and say, "We're not really interested." You develop a sense of humor.

M.B.: The Guerrilla Girls are receiving a lot of press right now for drawing attention to discrimination against women in the art world. How much of that do you find to be true?

McCrum: I guess I'm idealistic, but I think that if your work is really good, you'll be noticed; you don't hear Susan Rothenberg, Jennifer Bartlett or Elizabeth Murray complaining about it. I think that regardless of your gender you're going to have to put up with a lot of nonsense, and eventually things will fall into place if they're going to. One's time can be spent in a more productive fashion, by painting as opposed to squawking. I have heard a lot of female friends talk about it, and I don't mean to be dismissive of the issue, but I just think really good painters should be perceived as really good painters. I would hope that when I'm dead and gone, people would look at my paintings and respond to them, and my gender will be incidental.

M.B.: Since art is such an integral part of the apparatus of "high culture," and "low culture" too, do you as an artist find a responsibility to address certain concerns in your work?

McCrum: I think that those are the sort of issues that you don't actively think about, although, in the back of any painter's mind, on some level, is the realization that he is leaving a legacy; whether artists

want to believe it or not, their work is a reflection of its culture and its time. Most artists have an enormous ego, although I think that "ego" is a word that is really maligned; creative people who spend tremendous amounts of time by themselves, pursuing their visions, have ego. You have to believe in yourself to think that you are contributing at all by articulating your vision.

M.B.: In your work, you combine symbols from both past and present myths. Do you see the role of myth as changing in society over time?

McCrum: Well, I think it has to do with what we were discussing before: it has to do with truths, and I think they remain constant, only the vehicles change. So you can talk about these truths that have always been there, but in a language that people in the twentieth century can understand. I think one of the most flattering things I ever heard was at my last show. A woman came up to me, and even though there was a lot of iconography, and you had to know the stories to really tap into the paintings, she said, "You know, I don't understand them, but they really move me." In really good paintings, you don't have to understand a lot about art to look at them. It's basically from the neck up. If you look at any painting that is of the caliber that takes your breath away, up to a certain point you can talk about why it's a great painting, according to things like the composition and color. But there is always going to be the part of the painting you can't describe, the part that brings you back, that gives you the mystery, the seduction or the repulsion. That is the element, but there is no formula.

M.B.: How does a specific work start for you?

McCrum: Well, usually I work with themes. I'll have a central idea, like in my last show I worked with the signs of the horoscope and Christian iconography, and everything will feed off of that; sometimes I find that I'll go up one avenue, and I'll discover something else that will be better. I always have a theme, though; I don't paint just isolated paintings. They all tie together, and sometimes the central themes will sustain me over a period of years.

M.B.: Have you always made your paintings work together as a set?

McCrum: Yes, I have always worked that way. A friend of mine described my work as a sustained vision. I think that really sums it up best. It all feeds into a larger picture, so I think there is a logical pro-

gression in my work. The paintings I was doing two years ago, last year, and now all make sense together. In the work of a lot of the artists I respect I can see a continual thread. It's always done by the same hand, and there's a great intelligence that comes through in the work.

M.B.: Making twelve pictures that have to do with the zodiac, with tarot cards and then with the Crucifixion is extremely unified. Is this process perhaps too confining?

McCrum: Well, I like to have that, because in certain ways those restrictions really free me. People will ask me, "Don't you find that those restrictions really hinder your creativity?" But I tell them to think about Giotto, for instance, who was told by the Church, "We have a budget on this, so let's go easy on the blue and the gold leaf this time, and we need an Annunciation and an Assumption, and this cat over here has donated a lot of money, so would you please put him in the foreground and make him look a little nicer than you did last time." Artists then were told exactly what they had to do, and it certainly didn't hinder their creativity or self-expression. It actually makes the artist's job a lot easier.

M.B.: Can you trace how you become acquainted with certain iconographies?

McCrum: Well, one thing directly from Yale was an art history course that I took. I think the professor's name was Jonathan Post, and it was fifteenth century Netherlandish Painting. In the course, he really got me turned on to symbolism, in that each painting had a story in it. With the Annunciation, for example, you have light shining through unbroken glass as a symbol of the immaculate conception, and then the Virgin in a walled-in garden with a lily in her collar—it was such fun. You could always look at a van Eyck and appreciate it, but then when you knew all the stories, it was like a treasure hunt. I really like incorporating symbolism in my own paintings; sometimes, when I have an exhibit, I'll have a card adjacent to the painting that will say, "This is Luke, his symbol was the oxen. He was the portrait painter of Christ." I've found that gives people a handle for looking at the work, and allows them to participate in the work. Obviously, the more you know about the paintings, the more you get out of them. I would hope that someone could look at my paintings without knowing anything about symbolism and get something out of them, but when you know the background, it enhances the experience of looking at them. The most

important thing for me is communicating, and I think that sometimes it's really unfortunate when the art becomes so detached or self-absorbed that it fails to communicate at all. Or that you have to know so much about art that a person off the street couldn't look at it and appreciate it. I'm not just talking about figurative painting, but abstract too. You can know nothing about art, and go to the Rothko Chapel and still be moved. You can know nothing about art and look at early Jackson Pollock, or early de Kooning or a Stella, and they will evoke a response. The really successful artists really do evoke a response and usually there is a real intelligence which comes through in the work. Jasper Johns is a really good example.

M.B.: What contemporary works interest you?

McCrum: Of the older contemporary figures, I think Frank Stella is great. I've always been a big fan of Susan Rothenberg's. I like Neil Jenny's stuff and Brian Hunt's work a lot. I think Annette Lemue, the conceptual artist, is terrific. There's an artist who is my age, George Condo, and I like his paintings quite a bit. He's still young, and it will be interesting to see where he goes, but I think that he's talented. I also have an enormous respect for Jasper Johns. Oh, I also like Terry Winter's stuff a lot. And of course I look at the old masters always, always, always. I spend an enormous amount of time in museums.

M.B.: Would you say the masters of the Italian Renaissance are your favorites?

McCrum: I have a special affection for them, an affinity, I guess, at this point. But the painters one looks at are always changing. As your work changes, you hang out with different people. The artists I was looking at when I was fourteen aren't the same as when I was twenty. It's constantly changing. As your work moves toward a certain place, all of a sudden some other painter will have some relevance.

M.B.: There's a great suggestion of accessibility in the way you say "hanging out with the masters."

McCrum: Well, I think that's the key. Since I have always spent a lot of time with the old masters and have had the opportunity to see a lot of their paintings, I've learned you should never be scared to take what you want from those guys. So many times you find artists who never look ten years down the road: they only look at their peers or work that was done in the fifties, instead of pirating even further back. For me, nothing is sacred.

Eudora Welty

Talking About Writing About Talking

Eudora Welty, one of the most celebrated writers in America, has over the past fifty years produced a dazzling and important body of fiction. In her five novels, seven volumes of short stories and best-selling memoir, she explores growing up in a south rich in redolent flower beds, lilting town gossip and ever shifting black and white relations; in so doing, she at once upholds and challenges the legacy of the America's Southern literary tradition.

Welty was born in 1909 in Jackson, Mississippi, where she still lives in her father's house as an adored local heroine. In 1925 Welty enrolled in Mississippi State College for Women, and in 1927 she transferred to the University of Wisconsin. After some initial difficulties having her work published and with some help from friends, her first book, The Curtain of Green, *came out in 1941. Since then, Welty has steadily accrued critical and popular success. Her many literary honors include the Pulitzer Prize, the American Book Award for Fiction, and the Gold Medal for the Novel from the American Academy and Institute of Arts and Letters.*

The great Southern writer Robert Penn Warren once said, "It is easy to praise Eudora Welty but it is not so easy to analyze the elements in her work that make it so easy — and such a deep pleasure — to praise, for it implies that the work, at its best, is so fully created, so deeply realized and formed with such apparent innocence that it offers only itself, in shining unity."

On a sweltering late July day in 1988, Brian Edwards visited Welty at her home in Jackson. A wonderfully gracious hostess, Welty proved to be more of a dynamic conversationalist than an interviewee. Edwards said "that her eyes were big and blue and alive with thought, while her hands worked the way italics would in writing: emphasizing, highlighting and energizing her ideas."

Brian Edwards: What I've noticed since I've been in Mississippi is that it seems that everyone has a way of telling things or explaining things that seems more like a story than what I'm used to up in Connecticut.

Welty: Have you noticed that? That's interesting. I know it's there, but it's interesting that it would come out. I bet that's the way we

hold conversations. Sort of a narrative fashion. Sometimes you want to shake people, you know, when they walk up and start to say: "Well I'll tell you. . ." I say, "Tell me first, are they still living or dead?" (You know you can't tell about some people.) "Well I'm telling you! Now just wait," they say. Then they take you through the whole day, and all the horrors that went on and finally they say, "Oh, it turned out not to be anything. You know, they're all right now." People tell things the way they happen, not as a résumé. I think that's Southern. People enjoy that. I enjoy it too.

B.E.: Are you a storyteller in that way?

Welty: No, I try not to be. I try to convey the sense of it but not do it that way. I try to get the flavor of how people tell things. But in all dialogue, you know, you have to make it a plot ingredient: to advance the plot and to show relationships. You have to use every line in it. You can't just go off and soar in the blue sky.

B.E.: In a playwriting course I took, the instructor quoted a man by the name of J.L. Styan, who was writing about dramatic conversation. The first thing he said in his book was that ordinary conversatiton is not the same thing as dialogue. Ordinary conversation is boring, repetitive and doesn't advance anything. But dramatic conversation has to be moving.

Welty: It's like action. Especially in a play.

B.E.: You use dialogue a lot to move the story, maybe more so than other writers. Do you see dialogue in that same way as Styan? What does it have to accomplish?

Welty: Yes, but it took me a long time to realize what it could do. I seldom rewrote my early stories. I just sat down and wrote the way people talk. Sometimes it worked out and sometimes it didn't. But when I began to write with more intelligence about ways of handling things, I learned about dialogue. And then I learned more about it by teaching myself. I really love to write dialogue and I work hard at it. And I thought, "Well, I don't see why I couldn't write a play, because I can do dialogue in short stories." Well, I learned in the first fifteen minutes what the difference was. In the first place, there's so much less of everything in a play than in a short story. Every line is there and has to count. There's brevity and concentration. A whole kind of action has to be implied, to advance the plot and so on. So it didn't do me a bit of good. I learned that what I had learned was not useful at all for a

play. But that made me want all the more to try to write a play, to see if I could.

B.E.: Didn't you write a short play?

Welty: I've written some skits. I wrote a skit for one of those little Off Broadway plays one time. It was called "Bye-Bye Brevoort," which doesn't make any sense now. It was topical at the time. I was living in New York and they were getting ready to tear down the Brevoort Hotel, down near Washington Square; only they never did do it, I think. It was full of old ladies that had been living there for a thousand years. I lived in the Village and I used to see them walking out, just like figures out of a novel. So I wrote this impudent kind of skit, called "Bye-Bye Brevoort," when they're trying to blow it up, in the skit, you know carrying around the dynamite and everything, but these old ladies are still living there, drinking tea in the afternoon and ordering crumpets from nearby. And while they're having tea, there's a gentleman who joins them. And he brings news from the outside world that the bullies in Washington Square Park are using skates nowadays. You know, they all scream. It's all silly. In the end the dynamiters come in and carry them out, you know, still drinking tea or fanning, something like that. Anyway. That's not . . . I'm sorry I went — I'm Southern, I'm telling you everything.

B.E.: Back to the stories, there's an interesting relationship between your stories and your novels. Which do you put first?

Welty: Stories. I think I'm naturally a story writer. I never wanted to do a novel. That came about more or less accidentally. I sent in a story called "The Delta Cousins," and my agent, Diarmuid Russell, who was very astute, said, "I think you have Chapter Two of a novel." And I decided I would try. It was pretty naïvely done.

B.E.: That became *Delta Wedding?*

Welty: Uh huh. And I enjoyed doing it. It interested me to do it. I didn't go into it in a sensible kind of way.

B.E.: There's something about *Losing Battles* that's both a story — stories — and a novel.

Welty: Well you're astute, because it started off as a story. It was a long story, the length I like: about forty-five or fifty pages. It's still a story in one tight, long string without loops and slacks and so on, like a novel. The story was telling about the hero, the story of his arrest. It was still at the reunion. They said they knew he was going to come out

of the pen and get there. All the story is behind it, you know, what he did. And it ended with his entrance. He said, "What happened?" He thinks something is wrong with them at home, because they did expect him, but they didn't *really* expect him. But he came. But you see, as soon as he appeared, I thought, "I want to go on with this!" That's why I did it.

B.E.: It's a real fun novel. I identified with the woman who just married one of the uncles, Aunt Cleo.

Welty: I had to have her in there, because there had to be somebody who didn't know everything about the family, to ask the questions.

B.E.: I really felt like her, not only knowing the story, but being away from that part of the country.

Welty: Yeah, well, she was essential to the story. I couldn't have told it without her. Outsiders were everything. I mean, the bride was an outsider. The schoolteacher was not only outside it, but dead — but she had tried her best. And the go between, Judge Moody and his wife. That was fun to write.

B.E.: Something else I really enjoyed in the novel was the way you had the night-blooming cereus open at the end of the reunion. I had just a year before learned about that flower; I'd never seen it. How it just blooms one night, and that's it. You have to be there.

Welty: You have to be ready. It's a cactus.

B.E.: That was very dramatic in its own way.

Welty: I'm glad. I had to put that in. During the Depression in Jackson we used to amuse ourselves, you know, on dates without any money. And one of the things, this was a much smaller town then, was that when anyone had a night-blooming cereus, they'd put it in the paper that it was going to open that night and the public was invited. And we used to go by and look at them; they really were amazing. And we even had a tongue-in-cheek club called the Night-Blooming Cereus Club. Our motto was: "Don't take it Cereus." But they were beautiful. I heard the line that's in it, I think I put it in that one: "Better look tonight because by tomorrow morning it'll look like wrung chicken's necks." An old lady said that to me. *(Laughs)* I couldn't have made it up.

B.E.: Do you do much gardening?

Welty: My mother used to have a beautiful garden here. It was in

the back. But I had to give it up, because I got arthritis in the hands. You can't dig. You can't do anything. You can't plant. It broke my heart to do that. But I know about gardening because my mother was a wonderful gardener. And I was her yard boy.

B.E.: I wonder why so many writers and artists have enjoyed gardening so much? I think of Alexander Pope who said that it was his favorite thing to do, other than writing.

Welty: It's a quiet thing to do. You can think when you're doing it. And it's rewarding. Also, you plant a garden and you are rewarded. You can work all year and it takes a long time, but you are rewarded. You know if you plant something in the fall, it'll bloom in the spring. It's just like painting a kitchen chair. I like to do that. Just to do it, the household act. You see the results. It's very satisfying.

B.E.: Do you feel that way about writing, too?

Welty: The reward is in the work, actually. You know when you write you're rewarded the best way you know in the work. But just to finish something, like finishing *Losing Battles,* which took me an awful long time, to complete something like that is good. That's completing. But as far as rewarding goes, I think you've been rewarded when you write it, even if nothing ever happens to it. Of course that's your aim, is for somebody to read it. But I think it's a rest to a writer, or somebody that works that way, to do something that's a cinch to complete, like a household task.

B.E.: Back to your stories, what's the relationship between your written stories and the oral stories that this state and area of the country is famous for?

Welty: Well, of course, they're not at all the same thing. One is, you hope, a work of art which you write. You have the same roots I suppose. And often you're aided by the told story. But storytelling itself is an artless thing, I think. That isn't its purpose. In the sense that they were told in Ireland and around there. It was bringing something that was familiar and dear to the heart and not otherwise acceptable. Do you know the old poet Padraic Colum? He talked one time and said that in Ireland when he was a little boy, nobody had anything. They were very, very poor. And at night the storytellers came around. They would come to the home, and then people from around would come too. He was a little boy then; this was all very much his life. And he said, "We would all sit around the fire, listening." And he said, "The dogs would lie there

in a loop." Don't you like that? All the dogs lying around the fire, which would be in the middle of the room, peat pods going up. And the storyteller would tell the stories. And they all nearly knew them by heart, but there were no books or anything like that. And Padraic said as a little boy, that's what made him be a poet. He was just on fire with words and what they did. As a young man, he still didn't have any money and he went to some city, I don't think it was London, must have been Dublin, into a library and sat down and just memorized. I mean everything he could get hold of that he wanted, he memorized it. He can quote everything now. He remembers everything. It's all in his head. He said, "I was to get it the way I could." But it was those stories that began it for him.

B.E.: In an art class I once took, we had drawn portraits of a model. During the critique someone said that one of the portraits looked a lot like the student who had drawn it. So then our professor said that every painter when they paint a portrait puts a little bit of themselves in it, that it looks a little like them. It made sense. I don't know how much it works, but do you think this is true in writing also? In characters?

Welty: Oh, I'm sure it must. I don't mean anything direct. Because in the first place, I try not to write about—I mean I don't write about real people, but I write about real emotions. Often real situations, but I have it acted out by characters that can carry out what I want to do. But, how do I know certain things? It has to come from my own feelings. The character is not me, but the things he feels and sometimes the things he or she experiences are drawn from what I know. Of course, they're not there as they happen, but some kernel of them. I think every writer's different, I don't know. Some people do put themselves in. I couldn't put a real person in. I don't feel that you know any real person enough in and out to think that you know all about that person.

B.E.: Unless you write about yourself, I suppose.

Welty: Yeah, then that would be something else. That wouldn't be fiction.

B.E.: Have you written characters that are based on yourself?

Welty: No, I wrote a little autobiographical book.

B.E.: *One Writer's Beginnings?*

Welty: Yeah, but that's all I've ever done. I was thinking about Geraldine Fitzgerald, who used to play a lot of the O'Neill. She played

Long Day's Journey, and so on. She came to New Stage one time. And one of the wonderful things they do there is to get a fine actress like that to come down and be in a play — well, we are now a professional theater but at that time we were amateurs — to play with an amateur cast. Rehearse with them for six weeks, act a part that she knows. Can you imagine what it must have been like for the actors? But she was so giving anyway, and so gentle. I remember when we did *Long Day's Journey,* she would say, "Now I'm standing here at the door with my back to you. I'm not saying anything. But do you want to know what's going through my mind?" And you know exactly what she's conveying. "Mr. So-and-So is passing in his carriage," she said. "That all could be conveyed in the way I'm standing at the door. Through my back you must be able to know what I'm going through." It made chills run up your spine. It shows how much you have to know when you're acting a part.

B.E.: When you're writing a character, is it the same thing?

Welty: Yeah, I think it is. It has to be. Because you can't leave anything undone. Chekhov says, "If there's a gun onstage, it's got to go off." You know, that famous saying. But you can't do that in a story, either everything you use has got to be connected or you don't want it.

B.E.: How did you know that you were to write stories and novels as opposed to poetry or plays?

Welty: I don't know. Of course, as a child I just wrote awful things. But it's stories that appeal to me. It's what I love to read. Not that I don't read poetry, but it was always something in another realm. I felt very close to stories. It's just what I like.

B.E.: What stories, which writers did you look to?

Welty: As a child? Oh well, I read just about everything. Of course I read fairy tales and all those when I was growing up. But I read everything we had in the house and the public library. You know, without discrimination. Everything. But I always loved narrative.

B.E.: Why write as opposed to anything else? What is that attraction?

Welty: I don't know, I love words. I love the language. But of course, I had to learn to love words and the language through reading. You're not born loving it. Before trying to be a writer, I wanted to be a painter. That's what I really thought I could do. But I couldn't. I mean

I learned that I wasn't good enough to do that. I have a visual mind and when I write I see everything. Don't you? I mean I see it. I don't know. How do you know? I love the sound of a voice. I associate that with growing up and being told stories at night out on our sleeping porch with the dog. Our mother would come out and tell us stories.

B.E.: You had a very supportive mother, from all I've read. For your writing and reading.

Welty: I certainly did have a supportive mother. And father. Thank God, what they most wanted their children to do was to get a good education. For instance, I'm so glad that I studied English literature in college and majored in that, instead of writing — although I don't think they had creative writing courses then and if they did, I didn't know it. But I'm so glad that I learned what mattered.

B.E.: The background?

Welty: The background. I'm not talking against creative writing. I'm all for that. This interviewer that Bill Ferris got up, somebody from the humanities, asked me if I thought that creative writing classes have made all the improvement in writing. I said I didn't know what he was referring to exactly. I said, I don't know whether the level of writing has risen or not. I will say that — I have worked some with colleges in the past just to go and read something and then they ask you to read some of the stories — that they had a level of competence I could never in the world have achieved at that age. They're competent. Whether they've got that extra thing you don't know yet, because they haven't gone on out into the world.

B.E.: So you have to live first and experience.

Welty: I know a painter who taught painting classes. Often, you know, children are gifted in things before they're self-conscious. Wonderfully imaginative. Some of the students keep on until they're teenagers, she said. The really gifted ones are very rare — the ones that can go on from the wonderful burst of imagination that they acted on as children. In the average child, it doesn't go any farther. It would be much more evident in painting than in writing, wouldn't it? I just wonder if there's a period of life and growth in a writing talent. I know some people are late bloomers — I was sort of a late bloomer — and some people are, of course, precocious. But it's kind of fascinating that the life of a talent doesn't seem totally related to physical years of a person. And maybe college age is not the right age to teach creative writing. I

don't know. It's just something more to worry about. As if we don't have enough to worry about.

B.E.: I just read *The Optimist's Daughter* this summer. When I read the funeral scene, I was immediately reminded of the funeral scene in *The Golden Apples*. There were a lot of similarities.

Welty: I bet there was. I've never gone back and read *The Golden Apples* but I was writing about the same kind of thing.

B.E.: Both have that view that funerals are false or that people deal with them in a false way.

Welty: I know it. I never thought about comparing them, but I'm sure it's the same kind of thing. It is apparent when you go to some of these, especially in the country because it's really a country funeral, in which they're big affairs. Important, not only important because it's a human being which everybody knew, but it's also a time when people vent their emotions sometimes in a frightening way. I didn't know I was going to bring Fay's family into it until I did. But I felt I had to. I really just couldn't stand her. I knew that I was so wildly prejudiced against her. I made her up, but there are still lots of people like that. I thought, "Well I've got to do something to explain her." So I brought in the family. At once I knew—I mean I just brought them in and I didn't have to give them a second thought. I knew exactly the kind of family she had. They're also the kind of people that you know, if you ever have anybody in the hospital in the South, the way this family acted was the way they acted here. The whole family will move into the hospital and just live out in the hall. And they talk all the time about everything, just like these hospital scenes, and ask you personal questions and all of that. I knew just exactly what they were like. I'd heard it all many times. I think it did serve its purpose. Don't you?

B.E.: Yes, because before you see her family, you know you don't like Fay but you're not sure where she's coming from.

Welty: Where she came from. Texas. *(Laughs)* Also the kind of people that they were, I had to explain it by showing the group. Then I could also put two sympathetic people in it, like the old man who was gentle and kind, the one who would shell pecans. I've seen that happen a lot, instead of reading, they shell pecans to give to somebody. And the little boy Wendell. They were both innocents. They had not been corrupted by the vulgarity in the family. Then I tried to give Fay a touch of Wendell in the end. I learned a lot writing that. I wrote it twice. Once

it was in *The New Yorker* and then I wanted to not publish it in book form until a length of time had passed. And so I started at the beginning and retyped it, working as I went. I don't know in what respects literally I've changed it, but I hope that it got more understanding and deeper.

B.E.: It's very deep. Those scenes where the daughter is upstairs looking through the things are very moving.

Welty: I hope so. All that was very close to me.

B.E.: It's the most emotional thing I've read that you've written.

Welty: It is. If I had known ahead how hard it was going to be to do, I'm not sure I would have had the courage to do it. I know I needed, I wanted to do it.

B.E.: Why was it so difficult to write?

Welty: It was too close to me. I had none of the situations that were described in there, but I had some of the experiences. They were not characters in it. My family was not. For instance, my father died at the age of fifty-two, when I was still at Columbia — I mean just out of Columbia, so there was no — and he was not a Southerner either. So, the judge was not my father, which a lot of people assume. My mother had a background in West Virginia. That's almost true, what I put in. I couldn't have made that up. But the character was different. You know, I used things that I knew to explain and make you believe what was happening to my characters. But they weren't — I was not the girl, although I certainly have been in situations like that.

B.E.: When I read the novel, it came through that it was very close to you. It moved me as a reader because of that.

Welty: Thank you. It was close to me. For that reason, I didn't want anything to be left raw or ragged in it. There's a thing called Audio Books — is that what it is? Anyway Random House publishes tapes of books. They said they would like to do *The Optimist's Daughter,* but they would have it done by a professional actress. They would cut it and have another voice make the bridges, telling everything that happened in between. So I said I didn't want to do it. I'd rather not do it at all. They said, "We'll have it in two cassettes." I said, "I think it could go on two cassettes, and in fact," I said, "I'll be glad to try." That was madness in me to do that. But, in a way, I did it. And they said they were willing to let me try, and if it did not work on two cassettes, they would just lose — in fact, they would ask me to read *The Ponder Heart* instead. So I went to New York and did it at a big professional studio.

I learned how to do it, you know when you couldn't breathe or touch the paper or anything. You couldn't touch the page you were reading. You certainly couldn't have the hiccups. But I went everyday and read for a couple of hours and worked on it the night before. And I learned more about the novel by doing this, almost, than I did in the writing. I had a pretty good opinion of the novel by the time I finished it. Because it was really being objective about it, you know to do this. I really was outside it.

B.E.: You were getting it from the reader's view.

Welty: So, I was glad I did that too. I learned a lot from it. I could see weakness certainly. Anyway...

B.E.: Are you working on anything now?

Welty: No. I want to get back to short stories. I had begun some before I stopped to do the Harvard lectures: *One Writer's Beginnings.* I never have consecutive time left free, for the way I wanted to jump in on this. I can't stand to start a story and then have to stop. I'm hoping to start after I finish a couple of things this summer.

B.E.: More stories, then?

Welty: Uh huh.

B.E.: A lot of people will be anxiously awaiting them.

Welty: Oh, thank you. *(Laughs)* Well, I just love to write them. It's just hard for me to get consecutive time. For anybody, really. But I'm going to do it.

Peter Sellars

Stellar Sellars

A shining star in the galaxy of theater, young Peter Sellars shot into the drama world. While his brash style and apparent irreverence have offended conservative audiences, Sellars' genius at reinvigorating centuries-old classical plays and operas have won him critical respect worldwide. In 1984, at the age of 26, Sellars was offered the post of artistic director at the Kennedy Center's American National Theater in Washington. Since then, he has won the MacArthur Foundation's Genius Award, directed the snooty Glyndebourne Festival and emerged as a dynamic force in the cinematic arena.

Born in Pittsburgh in 1958, Sellars entered theatrical production at an early age. Sellars and his sister spent their teenage summers touring the Pittsburgh area with their own marionette production. He directed plays while at prep school and was influenced by European avante garde theories during a year he spent in Paris before attending Harvard in 1976. Though his early plays at Harvard led to his alienation from the college drama "scene," his senior year he was invited to direct at Robert Brustien's American Repertory Theater in Cambridge.

Sellars' souped-up versions of Mozart and Handel operas and Ibsen and Shakespeare plays have earned him such titles as "the punk Amadeus," enfant terrible and wunderkind. He has explored translating the messages of classical works into modern understanding in varied ways. In his production of Haydn's Armida *he substituted the Vietnam War for the Crusades, while his* Mikado *included Datsuns, Coca-Cola ads and mini-skirts. In the past few years, Sellars' spectral updates of opera classics—Mozart's* Don Giovanni *set in Spanish Harlem, Handel's* Orlando *set on Mars and* Antony and Cleopatra *set in a swimming pool—have generated a tremendous range of critical and audience reaction. And yet, amid the orations, the boos and the controversy which he incites, few disagree that Sellars is a talent to be reckoned with.*

Matthew Wilder spent four "burning hours" with Sellars in August of 1987 on the set of two Mozart operas he had in repertory. Sellars' musings on stagecraft politics, his sources and the state of American theater were true to form—as brassy and uncompromisingly complex as the shows he creates.

Matthew Wilder: I want to talk first of all about method. When you pick up a book or a play, what is your first method of attack?

Sellars: I have none. It's so odd, because I see that there's a need to get that. And I'm beginning to understand why Meyerhold and Stanislavski each made a system. Meyerhold made several systems actually. But there is a need to say after a certain point, "Okay, there has to be an organized way we can go about this, because not everything has to be this hard. Some things will always be hard, but certain things don't really need to be, and if we had a more organized approach, we might be able to make things that should be hard even harder, and keep some of the things that shouldn't be hard from draining our energy."

M.W.: Meyerhold was systematic in what way?

Sellars: Oh, at several different times in his life he gravitated toward very specific approaches. First with the Symbolists: Ivanov and Blok and that material; then with the Diaghilev/Ballets Russes style, which Meyerhold really pioneered in Russia before Diaghilev had supported it; then with the obviously revolutionary material, when Meyerhold just picked up the revolution and went with it; and finally, very late in his life, with that very magical, beautiful balance between pure Constructivism and a kind of Stanislavskian surround that became so moving. And in a way, that's what I have spent my life —

M.W.: Trying to synthesize.

Sellars: Working on. That end of the line. What Meyerhold and Stanislavski concluded with. In his last years, Stanislavski was giving his actors biomechanics, these astounding physical exercises to do with machines. And at the same time, he was directing *Camille* and Chekhov.

M.W.: Let's talk about a very difficult text, Khlebnikov's *Zangezi,* which you will direct at BAM (Brooklyn Academy of Music) next month. There are linguistic wars going on, events occurring in language but nothing very concrete on the stage. What can you do to increase the visuality of what is happening?

Sellars: The object is that we're dealing with a different type of theater. What appeals to me about *Zangezi* is that it's para-theatrical. It goes beyond theater; it will not fit into any kind of theatrical limitation or any theatrical device or plot. The question of "What is a character?" has to be taken into account all over again. It's so marginal to the history of theater and, at the same time, it's completely central. If you wipe away the glop that has accreted you come back to this need for, in the most literal sense, declamation. To cry out something. The

49

most theatrical thing in the world is speaking. The courage to speak is very powerful to me, and that is why I mostly stage poetic drama. I stage either Shakespeare, or Khlebnikov, or opera, where the issue of speech, of declamation, is central.

M.W.: Then why do critics never approach your work in terms of speech, in terms of the Word?

Sellars: That's the hilarious thing—people haven't noticed this about my work. No one comments on it; but to me, it is the text that holds utter primacy. The distance between my press and what I do is so bizarre. What I'm really interested in is words, and not necessarily for their *New York Times* prose value. Prose on stage almost never interests me. I love that Shakespearean feeling instead, where you don't know what the play really means, and even the plot is up for grabs. To me, Khlebnikov is really pure Shakespearean drama. *Zangezi* really takes up where *Lear* leaves off; it has that kind of crazy prophet screaming into the storm.

M.W.: When you have something like *Zangezi* that's so disassociated from narrative, do you think it's difficult to keep it from falling into a kind of formalist emptiness?

Sellars: No, not when it's real poetry. If it's junk, yes, but if it's Khlebnikov or Shakespeare, no, because it means things. It's very full. It's about a world that people can't touch with their hands, a completely nonmaterial existence.

M.W.: So it's about how to make that world material? Or make it legible?

Sellars: Or not. For those who can't read, too bad. I am really tired of having to reduce material so that somebody who isn't interested in it anyway can understand it. My feeling is that if you have to tell somebody something, already they will never understand it. I'm interested in awakening spaces in people, but spaces where they themselves will be able to find and take something.

M.W.: To move on to political theater, don't you have this desire—

Sellars: Wait a minute. In America, there are no politics, so how can you have political theater? There's no political system at the moment, there's no political discussion, it's totally collapsed. We have nothing but television shows. And prime time is in the White House. Until American politics becomes theater again, there will be no society.

As long as politics remains television, then America's in a crisis. I wonder if we can ever return to a period where politics becomes theater, and that is not to say when theater becomes politics. What I mean is when politics is theater; when it's about people in a room together talking about their lives instead of sitting at home watching TV, not responding, having no feedback, no friction.

M.W.: And theater in general?

Sellars: It doesn't exist either. Seriously, I'm not kidding. All of this, this lack of friction, is why there's no theater in America right now, political or otherwise. And the same thing is true for other cultural areas, because there's no culture without friction. So-called cultural events like, say, Lincoln Center performances, aren't real culture. They're pseudo-culture. Without friction, you're not getting anywhere.

M.W.: Now, to apply this sense of anesthesia you've been talking about to the opera world: you probably know more than anyone else in America that going to the opera now is like putting down a payment on a Saab.

Sellars: Or not. You know, it's odd. The tickets for *Don Giovanni* turned out to be expensive, which I regret, but the show just ran into a total budget crisis. Most operas I've done, you can get in pretty cheaply, for ten or twelve bucks or something, which, these days, gets you two bags of Fritos. Also, in opera, the best seats for the show tend to be way up in the fifth balcony. Not for seeing necessarily, but for getting the vocal thrill of the opera. So I never worry, because I spent my whole life sitting in the fifth balcony. I love the fifth balcony. I direct for it. I love the people in it.

M.W.: In Mayakovsky's *Government Inspector*, you kept the production pretty traditional, compared with other works of yours that have made critics tear their hair. But there were design elements that were apparently contradictory or irrelevant, for instance, the pineapple that just appeared on stage.

Sellars: Well that's Mayakovsky. You know the lines from *How to Write Verse*: "Eat pineapple/Guzzle grouse/Your last day draws near, bourgeois louse." Something like that. Anyway, the pineapple is this huge, exotic fruit in Mayakovsky's Russia. It's what Russian men thought of their women: this thing that's prickly on the outside, sickeningly sweet on the inside, and can only be obtained very rarely. But that's old stuff. I did that when I was in school. I don't disavow it. It's

a fun show, but it's not exactly what one had in mind. I mean, I wouldn't quite do it that way again. The work I do now is different. I don't have any big pineapples sliding across the set because, without wishing to be condescending, that's something a young director does.

M.W.: What about naturalism, which is something you've always disavowed? You're always chuckling about Mom and Dad in the living room eating Cheetos.

Sellars: All right, but that's because all that is only so interesting. There have to be other things that take place somewhere else.

M.W.: But if you bring a certain portion of naturalism to canonical texts, why not just reverse the equation? I'd think that you could create something really explosive—if you did, say *The Lower Depths* or some kitchen-sink stuff. Or Mamet.

Sellars: Mamet is just not interesting. It's really thin. I need something that's very thick, that has a kind of richness built in, and Mamet and some of the other material you just mentioned aren't compelling to me. Odets, to give another example, is just plain not interesting. I'm all for *Awake and Sing!,* I say, "God, let's do that!" And then I look at it and think, "Eh, well. . ." I'm not saying someone else couldn't do naturalistic material; other people do it wonderfully and make a really powerful evening. But I can't. It can't be part of the multi-layering that I do, which is, I hope, about producing something that's here and now, and moves forward and backward in time, and sort of touches eternity.

M.W.: But you did Ibsen.

Sellars: Sure.

M.W.: I don't see any difference between Ibsen and some modern American writers.

Sellars: Ibsen's a great writer.

M.W.: There are some great Americans.

Sellars: O'Neill. But after that, who? O'Neill is great. O'Neill is very great. The rest of them are just . . .

M.W.: So why not O'Neill?

Sellars: I will do O'Neill some day, somewhere down the road. It's just that there's a generation right now that is finishing up with O'Neill: David King, Jose Quintero, Colleen Dewhurst, people who should be allowed to own the material a bit longer. They've earned it, and they can have it, because they do know it. Mostly, I do things I don't think

are being done. I try and fill in something that I don't think one would otherwise see.

M.W.: I want to get back to Mayakovsky, whom we mentioned earlier. Why is he a large figure in the Western canon?

Sellars: Translation. He's almost untranslatable. It's the same as Khlebnikov: you need an inspired translator who has the correct turn of mind. That's why I never use a published translation for anything I do. I always either work in the original language or collaborate with a translator myself and go over every line of a text. I want to understand what original word order is in the sentences, how things are grammatically set up. What I understand with Shakespeare I want to be able to understand when I do Khlebnikov.

M.W.: So when you did *Bedbug,* for instance, you went right to the original and worked with that?

Sellars: Yes, Maria Markoff-Belya and I. All the Russian texts I've worked with Gogol, Mayakovsky, Chekhov — all of that I did working with a translator for months before rehearsals so I would be able to tell an actor what I tell him when I do Shakespeare: how a line is structured; how someone's thinking; which thoughts come first; how they're transformed; how sentences begin one way and then, halfway through, how the grammar goes completely to hell; how something starts in singular form and ends as a plural. All of those things in Shakespeare that are in Chekhov. That you have to know.

M.W.: What you've just described reminds me a lot of what's going on in *Timon of Athens.* Would you agree that it's one of Shakespeare's great plays?

Sellars: One of the great plays. Sure.

M.W.: Why is it so neglected? Because it's a little shambling?

Sellars: No, because it's not pleasant. People want to have a good time now. People don't want anything truly unsettling. For instance, the slam that John Rockwell made at the production of *Don Giovanni.* He said it was "intellectual and off-putting and alienating." What? Excuse me, but the day and age when "intellectual" is a pejorative in the *New York Times* is already incredible. *Timon of Athens* is not a good-time play. It's the end of the line for Shakespeare. That's why he had to write *Pericles.* Because *Timon* is a point of no return.

M.W.: Let's talk about the Wooster Group's production of *The Temptation of St. Anthony* for a moment. I just saw the film portion.

Sellars: Oh, you mean *Flaubert Dreams of Traveling But the Illness of His Mother Prevents It.* They shot that in Washington when we were there. It's a great movie, and Ken Kobland is a great filmmaker. Apparently what he's done is quite amazing.

M.W.: You've said before that the Wooster Group is the theater of the future.

Sellars: What the Wooster Group is doing strikes me as the only thing in theater right now that feels like what life feels like right now. Most things in theater remind me of what theater feels like, but not life. And the Wooster Group, even though what they're doing is totally incomprehensible, reminds me of what life feels like. It's evocative, and I don't pretend to know what it means, but it's fabulous.

M.W.: The one contemporary author that I think would be perfectly matched to you that you haven't done is Heiner Müller.

Sellars: I've always hated Heiner Müller — that is to say, his work. And then I end up spending all this time with him accidentally. Everywhere I go he's there, and we chat, and so I've looked at the work again. And actually I've been reading a lot of it this week.

M.W.: And?

Sellars: And I love it, though it did take me a while to be converted.

M.W.: Why the initial resistance?

Sellars: I thought it smelled academic.

M.W.: And Khlebnikov doesn't?

Sellars:: Khlebnikov is a trumpet blast. Khlebnikov is a voice in the wilderness, someone wandering in the desert. I've always been interested in Saint Sebastian and Khlebnikov and the lives of the saints, whereas Müller, I thought, was just sifting through the ruins of a no longer existent culture. Which is interesting.

M.W.: That's why it's interesting.

Sellars: But not yet, to me, a new statement.

M.W.: Really?

Sellars: Well, again, that was my original feeling. I no longer feel that way at all. I'm sort of thrilled by Müller's work, actually.

M.W.: Let's talk about *Don Giovanni,* your most recent show, and how it has evolved since its origins seven years ago.

Sellars: That was the first thing I did when I got out of college. The current production isn't like it at all. I guess there are two things I kept:

the moment at the end of Act II when she picks up the blanket and she and her lover are lying on the sidewalk, and the moment when Don Giovanni smashes all those bottles.

M.W.: Now that you mention specific moments, what about the lighting in the current show, those times when the only illumination comes from the orchestra pit, or maybe from a bulb or a piece of flourescent tubing?

Sellars: Because they call for a certain life of the soul, when the drama has nothing to do with what their souls are saying. So you remove their physical presence and the only thing the audience can feel is their souls. The light burning within people.

M.W.: Why don't we finish by talking about undergraduate theater, which is something you know all too well.

Sellars: Well, it's always been bad. I remember the politics of college theater being monstrous. It was incredible the kind of scheming you had to do to get the mainstage at Harvard. It was nothing but sheer political maneuvering, and who likes who, and who doesn't like who else, and it's never fair. I directed on the mainstage as a freshman, and the thing was a total catastrophy, hated by almost everyone, except, it turns out, a few people who actually loved it, but...

M.W.: That was the pantomime of Edith Sitwell's *Facade?*

Sellars: Yes. I don't know if I could take it now, but it was not, at least, what was being presented at the time. It was playing next to *Oklahoma!,* and I think it was more interesting than *Oklahoma!* That, I think, can be said.

M.W.: You also did some Ibsen.

Sellars: Right. I did *When We Dead Awake* with five actors, and the set consisted of three sets of bedsprings with an island of three folding chairs in the middle, and a pile of old newspapers sitting in one of the chairs. I couldn't get anyone to play Rubek, the lead male role, so I had the pile of newspapers represent Rubek. And I had all the women come and talk to this—

M.W.: You ventriloquized Rubek?

Sellars: Well, no, he didn't speak. All you had was these women who'd come and say, "Well, Rubek...," talking to this pile of newspapers. It was the only way I could put on the play, and I was determined to do it. Usually, when I couldn't get anyone to play a role, I'd play it myself, but I didn't want to, so I used a pile of newspapers. And it was

actually a very good show, a very felt play. The avalanche at the end was very beautifully done. We did that by having the nun come in and just cover the woman with plaster. She was plastered to the pile of newspapers, which became the sculpture. I don't mean to suggest all of this was a joke, because the moment was very beautiful and very scary. But again, the whole thing was done with two weeks rehearsal time, and I had to cut the play to smithereens just to get something I could deal with.

M.W.: And after that?

Sellars: Well, after that, starting with *The Three Sisters,* I did what I've done ever since, which is doing the most complete versions of shows that anyone's ever been to. I'm in love with every word Mozart wrote, every aria, every récit. We do the most complete performances of these operas that anyone's ever seen.

M.W.: You'll never cut again?

Sellars: I haven't cut since.

M.W.: What are you going to work on in the next few years? Is there anything you urgently want to do before you expire?

Sellars: Opera and film. A bunch of new operas. I want opera to be what it was for Mozart and Verdi. I'm doing new operas all the time. Every year I have a new opera. Sometimes two.

M.W.: No straight theater?

Sellars: No.

M.W.: No National Theater?

P.S.: Retired. Film is the art form, the paint you get. Film is the painting of our century.

M.W.: Do you have anything coming in film?

Sellars: Yeah. This January.

M.W.: Is it an adaptation of *On the Road?*

Sellars: *(Makes silent gesture of sewing up his mouth.)*

Ashley Bickerton
Boy of the Zeitgeist

In 1986 Ashley Bickerton and some similarly-styled yuppie artists took the New York art scene by storm. Aphorisms abounded from New-Geo and Post-Pop to Simulationism, as critics and collectors desperately searched for a name to attach to the most controversial new art school since Warhol's Pop Art Revolution. Though some assumed Ashley Bickerton, Jeff Koons, Peter Halley and Meyer Vaisman to be media creations or commercial hucksters destined for their comeuppance, their works have continued to garner critical acclaim, museum wall space and collector dollars.

Bickerton is one of the most controversial of the young Simulationist painters now dominating the international art scene. His representations of simulated bricks and sci-fi "sounds" have been denounced as clever appropriations of past styles by some critics, praised as ironic readings of the post modern art world by others, and quickly purchased by collectors.

Bickerton was born in the Barbados in 1959. He has since lived in Guyana, Hawaii, Britain, and California. After receiving a Bachelor of Fine Arts from the California Institute of the Arts in 1982, he moved to New York to establish himself in the art world. He studied briefly at the Whitney Museum while becoming a member of the East Village art set of the eighties. When the prestigious Sonnabend Gallery decided to exhibit his work along with that of Koons, Halley and Vaisman in 1986, Bickerton's successes and the Simulationist rage shifted into high gear.

In January of 1987 Jonathan Wright travelled to the artist's studio in darkest Brooklyn to talk with him about his work, American culture, the critics and more.

Jonathan Wright: What are some of your early conceptions about being an artist?

Bickerton: I suppose I've always wanted to be an artist. Ironically, it was when I was a student at Cal-Arts, that I lost interest in art and turned to films and poetry for a couple of years. I didn't do any painting at all. I wanted to be a writer most of my time in art school. As soon as I got out of art school, I went back to painting.

J.W.: What made you start writing poetry in art school?

Bickerton: It probably had a lot to do with the environment at Cal-Arts, which was very much against any traditionalist modes of working. The school was founded on late sixties, early seventies radical dematerialization aesthetics, so any kind of way that was not the normal route was encouraged. I just steered well away from traditional painting and developed my interests in writing and film as a means of having more lateral movement in this austere environment.

J.W.: You were once an assistant to Jack Goldstein. What influence did he have on your current work?

Bickerton: In a sense, Jack was more influential in what not to do. His extremely resistant personality was very instrumental in giving me something to pull against. I learned a lot just watching Jack. He was the one person who actually taught me how to produce work, to make it happen, or to quote him, "to get it up on the wall."

J.W.: The process of making was difficult?

Bickerton: Yes. I was always alive with ideas and spurting at the mouth, but Jack was the one who managed to transfer those energies into the actual production. Jack was also one of the most obsessively intellectual people I've ever dealt with, and he was always very inspiring in that manner.

J.W.: Who are some other artists that have been influential?

Bickerton: I think I must have been influenced by almost everyone at one time or another. But there are people that obviously stand out: Duchamp, Smithson, Judd, Hans Haacke.

J.W.: Hans Haacke has often stated that he considers his work antithetical to the art market. Do you consider your work subversive?

Bickerton: Haacke is someone who sets out with this as an explicit purpose. I have not chosen to be political or subversive in that manner. I'm much more interested in the intrinsic workings of power, of seduction, of commodities as a linguistic paradox, and so certainly my work has made explicit efforts to deal with these particular agendas, but in a very different manner than Haacke, who was nevertheless influential in revealing the underbelly of the art world, the dark backside of its insidious workings.

J.W.: Is the liberal humanist ideal of artist as genius-creator meaningful to you?

Bickerton: The notion of genius-creator is an archaic absurdity. I

don't believe that one heroic artist rises above the throng and leads everyone, like a Joan of Arc or Julian Schnabel, to glory, beyond glory. I just don't think that, on the average, artists are any more intelligent than anyone else, nor do I think that artists are necessarily more talented, whatever talent is. I don't believe artists have any greater degree of perception in identifying the general discourses of culture. I do think that, at certain times, areas of the arts move ahead of one another. At certain times, film can be a vital nexus of ideas; other times the world of rock-and-roll might erupt as a nerval center which infuses new possibilities into the cultural field. But I don't believe that one social or artistic activity can have a monopoly on cultural innovation. Art is just as capable as any of these, but then again, art can regress into a puerile conservatism as well.

J.W.: You probably feel this way about the labels high art and low art, which persist with surprising strength in this post-modern age?

Bickerton: Yes. The whole concept of high art and low art, high culture and low culture has to be absolute. I honestly believe that the Beethovens of the future will be the likes of Chuck Berry and Little Richard — that which was once deemed a low, vulgar sort of beebop speak — as opposed to the likes of Steve Riech and Phil Glass.

J.W.: Let's get back to your work specifically. Are the stylistic monikers now being applied to it — Neo-Geo, Neo-Minimalist, Neo-Abstract — too simple?

Bickerton: Oh you mean Neo-My-Ass and Post-Grapenuts. I think the labels given are indeed ridiculous. Labels themselves, though, are ultimately a banal but necessary evil. I'm continually amused that the critics can't seem to attach a handle to my work. Having the prefix "neo" applied to my art makes me a bit nauseous. Neo inevitably means "rehash," and it ties in with the "retro" state of affairs in the political arena and in American culture. After the great rushing of what I refer to as the classic late sixties, early seventies period of art central to which was posited the "isolated" figure moving into an alien landscape, moving onwards into the unknown, outside of the "space of art," we've now backlashed into this regressive era, where we want to feel a cushioned bliss and wallow in the warm amniotic fluid of what we believe was the nineteen fifties, or at least our collective cultural memories of the fifties. When we fear the future we turn to the past. What I think I have done, and what some of my peers have done, is to avoid complicity with this

soaking in the soap suds of a bygone fictional suburbia. I've tried to take a look at the forces, the motivations, the desires that created this complex and really deal with that analytically.

J.W.: How has this agenda affected the way you treat the art object?

Bickerton: In the late sixties and early seventies objects of art were ripped off the wall and strewn across the gallery floor and then outwards into Nevada and Utah. Slowly and sporadically at first, then quicker and then all at once, everywhere, in every crevice, this radically retro cultural consciousness reared its grisly head. After watching this all, there was a real feeling on the part of some younger artists to cynically make objects that said, "Look, I am not going to go with a polemical voice into this onslaught by strewing my excrement across the gallery floor. I am going to sit on this wall, and I'm going to sit on the wall with an aggressive and unnatural discomfort belligerently proclaiming that this is the place of the art object." This was an aggressiveness that moved beyond cynicism, beyond humor. A lot of the intentional duplicities of this work have, of course, been very misunderstood at this point.

J.W.: Much of the art media has lumped your work, Peter Halley's, Meyer Vaisman's, Jeff Koons', and that of some others together.

Bickerton: The groupings are almost a necessary package for consumption by a diverse audience in the early and often misunderstood stages of any cultural activity. It has happened with any number of artists who turned out, in their own right, to be quite different. As far as we're all concerned, we've been friends as artists for quite a while, and in my case, Meyer, Jeff and Peter have always been three of my favorite artists.

J.W.: Is the grouping an attempt at some sort of critical control?

Bickerton: The issue of control right now is very important, in light of the critics. I think what we're witnessing here is the plaintive hysteria of a vocation completely displaced at the grass-roots level. In the late sixties, many critics ascribed extreme manifestos to the art of the period. They were riding a very particular axis-point of what they believed the work of the time to be. By the late seventies many critics witnessed the work they had supported turn into everything that they despised in relation to the market system of information and meaning.

At least this was the case with the so-called radical critics associated with *October* magazine. So what had happened by the time we came around was that, for all intents and purposes at a grass-roots level, the critical structure had disintegrated or eroded. Artists were left to take care of their own critical and discursive needs by writing their own press releases and generating their own dialogue.

J.W.: Which is what Peter Halley has done.

Bickerton: Peter certainly has, in a very visible and positive way. And we all have in our own way. I've written a number of things, my own press releases, for example, to the ridicule of certain factions out there who find it quite amusing that artists would take such presumptuous liberties with their own work. To a lot of critics, artists are like pygmies. It's wonderful the resourceful ways they can track down and hunt animals and live a social and artistic life. But my God, any god, don't let them try and explain themselves! After all, we are the beholders of science and rationality; and, they are our laboratory experiment in blind passion.

J.W.: You just mentioned *October* magazine. I take it you have specific objections to this publication?

Bickerton: Maybe not so much in the publication itself, but certainly in the way it was used and received in certain ways much like the Bible was misused to bully the non-conformers into an unquestioning servitude. When one thing I realized early on was the complete and utter disrespect I had toward the formulation of a monocular aesthetic criterion based solely upon the philosophical criterion applied to another very specific social realm, which is what I felt—and this was echoed by certain individuals I was associated with at the time— *October* was doing. I believed that a really insightful artist, aware or not of certain advances in critical theory, was just as capable of producing new information as was an insightful new theorist. And the greatest ill, what I thought the greatest ill perpetuated by *October* magazine, was the establishment of a cultural hierarchy which posited philosophers and theorists, namely continental, as the gods, critics at *October* as their Mohammeds within the realm of art, and artists as the worker bees that went forth and mindlessly constructed the phenomenal visions sent down from above.

J.W.: Let's talk about some specific pieces of yours, your wall sculptures. *Wall Wall #6,* for example.

Bickerton: They're paintings. The less they look like paintings the more I must insist on the fact that I am indeed a painter. If a painting is something that sits on a wall and fills a space with color and meaning, then what is more obvious than a piece of colored wall to affect meaning.

J.W.: Not an erstwhile sculptor?

Bickerton: I've never been a sculptor. I make my decisions completely with the painted object/commodity/meaning, the pregnant vessel in my mind.

J.W.: Georg Herold, whose real bricks are arranged much like your simulated ones on a work such as *Wall Wall #6,* recently said that his bricks are not objects but metaphors for objects. Are those bricks of color objects to you?

Bickerton: Very much so — certainly no metaphor, but I guess that ultimately I'm a satirist, and in that sense they're caricatures or satires of the conventional art object. Or a discursive satiric analysis of the perceived ideas and notions of what an art object is.

J.W.: You're questioning the modes we traditionally associate with the art object and its making?

Bickerton: Right. That could be the art object itself, including the stretcher, including the frame, including its placement on the wall. The wall-furniture unit, if you will, the mark-point as you move through time and space within your domestic unit. All that kind of shit. I've painted nearly all the backs of my pieces with jokes, rebusses, conundrums, and various mass culture, photo-magazine imagery, purely for the amusement of installers, shippers, and movers. This further talks about the art object existing not at one specific juncture of its actual life, but at all junctures: in storage, in transportation, in the galley at the auction block where they keep paintings before the auction, as well as on the wall.

J.W.: Is *Wall Wall #6,* with its careful arrangement of paint, a poking-fun at the epic signification of the expressionist brushstroke so much upon us in recent years?

Bickerton: Satire and irony are not new to American art. I certainly have no dibs on them. My choice and use of materials is not so much to take the piss out of the heroic brushstroke, which is as fine an idea as any, as it is to locate the value, the saturated historicism, of a valuable art commodity. I use gold and silver for that reason also, because to me, they're not really colors but materials.

J.W.: Several of the works in your current show appear to be representations of techno-scientific structures and devices, quite different than your *Wall Wall* series. Most of these have nonce titles such as *Gugug*. Why?

Bickerton: Why *Gugug?* Why not? I've also used titles like Susie, Bob and God. In this culture, we have preliterate, phonetic rumblings which I believe carry as much rhythmic power, meaning, mystery, and possibility as anything else. I've painted non-words like gug, gog, gub, guh, ugh, for years.

J.W.: Phonemes.

Bickerton: I would like to put this techno-scientific label to rest right now. When we see a divergent set of codes in an unfamiliar schema we tend to just slap it under phonemes, right, phonemic utterances. Basically, these have always been my sounds. I call them coital blurts, bathroom symphonies, toilet melodies. I guess one could be a little bit more heavy and say the sounds of birth and the sounds of death. I started out, as I said painting words like Susie—Susie to me came from Susan—or I did Bob, which came from Robert, which went to Rob. I was playing with the slippage, the breakdown of formal language to a more familiar viscerality. I started to key up my form with a bombastic system of cul-de-sac meaning. What I was really doing was trying another tack on the old form-content dilemma. Finally, my words slipped in to the Buh and Gus and Guh and Goh, Buh, Ugh kinds of sounds and my form rose to this techno-scientific saturation of codes and signifiers all interacting with each other. All of this gets back to an idea I've been tossing around for awhile—it's not an uncommon idea—which is that in order to receive raw, amorphic cultural information within the coded confines of received information, it had to be elaborated formally. This elaboration of information necessarily changes it and, ultimately, its meaning. There we have the area of experimentation where my work takes place—in the changing manifestation of information as it is calcified into meaning.

J.W.: To sum up, disrupting the signs of modern life?

Bickerton: Well, I usually go to great lengths to avoid words like sign, signifier, signified, or hyper-anything, but yeah, sure, getting between the signifier and the signified or cross referencing and perverse indexing creating slippages of meaning and contextual ruptures.

J.W.: Is a work like *Gugug* a reaction to a work like *Wall Wall*

#6, where an epidemic tactility almost threatens to overwhelm pictorial unity?

Bickerton: That's a very good observation but I would not go so far as to call it a reaction — possibly a different stake on the far side of the epistemological field — a demarker of conceptual territory. I've done them all concurrently at different times in the past, so there's no chronological or visual logic attached to any of them as sequence. I'm not interested in a purely visual logic except where tactile consumer or designer package is concerned. I'm interested in visual signs as they apply to the construction of received cultural information, my work always comes down to a purely cultural or plastic premise. As far as the *Wall Wall* series goes, I realized that fundamentally, a painting was nothing more than something which filled the space on a wall with color and meaning. And so what could be more self-evident than a piece of colored wall to effect meaning? The works are just that — pieces of wall to fill wall; they're wall-filler. They come complete with the time and place where they were made because in our culture, art is priced in value through the time and place where it was made, whether that be Vienna eighteen seventy-nine, Timbuktu fourteen twelve or N.Y. nineteen eighty-seven.

J.W.: I find the gaze can apprehend your "wall-fillers" quite easily.

Bickerton: They don't create any sort of visual repugnance, and I'm not trying to. Seduction is part of the whole play. I'm interested in creating a system of swirling rapids and eddies of meaning which overlap and catch the spectator in between. I'm not interested in creating one single guillotine-edge of meaning. The act of seduction is one way to draw the viewer into this labyrinth of conflict.

J.W.: Seduction ... Do you consider your work erotic?

Bickerton: Yes, in the dandyish sense. It's more about the dance than about the act. Where one might offer a sort of visual or material resistance to the audience, I don't offer it in the physical look of the object, it is after all designer art — name brand — Susie.

J.W.: Still, your paintings aren't simply gazebound areas of color.

Bickerton: The interference is possibly in the nature of the desire itself, in the manifestation of what one's relationship to these objects could possibly be. But ultimately I'm not so cynical that I believe the viewer is my enemy. I'm not a "fuck-you" artist. I do like to create a

certain amount of visceral and intellectual enjoyment, but it's enjoyment at a price. Always. A kind of complicit, not didactic, search with the viewer, a search to locate and construct plastic manifestations of our collective cultural desires and ills I don't want the object to discuss the epistemological knot—I want it to be it.

J.W.: There is the idea among critics like Donald Kuspit at *Artscribe* that work such as yours, for all its pleasing appearance, is only a clever appropriation of past abstract styles.

Bickerton: I don't like to directly appropriate. The closest I'll ever let myself come is a loose and coded "quotation," and even that is slipping from the agenda. I have no affinity whatsoever with people who quote for the sake of quoting because to me, this retro stuff offers no real possibilities for a new communication. My work is more optimistic towards the future. Let's put it this way. Certain languages were developed by the minimalists and by the conceptualists that were very innovative, essentially American forms of cultural speak, but these languages, at the time they were formed, seemed capable only of talking about their own formal and architectonic elaboration. Minimalism, for instance, essentially addressed its own structural premise. What I am attempting to do is put together some of these languages that in the past have only been capable of discussing their own formal precedent and use them to talk about the larger cultural scenario in cohesion with other modes.

J.W.: Your work is more about minimalism, say, than minimalist?

Bickerton: Nothing to do specifically with minimalism, much more to do with semiotics and appropriation art. I just took these languages and put them together in a forward-looking direction. I just happened to like work that was cold, industrial, fabricated, and shamelessly beautiful. I could say what I'm trying to say using completely antithetical means, but these are the means I have chosen. They seem the best to suit the purpose.

J.W.: The post-structuralist Jean Baudrillard is often mentioned in connection with your paintings. To what extent have his theories been influential?

Bickerton: Baudrillard has been one of a number of influences in my work, but his is by no means essential to it. Of course, there are certain Baudrillardan ideas that seem to have a lot of currency right now

like the simulation of an already purely simulated phenomenon which seem to be popular amongst certain of my peers, myself included, to a degree, but I don't think I read Baudrillard and translated any of his ideas. In fact, I've never read a book by Baudrillard all the way through. A lot of my work comes out of Marshall McLuhan and Foucault, who actually has been more influential to me than any other theorist. And it was possibly as much through a misreading of his work as an understanding of it. But I saw in it what I wanted to see, and who knows if I couldn't have seen the same things in *The Voyage of the Dawn Treader,* by C.S. Lewis due to currents of information and dialogue that manifest vitality at the moment.

J.W.: According to Baudrillard, the power of the mass media has produced a world of signs that have become detached from the things they represent, in other words, a world of simulcra. Has your widely publicized art also been replaced by its simulacrum?

Bickerton: Certainly I've built my art with that in mind. That is one reason I've written Susie down on the side of my works and used all the metal armature. I anticipated the ultimate destination of the art object and how it is absorbed, through the media, into the catalogue of art history. I wanted to give the art object a brand name. And construct it specifically to dialogue with all stations of its existence — whether it be shipping, installation, storage, reproduction or point of aesthetic reckoning on the gallery wall — even in this last position it would address all other stations.

J.W.: Is this the reason so many critics have treated the area of artistic activity of which you are a part so harshly?

Bickerton: Well, firstly and most obviously, they react to the injection and clouding effect of "hype." But I think this is part of the problem the work has with the critics. They expect from radical art a certain look and a certain received system of tactics and possibilities. This is an art that attempts a wholly other tack, that carries radicality into the dimension of its own conflict. It accepts *a priori* that much radical art ends up above a sofa, that a Frank Stella painting just becomes a logo for the corporation Stella. It accepts a lot of these cynical notions and then moves under the posturing of much so-called radical art and sees it for what it ultimately is or becomes. This art imitates the posture of its own corruption, and in that sense adopts a very inverse sort of radicality. It attempts to forward the question of where precisely

conflict exists in this morass of ideal, compromise and duplicity we live in.

J.W.: Some would call that rather glum — almost an art which "incorporates its own eclipse," to quote Adorno, obituaries in paint.

Bickerton: Well, I've jokingly called these more of the last paintings that can be painted. I think it's known as endgame art. But I wouldn't even go that far anymore, fortunately or unfortunately. Art, as we know it, will go on as long as there is a market to support it. No matter what glorious idealisms have been proposed by certain individuals, essentially what governs the space and shape of art is the financial machinery which makes it possible. The machine shapes the ultimate package.

Ntozake Shange
Murdering the King's English

Ntozake Shange was born in Trenton, New Jersey, in 1948, but spent much of her childhood in St. Louis, Missouri. W.E.B. Du Bois often stayed with her family when he visited St. Louis; and the late-night tunes and voices of Dizzy Gillespie, Charlie Parker, Chuck Berry, Miles Davis and Muhammed Ali sometimes drifted up the stairs to lull her to sleep at night.

Though Shange wrote as a child, it was her involvement with the black and women's movements that prompted her to embark on a literary career. From public speeches in San Francisco and New York, Shange's social protest burgeoned into skits and plays, then into poetry and novels. In all of her works, she tackles the complexities of black women's emotions. In a grammar void of capital letters and rife with abbreviations, Shange speaks sometimes angrily, sometimes joyfully, but always perceptively.

The 1976 Broadway production of Shange's For Colored Girls Who Have Considered Suicide When the Rainbow Is Enuf *received critical acclaim, extensive media coverage and an Obie Award. Shange, though disappointed by the commercial exploitation of the play, managed to dramatically expose black women's vulnerability and suffering at a time when black artists only portrayed positive black images.*

Née Paulette Williams, Shange adopted her Zulu name in protest against her Western roots. Ntozake means "she who comes with her own things" and Shange means "she who walks like a lion." In addition to For Colored Girls, *she has written six books of poetry, three novels, including* Sassafras, Cypress & Indigo, *and two plays.*

Melissa Biggs called Shange's publicist to ask for an interview in the winter of 1987. Two days later the publicist called back to say Shange would do the interview by phone that day. She gave Biggs a number in New Jersey where Shange was staying for a few days. "She just happened to be in the area," said the publicist. "You got lucky."

Melissa Biggs: You work in three literary genres: plays, poems and novels. I know you've said poetry is your favorite. How do you decide to put an idea into a genre?

Shange: I think that, for me anyway, it's not a conscious decision. The projects or impulses manifest themselves in their proper genres. Whatever it is comes out as poetry or as a story. As the topic flows it dictates the form. Then once I have done the piece, whether it's a short story or a poem, I can say there's enough action in these poems that they can go on stage or this short story should be extended into a novel.

M.B.: You've said that Ishmael Reed and Amiri Baraka have influenced your writing. Is there a playwright who has greatly influenced your work?

Shange: Peter Weiss, A.J. Kennedy, Amiri Baraka as a poet and as a playwright. And of course, Brecht. How could I have forgotten Brecht?

M.B.: Brecht in his epic theater tried to prohibit the audience's emotional involvement in the play so they would be forced to interpret it only on an intellectual level. In your title, *For Colored Girls Who Have Considered Suicide When the Rainbow Is Enuf,* were you trying to set up a similar relationship with the audience?

Shange: I am not absolutely certainly that's what I was trying to do. I think that the title of any piece allows the audience to have certain hidden expectations about it. The expectations that the audience forms from the title definitely affect how they understand a piece, and they should. I think that about the titles I give everything. Maybe that's anti–Brechtian, but my primary goal in theater is to create emotional catharsis. I am not terribly concerned that the audience necessarily understands everything that goes on on stage, but they should respond. What I am interested in more than their understanding is that they must respond emotionally to my work, that they can't not respond.

M.B.: Do you aim at different emotional involvement from the audience in a poem than in a novel or in a play?

Shange: No. I want the audience to respond emotionally to all of them.

M.B.: How did you find your voice? Your use of words such as "waz," "wd," "cdnt," and "&."

Shange: I found it trying to entertain myself. The alphabet was very boring to me. Also I did not find the words in English that I wanted for my black and white characters. English, by its nature, inhibits the colloquial use of words. Black English moves much quicker than formal English allows it to in writing. It is also more improvisational as

I like my characters to be. The spellings I use give the characters and the reader the natural speed and rhythm that the words have.

M.B.: Toni Morrison once described herself as "not a citizen of the English language," but as "a saboteur of the English language." Would you describe yourself similarly?

Shange: I would have to say that I took my primary clue to language identification or to sabotaging language from Judy Grahn, a feminist poet from California, who said that it is a feminist's job and a person of color's job to murder the King's English. Because it is the King's English that has enslaved us, does enslave us. In order to make language a tool of liberation you have to dismantle it, attack it.

M.B.: In the preface of *For Colored Girls* you described its creation as an evolution over a number of years of poetry, music and dance. Has your writing process changed as you've written more?

Shange: I am more disciplined. I am more disciplined and more focused. Not that I lack spontaneity; I have a journal that I write in everyday. But now I think I'm much more conscious of attempting to finish projects as opposed to just letting them go on forever. I'll work on a series of poems and decide that I have written enough of them and I'll look for a poem to end the series, to clinch it. I'm aiming at completion. When I write a collection of stories I want them to have an important coherence that I could not have been aware of before I had written a book. When I was younger I didn't feel the need to finish anything; I was happy just writing and my poems would go on forever.

M.B.: What kind of influence do you see the media asserting on Afro-American literature and women's literature today?

Shange: Their major influence is their refusal to review certain visual art shows, theater productions and novels in a serious way. They contribute to the general public's lack of knowledge about what women and Afro-Americans are doing. Even though a lot of creativity exists and there are great art events going on, when they are not documented in the major newspapers and journals, they are missed.

M.B.: Critics have called you a black bourgeoisie writer and have said you focus on the victimization of black women by black men. What kind of writer do you see yourself as and what do you see yourself writing about?

Shange: I write about the experience and the mythology of con-

temporary people of color in North America, some of whom are children, some of whom are men and some of whom are women.

M.B.: Do the labels bother you?

Shange: They bother me because what they apply to is an accident of birth. I am not embarrassed of the kind of family I was born to. I am not embarrassed of being born.

M.B.: What advice do you give to your creative writing students?

Shange: I tell them to define what they imagine their limits to be and to defy them. I tell them to identify their deficiencies and try to turn them into their strengths. This way one is not inhibited by fears but can exploit them. Actually, it is often in fears that we can find our clearer, truer voices. For instance, I am terrible at plot. So I've realized that and I do my stories without it. I say I just can't do it. I don't want to learn it and I go along happily doing what I *can* do. And there are enough people who like what I do that it doesn't matter.

M.B.: How do you pronounce your first name?

Shange: EN-toe-zah-kay.

Harold Brodkey
In a Far-from-Classical Mode

Harold Brodkey has been compared to Freud, Wordsworth, and Whit-man. As a literary lion, Brodkey emits and elicits roars which are amazing in their own right, and even more so considering the fact that he has published only two collections of short stories in his 30-year writing career. Devotees have dubbed him "the American Proust" while detractors have deemed him nasty and empty. For over a decade, rumors of the publication of his novel, A Party of Animals, *have fanned the flames of controversy; while Brodkey revises and revises, the debate rages on.*

Brodkey was born in Staunton, Illinois, in 1930. His father was an il-literate junk man and his mother died when Brodkey was 17 months old. At two, he was adopted by an aunt. He spent a difficult childhood in Missouri, during which he suffered three nervous breakdowns. After graduating from Harvard, Brodkey worked in radio and television until, in 1958, he published a collection of short stories entitled, First Love and Other Sorrows, *which pro-pelled him to immediate literary stardom.*

From 1958 to 1988, Brodkey's fiction appeared only in literary magazines. His short stories were published in The New Yorker, Esquire *and* American Review. *His breathtaking fiction examines emotions to the minutest degree. In one of his most famous stories, he describes a child's glance at his father and the emotions it encompasses for 11 pages. In 1988, Brodkey published a second collection of short stories, most previously published in* The New Yorker, *under the title* Stories in an Almost Classical Mode.

Margo Schlanger phoned Brodkey in the spring of 1989 to ask for an inter-view. After an interesting form of screen test, which she describes in the begin-ning of her interview, Schlanger was granted her request.

After failing to get in touch with Harold Brodkey's publisher, I decided to try to call him directly, to see whether he would agree to an interview. I looked up his address in a directory of American authors. Although his number wasn't in the phone book, there was a listing for a woman, last name Brodkey, at that address. I called her number, a bit nervous that she would answer and tell me off for bothering her and tell me, "if Harold wanted to re-ceive calls here he'd have put his number in the phone book and who do you think you are, anyway?"

Instead a man answered.

Why did I want to talk to Brodkey?

I wanted to interview him, I was a senior at Yale, it would appear in The Yale Vernacular, *etc., etc.*

And what's your angle?

I didn't really have an angle, I said. I just wanted to talk about writing. Is this him?

No, this is his stepson, but I try to shield him, some. How did you think to ask for an interview, are you a fan?

Well no. Actually I've only read a little of his writing. But a friend told me he was one of his favorite authors, and I asked some people about him, and read an article or two, and decided to see if he would do the interview. I'll do all the reading in the next week or two.

He'd really think that was funny, since he's always saying how famous he is. He was on the cover of *New York* magazine, recently — a writer on the cover, that's got to be a first — and in *People,* and he always thinks everyone's heard of him.

I read in an interview that he always says yes to interviews.

Well, yes, he always does, if you've read the book, but then he complains about it later. I should tell you: he's different from other writers in that he's not very professional. [*What does that mean, I wondered, but didn't ask.*] He's got sort of a reputation here, in New York. Among writers, I guess, but it's not really based on his writing. It's more like, well, he gets dressed up to go out to a party and then he goes, and people meet him and they might not like him, just because of the way he looks. Or they might like him because of the way he looks.

How do you feel about him?

I think he's the smartest person alive. I can't stay too near for too long, or I'm influenced by him more than I like.

Are you a writer?

No, I'm a med student at Harvard. Maybe I would have been a writer if my mother hadn't married him. The first time I read one of his stories, I was just overwhelmed. Maybe I wouldn't have been, but I just couldn't believe he was in the family.

A longish, chatty phone call, and I was told that I should just call back on Sunday. "Thank you very much," I said, and asked the name of the man on the phone.

Oh, I'm actually him. I was sitting here writing, and my wife's phone rang, and I thought I'd better answer it in case it was an emergency, but I dropped into another persona. You got two for the price of one. But I need to write until Sunday, so call me back then.

When I called again, Brodkey (no disguises this time) agreed to meet and talk with me several weeks later. Before, I spent hours reading his short stories, which I found I liked a great deal. Then I spent hours reading reviews and articles. I encountered some strong opinions. Brodkey is "an American Proust . . . Unparalleled in American prose fiction since the death of William Faulkner" (Harold Bloom). His immense novel-in-progress is "a work of genius" (Denis

*Donoghue) and "the one necessary American narrative work of this century"
(Gordon Lish). Others are more skeptical and point to the fact that for 30-odd
years Brodkey's novel titled (perhaps)* A Party of Animals *has been "almost
finished." Brodkey's critics say what has been published—short stories—isn't
even that good. They are "solipsistic" and "self-occupied" (Jonathan Yardley).
They establish him only as "an unpleasant man immensely alive" (Leon
Wieselter). Not so—"isn't 'immensely' too big a word" and besides, the stories
"are more boring than nasty" (J.D. Enright).*

Since 1958, and the publication of First Love and Other Sorrows, *a book
of short stories most of which had previously appeared in* The New Yorker,
*Brodkey has confined his work to magazines. However, this past fall saw the
appearance of a new collection of all Brodkey's fiction since the fifties, under
the title of* Stories in an Almost Classical Mode. *Most of the stories since the
1970s chronicle one character, usually named Wiley Silenowicz. Wiley is to
some extent Brodkey himself. His (and Brodkey's) mother, a Russian-Jewish
immigrant, died when he was two, and he was adopted by some distant
relatives. Wiley is almost preternaturally acute, and the stories involve recollec-
tions of some incident in all its glory and ambiguity. "His Son, in His Arms,
in Light, Aloft," for example, is about a time when Wiley's father lifts him up
and carries him to the patio, to look at the night. In some sense, the subject
is recollection itself: "What if I am wrong? What if I remember incorrectly?
It does not matter. This is fiction—a game—of pleasures, of truth and error,
as at the sensual beginning of a sensual life." The writing in* Stories. . . *is at once
skilled, complex, infuriating, engrossing. While some stories failed altogether,
several embedded themselves in my mind, images and moments of them pre-
sent themselves to me at odd moments since I read the book.*

*The book provoked not only reviews—ranging from guarded approval to
pans—but discussion in* Vanity Fair, New York *magazine,* The Economist *and*
People *magazine, hardly typical places for analyses of the merits of a relatively
obscure author. With titles like "Man or Messiah?" and "The Genius," these
articles ask if Brodkey deserves the ecstatic praise he has inspired.*

*I don't know the answer, and in preparing to talk with Brodkey I decided
not to ask him about the reviews, attacks, and articles, because I found their
vehemence disconcerting. But the question of his reputation seems to haunt
him, and he made it one subject of the interview.*

*When I got to Brodkey's apartment building, on New York's Upper West
Side, the doorman told me he had been away for three or four days—was I
sure I had the right day and time? I was sure. I waited a while and was just
about to leave when Brodkey arrived at the door, luggage in hand from a
speaking trip to Harvard (where he went in the forties). I helped him get his
mail and went with him upstairs. He had forgotten to check his calendar, where
our appointment was recorded. We sat down. He was intrigued by the thought
that I, who had never heard of him a month before, had sat down and read
all of his stories, and many of the articles about him, in such a short time:*

Brodkey: I get more confused about who I am and what I'm do-

ing. You probably know a good deal more than I. The work I've been doing—that's in my head, and all the stuff I said last night, that's in my head, but the overall picture—I don't think I have it. But you've just immersed yourself in it so you must have it very strongly. Also, I stopped reading the reviews about two months before the book came out, and I haven't started up again.

Margo Schlanger: Are you interested in the reviews, then?

Brodkey: Someday I'd like to know how much of it—the attacks and the politics—was my fault; if I could have been politer and smarter and slicker and whatever. I can't say it came as a surprise, though, because people had warned me that they were going to do this. I mean they sort of bargain with you. They don't come out and say, "This is a bargaining session," but that's what it is. In our society, where almost everything is political you expect a political response, rather than a particularly honest response. Of course you don't know. I think at the center of my particular controversy that what was at stake was reputation, and that the book itself wasn't that much discussed. One almost gets a sense that it wasn't read.

It's hard to be happy with all the stir and fuss. On the other hand it's generally true that the very fact of an attack indicates that the position exists. And the more violent the attack the stronger the position must be; you don't use four divisions to take a foxhole. So whatever I thought I was, as a writer, and whatever I thought my writing was, all that had to be reassessed after the attacks. So along with the painful side to being attacked so violently comes this new knowledge of my own importance, or overratedness or whatever, which I can't say I was aware of before. And I guess it's fun. Would you like it?

M.S.: No.

Brodkey: They actually don't make sense, these attacks: I wasn't that famous. Because of all the attacks, I'm much more famous now than I was before, but I'm still not famous. Everyone kicked and screamed and I must have posed for twenty-five photographs, I did a book tour, I was on National Public Radio, and it was all—for me it was dead serious. But I guess in each instance you only reach a relatively small number of people, and it doesn't change anything. To be a best seller, or to become a kind of newspaper celebrity, I guess, takes much more...

M.S.: Are book sales good?

Brodkey: For a serious book, yeah. For someone my age, who's

been around as long as I have, it probably didn't sell in fantastic numbers. What I think the attacks do is scare people. If you know a book has upset somebody, you stay away from it to avoid being upset yourself. So it comes down—the way it comes down for almost any book anywhere, popular or serious or super-trashy—to what your friends say. You read my book because a friend recommended it. That's the real life of a book and that's what the fate of the book over the next ten years will depend on. But the initial group that was exposed to the book—the attacks probably cut that down.

You should ask, to balance this about the attacks, does the praise increase the number of readers?

M.S.: Does the praise increase the number of readers?

Brodkey: No, because the praise like the blame sets up the same kind of tension, it said that this was not an ordinary book. So people think they sort of have to wait, before they risk it. You kind of just don't start it any old time.

M.S.: Do you think it's an ordinary book?

Brodkey: Well, no, but I'm American enough to want it to have the rights of an ordinary book. I mean, I'd love to have a couple of reviews that say, "there are eighteen stories here, and there are six good ones, and six fairly good ones, and two I really love and four that I really hate." There's a daydream quotient I suppose to all writers.

"The Pain Continuum"
She hit me lightly on the chest and then a little harder. Small lumps, knobs of being bumped, like thickened mosquito bites, formed: they did not engulf my consciousness but made me blink, surprised . . . she drove the stick harder perhaps as an experiment in correcting my facial expression, my attitude, in making my affection more correct: she meant to put an end once and for all to her being horrified by me.
It was like that.

M.S.: Two of the stories, "Play," and "The Pain Continuum," seem to me similar—both are about pain and remembering.

Brodkey: I see why you put them in the same category. But there's a huge difference in the technical reality. "Play" is clumsy. It's very clumsily written, very clumsily edited. The attempt is to get you to remember the things that you did and enjoyed that you shouldn't have enjoyed. But "The Pain Continuum" is something else: an experiment to both remember and write about the experience of pain. Pain is like

the biological universal; everybody breathes, everybody dies, and everybody suffers pain. In trash fiction and also in serious fiction, there's a certain kind of obscene thrill when there's physical pain. It's done in various ways in the language. But "The Pain Continuum" asks, "Do you know this about yourself, do you know these feelings? And if you do, what are you going to do about it, when you realize how much of your behavior is governed by your fear of physical pain?"

It's essentially an experiment, so it doesn't proceed on the basis that it's going to succeed. And there's not a sequential story. If what I wanted was to make you read it, then I would have made a plot—maybe something about the body of a policeman or a jockey—and I would have traded in violence in a way that would have guaranteed an audience. This was really something a lot different. It's not a story in the usual sense. I think it's really much more direct. I don't know how many times I've read it—one hundred times, maybe three hundred times—that you can't remember pain. So I wanted to prove that I did. And it's like a base or baseline which should be touched in a book this long. There are other stories where pain is referred to, but isn't gone into, so you needed this.

M.S.: That story is almost painful to read.

Brodkey: There is a relationship a reader has with any given story of mine; I think of it as much freer than your relationship to other writers' stories. Because I assume that readers from now on will read when they can, and fit it in between other things. Nobody has servants; leisure time is gone, so that reading doesn't have—it has some class attributes, but not the class attributes it used to have. And so I imagine the reader is stopping and starting. Also I imagine that whatever is intelligent in my writing causes a surfeit; a certain number of paragraphs and that's enough. So you walk off. And then you may come back in an hour, you may come back in three weeks. My stories aren't cast in the kind of public space which involves a mass response. It's more or less one mind or sensibility and its relationship to language addressing another mind. It's not like a lecture, it's not even a party—it's not like seven people sitting around and one person holding the floor. It's really one on one. And as with us, if you get up and want to make a phone call, or if we stop while the noise dies down from the kitchen, we just stop. And I think that's good—there's no coercion, no bullying, that way.

M.S.: Does that mean you don't try to make the reader finish any

story? There's a certain relief in "The Pain Continuum" when the story ends. So there's that motivation to finish — you get caught up in all this pain and want it to end.

Brodkey: Yes, if you're remembering your own experiences. Were you telling yourself stories as you went along? I think that's built into the way I write — the extent to which I don't use literary forms or credentials, but instead as mechanisms for conveying information and what I consider plot and story. What I then depend on, since I'm not being conventional, is the reader's sense of life. And I don't see how you can read what I write without using your sense of life. I don't care how conventional you personally are, you're more or less forced — see that's bullying again — to deal with experience, not with books.

M.S.: Are you trying to avoid bullying? Can a writer do that?

Brodkey: Maybe; it's hard to remember back, but I thought I'd sort of gotten around it, mostly. Now I'm very self-conscious about it because of the reviews. I don't like to be bullied. When I read, the amount of attention I give to another writer I give pretty freely. One reason I don't like, for instance, the movies or movie theaters, is the way they bully you — the music and the size of the screen and the audience. And I would think when I write my own dislike of being bullied would be part of the aesthetic.

"Story in an Almost Classical Mode"
...with what seemed to me incredible daring (and feeling unclean, coated with uncleanliness), I imagined my hips as being my shoulders: I hardly used my hips for anything; and my shoulders, which were sort of the weighty center of most of my movements and of my strength, as being my hips. I began to feel very hot; I was flushed — and humiliated. Then after a moment's thought, going almost blind with embarrassment — and sweat — I put my behind on my chest. Then I whacked my thing off quickly and I moved my hole to my crotch. I felt it would be hard to stand up, to walk, to bestir myself; I felt sheathed in embarrassment, impropriety, in transgressions that did not stay still but floated out like veils; every part of me was sexual and jutted out one way or another...

I had only the vaguest idea of female physical weakness — women controlled so much of the world I was familiar with, so much of University City; but all at once, almost dizzingly, almost like a monkey, I saw — I saw *connections* everywhere, routes, methods (also things to disapprove of, and things to be enthusiastic about): I was filled with a kind of animal politics. But I was afraid of having my arms and legs broken. When I was a man, I saw only a few logical

positions and routes and resting places, but as a woman I saw routes everywhere, emotional ways to get things, lies, displays of myself: it was dazzling. I saw a thousand emotional strings attached to a thousand party favors. I felt a dreadful disgust for logic: logic seemed crippling and useless, unreal; and I had the most extraordinary sense of danger: it almost made me laugh ... (I had read a number of books about women: *Gone with the Wind, Pride and Prejudice, Madame Bovary.*)

Then I saw why, maybe, Doris was a terrible person—it was her attempt at freedom.

M.S.: Is "Story in an Almost Classical Mode" an attack on the mother?

Brodkey: I didn't think so when I wrote it. I thought by making Doris first of all morally responsible for everything she did I gave her the same kind of dignity that Homer gave his men. And I also thought that I was making her—I thought that what was happening was that I wasn't blocking this truly remarkable character who was coming into existence. And no matter how negative some of the things were that were said, she kept just blossoming past it into life. And by the end of the story, she was so much greater than the narrator. I mean here's this stodgy college boy, and next to him is this big-souled woman who was as big-time as a good person as she'd been big-time as a bad person—maybe even more big-time; sort of soaring and living. But I'm not sure that other people take it that way. I just read this chapter from a draft of a book where the story is analyzed, and what the woman, the author, keeps saying about Dickens and Lawrence and me is that we receive our permission to be seriously good writers through the deaths of our mothers. Now what I argue in the course of this story is that we get our language from our mothers anyway. She's not actually contradicting what I say, although it wouldn't have occurred to me. What I didn't realize when I wrote it is that there's this implicit claim again. If you say this woman is a great person, a great character, then to whatever extent you succeed in describing her, you're matching her—you're almost as big-time as she is.

M.S.: The author or the narrator?

Brodkey: The narrator. And I didn't see that—I didn't see how anybody finishing that story could be particularly interested in the narrator. Except for the fact that he was smart, that he had done the transformation scene. I don't cut the narrator down; he really has done

this thing, which impresses me, anyway. But it seems to me that she goes even beyond that; as a voice Doris get to go places that we don't. You know, I've gotten so used to having written the story. I read it over yesterday and I couldn't believe how shocking it is.

M.S.: I've never read a scene like the transformation scene.

Brodkey: I don't think it's ever been done. It's interesting because it's forbidden, but also because it's essentially impossible. The only thing that can be considered related to it culturally is when Elizabethan boy actors played female characters. The narrator starts off saying that the story is going to be about a boy's mind, and that scene is a display of mind.

M.S.: Is Wiley you?

Brodkey: Well, it depends. In "Story in an Almost Classical Mode," it's not me. I mean that's not an autobiographical story. I thought it was a really good story, and I meant it to be good. But then I thought doing it as a story was all wrong because it was detracting from her. So I made it a memoir — changed the narrator's name from Wiley to Harold Brodkey, and tried to focus on the facts — planning that what would happen is that the narrator would get erased. Now that didn't happen. The mother was maybe overshadowed by the son's ability to write well.

M.S.: So given this relationship between you and the protagonist, do you feel personally attacked when Wiley is attacked as a character?

Brodkey: I don't like David Copperfield, but I like the book. And in *Anna Karenina,* I don't like any of them — the male characters. And of Chekhov's men, there are almost none that I really like. But I like the patterns of the stories quite a lot. If you said you didn't like Wiley, well first of all I wouldn't entirely believe you. I would say that what it is is a kind of sensible rivalry with a fictional character. I don't mean that it's stupid or mean or anything like that. For instance, when I read *Pride and Prejudice,* I'm always a little bothered, not by Darcy, because he's an ass, but Eliza is so wonderful that I can't help, I'm jealous that I don't know her, that I can't talk to her. So I think something like that could come into play with Wiley; especially since he's newer and fresher. The thing about Wiley as a character that's so odd for an American character is the particular way in which he's apologetic. He'd be more fun, and maybe it'll get fixed in the novel, if he were just a little

more wicked, a little more given to lying and cheating. But we keep catching him in these moments like when he's so embarrassed by what Doris grew into as a soul that he's forced — that was a crazy idea for a story.

Also, when I see the attacks, I think they attack the women. I think "Ceil" is a really good story, and I think it's very pretty as well. So in the attacks against that story and "Story in an Almost Classical Mode," first of all I assume there were some kind of Jewish politics. So that part I don't take personally. But not to be impressed by these two women as people? I take that personally. Ceil is probably forty percent accurate. It's drawn from life in a way none of the other stories is. But, because of the editor I was working with, it's so shaped and articulated as a story that even though I used my mother's real name it doesn't feel autobiographical. But that comes the closest of any of the stories. The thing about Doris or Lila is I guess I'm just conceited — I don't want you to use the word conceited, unless you have to; I'm trying to be modest — but I'm so proud of her. I'm not tired of her at all as a character; I could go on writing about her until I die. So if you insult her, I get bothered. Because I like her so much; every time I read over the stories there's this burst of energy and burst of life when she comes on the page.

"Innocence"

I distrust summaries, any kind of gliding through time, any too great a claim that one is in control of what one recounts; I think someone who claims to understand but who is obviously calm, someone who claims to write with emotion recollected in tranquility, is a fool and a liar. To understand is to tremble. To recollect is to reenter and be riven ... I admire the authority of being on one's knees in front of the event ...

She took the thrust: she convulsed a little; she fluttered all over; her skin fluttered; things twitched in her, in the disorder surrounding the phallic blow in her. . . . She half rose; and I'd hold her so she didn't fling herself around and lose her footing, or her airborneness, on the uneasy glass mountain she'd begun to ascend, the frail transparency beneath her, that was forming and growing beneath her, that seemed to me to foam with light and darkness, as if we were rising above a landscape of hedges and moonlight and shadows: a mountain, a sea that formed and grew; it grew and grew; and she said "OH!" and "OHHHH!" almost with vertigo, as if she were airborne but unsteady on the vans of her wings, and as if I were there without wings but by some magic dispensation and by some grace of familiarity; I thunked on and on. . . . She called out, "Wiley, Wiley!" but she called it out in a *whisper,* the whisper of someone floating across a night sky, of

someone crazily ascending, someone who was going crazy, who was taking on the mad purity and temper of angels, someone who was tormented unendurably by this, who was unendurably frightened, whose pleasure was enormous, half human, mad.

M.S.: "Innocence" resembles a Norman Mailer story, "The Time of Her Time"; they're both about a man and a woman and her first orgasm. What is the difference?

Brodkey: Mailer's is really a story about people; it's not the recreation of a sexual moment. In that story the end, the climax, is completely credible, but not based on what's led up to it. That doesn't mean it doesn't work as a story, it just means that representation is not really what Mailer was after, and it is what I'm after in "Innocence." Because there is no such thing as actual sexual memory. If you enjoy something, even something as mild as dancing with somebody, when you try to remember, you know the heat comes back, the excitement or whatever, and the memory keeps jagging. So if someone writes a truly sexual episode, and it's rare — rarer than the transformation scene — it more or less has to be a construction.

The Mailer story must have been a precursor somehow, but it wasn't. I must have read it or glanced at it at some moment and said, "Oh yes." *Lady Chatterley's Lover* is much closer to "Innocence" than the Mailer story is. It seems to me that if you read the unexpurgated *Chatterley,* you could see that somebody was going to try this, at least somebody like me. But "Innocence" goes further. In *Lady Chatterley's Lover* social classes are still operating as people (which by the way is not unreal about Europeans). In my story, you have something else more anguished and much more unsettling. Of course sex was a different world, in terms of sensibility — it's an extension of character. If there is pleasure it's only partly earned, but "Innocence" is a story about earning, and not really a story about sexual fantasy. The story says that what happens in sex follows a certain kind of logic. Ora's arrogance and her taking herself so seriously is based on the fact, she is kind of wonderful, and so is the rest of the story. This sort of common sense is really opposed to the sexual fantasies of certain people who are not terribly interested in sexual reality. But maybe most readers are. That story's been reprinted quite a lot, considering how explicit it is.

M.S.: I was amazed to see that one place was *Ms.* magazine.

Brodkey: They really changed it around. I'm not sure, because I

haven't read their printed version, but I'll bet you anything it's closer to the Lawrence — it's more the woman getting her just desserts. Do you like *Lady Chatterley's Lover?*

M.S.: Um, I do, but. . .

Brodkey: But it irritates you and you want to do your own version — that's what happened to me.

M.S.: In a book I read once there's a character who talks about all the years she felt guilty for not feeling sex the way that Lady Chatterley does; and then she realized that Lawrence was a man and how would he know.

Brodkey: Exactly. I think Lawrence decided to write about her feelings and not the gamekeeper's because male feelings aren't acceptable. So I did a story in which male feelings are forward. On the other hand there's a cheat, which is that he's doing it for her.

M.S.: What writers do you see as having the most influence on you?

Brodkey: The two women who've probably influenced me — actually there are four women, Billie Holliday and Emily Dickinson, and Austen and Eliot, but that's partly because Austen and Eliot are technically so extraordinary. The way Billie Holliday will phrase ordinary words so that they carry a burden of emotional unhappiness or emotional happiness or whatever; I used to practice trying to get those effects. It's quite clear to classicists that sometimes I've imitated Caesar's *Gallic Wars,* but they miss the fact that in the same sentence there'll be a run of words that are set in such a way that they come from Billie Holliday. Since she doesn't actually arrange the words, it's trying to get the effect of her inflection; as if she invented a way of conveying meaning and I try to do the same thing. Dickinson is a big influence, but only in the later editions when they started letting her have her own punctuation, with the dashes. That's where my dashes come from. *Moby Dick* is almost without human intelligence; it's about big things, not about relationships. Dickinson is the opposite. She's extraordinary in her power of focus and of immediate meaning. When she looks at the grass or something like that, for me that's really a high point in art. So when I'm influenced by it, I can see why people who don't like her writing then don't like mine. She invented a change in scale and subject and focus.

I can't think of a writer or book that I haven't stolen from, but I

think I'm more like the classical writers: Wordsworth and the Greeks. I'm not as good — not even that I'm good — but the patterns that came after them seem all used up. When I got ready to write, the forms were all so tired. Since T.S. Eliot, I think, there's been this conscious sense of exhaustion. I'm opposed to that, in my writing. So I invented things, forms. Some of what I invented, other writers took and have carried much farther than I ever have — Updike, O'Hara, Nabokov. In my writing it's as if I convert Eliot's dialogue. Where he looks at language and sees all the failure to communicate, I look at it and see all the things people are saying. If you combine Melville with Stendahl, throw in F. Scott Fitzgerald, some rock 'n' roll, and the way kids talk in a locker-room, you're not far from what I do.

As I was putting away my tape recorder, I asked Brodkey if he actually had a stepson at Harvard Med School. "Why?" he asked, "Do you know him?" I just answered no and thanked him as I left.

Ellen Gilchrist
A Voice of Southern Conflict

When Ellen Gilchrist's grandchildren come to visit her in Arkansas, they all sleep together in a big bed and tell each other stories. The tales that fill that crowded bed probably approach the beauty of the ones that fill the pages of her books. Gilchrist begins her stories to her grandchildren with "Once upon a time." The stories of her books also reflect the Southern literary tradition's reliance on the evolving narrative voice. The author of two novels and three books of short stories, Gilchrist has recently published an autobiography, Falling Through Space.

Gilchrist was born on the banks of the Mississippi—what she affectionately calls the Delta. At 14 she wrote a column called "Chit and Chat About This and That," for a local Franklin, Kentucky, paper. Though she continued to write occasionally, it was not until she was 40 that her writing career took off. She became the editor of a New Orleans paper and later enrolled in creative writing classes at the University of Arkansas.

Her first published book was a collection of poems entitled, The Land Surveyor's Daughter. *In 1981 a collection of her short stories,* In the Land of Dreamy Dreams, *was published to immense critical acclaim. And her next collection of stories,* Victory Over Japan, *won the 1984 American Book Award for Fiction.*

Gilchrist writes predominantly about the South. Her protagonists are usually upper-class women struggling with society's constricting mores. Trapped between their own desires and the demands of Southern society, these women grow desperate and destructive. On a scorching Arkansas day in the summer of 1987, Gilchrist spoke over a crackling phone line to Melissa Biggs about her works and life as a writer.

Melissa Biggs: When did you first start writing?

Gilchrist: Oh, I've done it all my life. I could read and write before I went to school. I was raised in the Mississippi delta and there wasn't anything else to do. When I was little, I pretended to read and write before I could read. I don't even remember how I learned how, I wanted to do it so much. People in my family are all literate people. My grand-

father was always sitting at his desk writing, and my father walked around with pencils and paper in his pockets. There was this solitary thing that all the members of my family did; they would be sitting somewhere at a desk writing and I always did that. I don't think what I do now is qualitatively very different from what I did when I was four years old. It's a perfectly natural thing for me to do, to recreate reality and express joy or horror or whatever by sitting down at a desk and doing it.

M.B.: What writers do you think have influenced you the most?

Gilchrist: I think the primary influence on my writing and on the way I write and the forms I choose to write in is J.D. Salinger. After I've come back around to him from everywhere. I don't even think of Salinger as modern because he's been gone for so long. See, I approve of everything he's ever done. I love the way he quit. He said, "Fuck you," to everybody. They published a book of critical essays about his work, in which a whole bunch of assholes, who later went on to become sort of half-shot writers, all sorts of people who couldn't even touch his wings, were taking off against him.

M.B.: Is that when he stopped writing?

Gilchrist: Yes, they published all of this criticism against *Frannie and Zooey*. He obviously thought, "I don't need this," and just stopped. And all he's been doing since is living a sort of wonderful normal life. So I am influenced by how he's led his life as a writer, because it's true to what he wrote. It's true to what he told me he knew about human existence. He told me he wasn't going to fuck with assholes and I believed him.

M.B.: Can you define what you want to get out of writing?

Gilchrist: I want to have a good time and make other people have a good time. And if there are bad guys I want to hate them and if there are good guys I want to love them and that's it. That's what I want to do in life; that's what I want to do as a writer. I already know who I want for my audience. I want people with a sense of humor. People who don't have a sense of humor can't read my work. Because even the darkest thing I ever wrote is funny.

M.B.: What do you consider the darkest thing you've ever written?

Gilchrist: The story "Rich." That story's not really funny. It's about New Orleans and the decadence and sadness and disease of that

culture that I lived in and that many of my cousins still live in. It's why those people jump off the bridge every day. Wealthy, wealthy people who have everything in the whole world kill themselves every year in New Orleans. Always the most beautiful ones kill themselves.

M.B.: That is an incredibly powerful story.

Gilchrist: It's about the disease of that city. Writing the story cured me of that. It was a hard story to write.

M.B.: Have you taken any formal classes in writing?

Gilchrist: I took a class with Eudora Welty once. But she didn't teach us anything. She was just a kind and lovely old woman. But like all great writers she couldn't teach writing because she doesn't know how she does it. I can't teach it either. I tried once. I can help someone occasionally. I can tell them what I like.

Later I went up to the University of Arkansas to study poetry with Miller Williams, and there Bill Harrison showed me how to write a short story. He literally showed me how to write a short story in about two months. And then I didn't study it anymore, because he showed me what I needed to know. He told me that it had to have a beginning, a middle, and an end and a couple of other things. And that was all I needed to know. I wrote "Rich" for him. I think I was curing myself of the years I put in in that swamp.

M.B.: Do you adhere to any sort of writing routine?

Gilchrist: During the years that I created that body of fiction that is my work, I was working from dawn until past noon and not doing anything else, except maybe going out to run. But I'm not working that way now. I mean I've gotten to the point now where if I'm in the middle of something I still work like that, but I don't work like that when I'm developing ideas. Now I can be developing ideas down at the Station restaurant talking to my friends. But when you're beginning you don't trust yourself. When you're beginning anything you have to pay your dues, and it's real hard. I lived by myself a lot of that time which is really unusual for me, living all my life in a house full of people, and I'll never do that again. But it was important at the time.

M.B.: You started writing poetry?

Gilchrist: My ambitions were always to be a poet. Although, that was the thing Bill Harrison taught me. He taught me that you can contain poetry within fiction. That fiction contains poems, that it can contain poems. And what he told me, and this is interesting and can be

useful. He told me that you have to write the *libretto* before you can write the *aria*. Wasn't that wonderful?

M.B.: How have criticism and acclaim affected your approach to writing or haven't they?

Gilchrist: Well, I was very fortunate, because I was in my forties when that began to happen, and I was old enough and I had good enough friends who were established writers to be wary of it and to take the good parts, but I mean I am sure that it exacted a price on my writing and my life but not a big one and not anything I can't get back. I just shudder to think of what would have happened to me if I'd been young when that happened or what would happen to anyone, because I would have believed what they had said instead of what I knew in reality. Someone's subjective judgment of you and your work is their subjective judgment, whether it's praise or not. Writers have to become good judges of their own work. You have to keep trusting your own mind about it.

You know, I have more fans and greater reviews in London than I do from any place in the world, and my stories have been translated into many languages. The British really understand what I'm doing, and they will over and over and over again pick out the stories to praise that are the ones that I know are the best pieces of work. The ones that the American reviewers a lot of the time don't like at all.

M.B.: That's fascinating. Why do you think that is?

Gilchrist: I don't know. I think it's because I've read more British literature than I have American literature. I really think that's why, because I'm more on their wavelength. My ancestors considered themselves Englishmen and Scots. They came here in the seventeenth century but they considered themselves Scots. I don't know why that is, but it's the language, the language of Shakespeare and the language of the King James version of the Bible. I've been reading Shakespeare all summer, and my God, it is so wonderful. My son tells me that there are a lot of studies now that say a lot of people think that Shakespeare wrote part of the King James version of the Bible. He was a contemporary and he was the reigning language expert. All of those guys were in it together back then and they were doing it right.

M.B.: Having written a novel and short stories, do you find one genre more interesting or more difficult than another?

Gilchrist: Well, the novel is not fun. The novel demands from a

poet's mind or short story writer's mind that we write things that we would never leave in. You have to write passages that I would never leave in a short story or a poem, because they're boring prose. And your editors and people say, "You have to tell us this and you have to tell us that." And I don't think that I have to, but sooner or later you make those compromises in the novel form. I never read novels. I mean I read a novel like *A Hundred Years of Solitude;* that's one of the great novels.

M.B.: You've said that you feel your writing is on a British wavelength, in any way do you feel a part of a Southern literary tradition?

Gilchrist: Well, I love William Faulkner and I love Ms. Welty's work. I don't like her novels but I like her short stories. I like William Faulkner's novels and Ms. Welty's short stories, and surely I learned from both of them that it was alright to use my own voice. But there wasn't any Southern literary tradition for a long time. It's just making a comeback, because we weren't allowed to talk about anything. We were just supposed to lie there on the floor and say we were sorry that our great-great-great-grandfathers had slaves if they did.

M.B.: You write about so many stages and ages of women's lives, is there one in specific that you are particularly drawn to in your writing?

Gilchrist: I think for a long time I was really fascinated with early adolescence, around thirteen, fourteen. Because I know during that time when I was writing, I think the Rhoda stories pretty much coalesce around that age, and I would see little girls waiting for the street car in New Orleans with their little Roman Catholic plaid skirts and their socks rolled down and a bit of pouty lip, and I think, "Oh God the power, the power that is in a thirteen- or fourteen-year-old girl." I mean they are just so wonderful. There's a wonderful little girl who is the daughter of a friend of mine here, who is just going to be about twelve. She's just got her braces. There's almost a radiation about her. It's almost like an aroma hovering around her. She's got a twelve-year-old buddy who looks like she's seventeen. I see the two of them together and it's just a wonderful sight.

M.B.: When you write about someone like Rhoda who appears at different ages and in different collections of stories, is it hard to pick her up again?

Gilchrist: No, it's like a friendship, like someone you haven't seen

in a year and they show up and you pick up the conversation where you left off.

M.B.: Do you ever think of gathering all of the Rhoda stories into one collection or writing a novel about Rhoda or Nora?

Gilchrist: My agent's always thinking that up, but I think it would be boring. I put the stories together the way they are because that's how they entered me. I think it would be really boring to have all the stories together in one volume.

M.B.: The dynamics of relationships plays a large part in your stories, and it seems that often parents are forming intimate relationships with children, specifically fathers and daughters, do you see that in any way as a reflection of adults' inadequacies in their own relationships?

Gilchrist: I would never use that word, because I don't think we're inadequate. I think we're wonderful and I think it's an amazing thing that goes on between parents and children, an amazing thing. You are the children. The children aren't you. They've got an open end and you've got an open end where you parents are concerned. In the sense that children don't think about their parents, except, "Oh God, I should call my mother." But parents from the moment their children are born direct their energies towards you all. The major creative act of my life was the birth of my children. And the most exciting thing in my late life has been the birth of my grandchildren. Literature doesn't hold a candle to it. Literature and the arts and bridge building is what men do because they can't do that, except now we're letting them. It's an amazing, amazing thing to be a father. I mean amazing.

You know, I keep thinking I have this father who was a great professional athlete and I have brothers whom he is so close to. He's eighty now and my brothers if they are not nearby in any two weeks, my older brother will come from anywhere in the world and just pass through Jackson, he lives in Mississippi, and just to be with Daddy. He's going to be with my father in the last years of his life. But I don't have that relationship with him, because I was a beautiful, attractive young girl and my father is such a good father that he wasn't even very nice to me after I got to be thirteen years old. That's the way they're supposed to treat us. That's an act of love and of caring for us.

There's a scene in a Rhoda story that is the most insightful thing I've ever written about it, and after that I haven't thought about it,

because I got what I wanted. I mean that's as much as I think I can know. It's when Rhoda and her father are together in the woods, and they look at each other, and they love each other so much that there's nothing to do but start an argument. That's how he protects her. That's all I know, and that's as much as I'm going to know about it, because that's all I need to know. When I wrote that I knew something about my father.

M.B.: In *Drunk with Love,* many of the characters fall in love but then they're separated or subject to a tragedy. Does that reveal a dark view that you have of love?

Gilchrist: Well, after I began to conceive of the stories as a book, I just thought, well, I am just going to write all of the love stories that I can think of.

M.B.: But they're all so sad.

Gilchrist: Well, a lot of the time a happy ending to a story just doesn't work. And at the very best the love just disappears and turns into friendship or the people run a family together. But the kind of madness that we call romantic love doesn't last. Isn't that a shame? It's the crazy stuff at the start, and then the next spring everybody's right back at work, trying to do it again. Just for that week or that month. The thing I hate about it is waiting for that phone to ring. I could never wait for people. I always called them up. Even when it was never, never done to call a boy, I always just called them up.

M.B.: Do you feel that women have different experiences and roles as writers than men do?

Gilchrist: Oh, I think it's more individual than gender. I mean writers are separated by galaxies. Anyone who is really talented or has a shot at really doing it is going to create their own reality. They're going to create the whole show. That's one of the reasons to do it.

M.B.: How much of your writing is autobiographical?

Gilchrist: Well, everything everybody does is autobiographical writing in one way or another. I mean all you have is your own experiences. It just depends on how much you're going to try to disguise it.

Jules Feiffer
Sketching Sophistication

Jules Feiffer, born in the Bronx in 1929, has been hailed as "the most talented social commentator in cartooning in our generation." His satirical comic strip has appeared weekly in The Village Voice *since the paper's birthday in 1956. An immediate success, his simply sketched cartoons with captions of dialogue are still popular in* The Voice, *and in syndication, over 30 years later.*

Throughout his life, Feiffer has explored marrying visual images and dialogue in his work in illustrations, cartoons, plays and films. Feiffer attended Pratt Institute in Brooklyn. Before establishing himself as a cartoonist, Feiffer worked in animation, layout and book illustration. Many collections of his cartoons have been published as well as his cartoon novel, Tantrum, *and his memoir entitled* The Great Comic Book Heroes.

Since 1961 Feiffer has also written for the theater. Little Murders, *one of his ten plays, was produced by Alan Arkin at Circle in the Square in 1967 where it won an Obie Award and an Outer Critics Circle Award. Feiffer has also written three films, including the controversial* Carnal Knowledge, *which was the subject of a Supreme Court ruling on obscenity.*

Feiffer talked to Holly Finn in the spring of 1988 in his Upper East Side apartment in Manhattan. The interview was conducted above the ringing of wrist and ankle bells as his wife Jennifer Allen, a freelance writer, and three-year-old daughter Halley were hosting a toddler dance class. Sitting with a cigar, just one step removed from the action, Feiffer explained a bit about his views on writing and cartooning, and his thoughts about some of the more immediate issues of life in his America.

Holly Finn: I think it's interesting that you write both plays and screenplays and comic strips. Is it hard to go back and forth between them?

Feiffer: No, it isn't because I love the restrictions of form. I love the exercise of having to work within a given structure.

H.F.: Do you prefer plays or cartoons? Would you rather be writing one or the other?

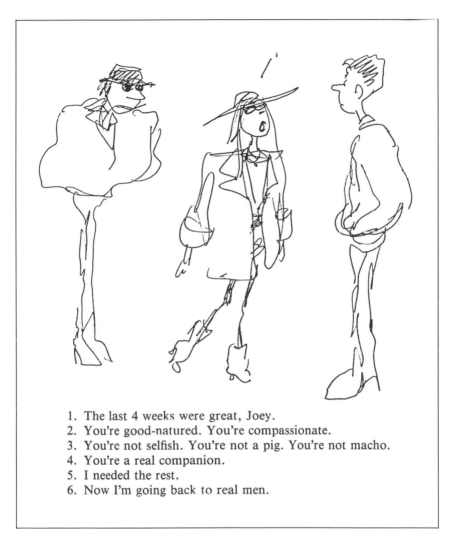

1. The last 4 weeks were great, Joey.
2. You're good-natured. You're compassionate.
3. You're not selfish. You're not a pig. You're not macho.
4. You're a real companion.
5. I needed the rest.
6. Now I'm going back to real men.

Feiffer: No, I don't have a preference. If theater paid off, which it doesn't, I don't think I'd ever do films. They're fun to see and fun to work on, but mainly films are my foundation money for a career in the theater. It's the movies and the cartoons that allow me to exist in playwriting.

H.F.: But the cartoons are not the same as playwriting?

Feiffer: No, the cartoons are another thing. I can do a cartoon on

Monday which will appear in the paper on Wednesday. It's a great form of release. It's wonderful. If something's on my mind, I can immediately get it out. Now the theater's going to take, even if you're lucky, at least a year. Movies, if the film is made, will take two or three years, and mostly they're not made. I've got three movies on the shelf now.

H.F.: I'm interested in what you have to say about your screenplays.

Feiffer: I didn't write my first screenplay until nineteen seventy. I didn't know how to go about it. I started writing plays three years earlier—in nineteen sixty-six. The screenplay form is more intimidating than the play form because the play form is more or less direct. You've got the proscenium or some version thereof, you write as few directions as possible, and if you're a young writer you put in "smile slightly," "turn slightly," "turns half pace to left," and all of those things that no actor nor any director will ever even look at. Other than that, it's fairly straightforward. But the screenplay is intimidating to a neophyte because it's so technical, or you think it's so technical and bad screenwriters have made you think it's technical because there's nothing that a bad screenwriter likes to do more than show off how technically expert he or she is, namely to cover up the fact that he or she can't write.

So, I got copies of screenplays to look at and study from, and the first thing that struck me with astonishment was that not only was this not an artform, it was barely even a craft. That, with few exceptions, the screenplays I read were barely literate. And the only good one I read that was both literate and technically interesting was Buck Henry's for *Catch 22,* which was then in production. I read a lot of others which were shocking to me. And since I'm primitive in almost any kind of technology — camera directions always throw me — I totally block when I try to think in those terms. After a couple of days of floundering around, I took a sheet of yellow pad and copied from Buck Henry, and one or two others, and wrote down all of the fancy terminology I could find, put it aside, and then just wrote the screenplay as if it were a play, but without the stagey speeches I would put into a stage play. When it was all finished I went back and put in all of the phony stuff.

H.F.: Which screenplay was this?

Feiffer: This was for *Carnal Knowledge.* It was originally written as a play, so there was raw material to deal with, to extrapolate. But there I learned a lot, particularly with Mike Nichols who was my editor at the time. There's a certain naturalism, so-called naturalism, which is perfect in the theater, so it's quite easy to accept two- or three-minute speeches. But in a movie they start making everybody a little nervous, so we had to find visual metaphors for speeches.

H.F.: Why did you originally change it from a play to a screenplay?

Feiffer: Mainly because that's how Nichols wanted to do it. I would have been very happy for him to do it as a play. He thought it would be better as a movie particularly because the first act was all short scenes and very cinematic. He said that if he put it on stage, he would stage it as if it were a movie anyhow. Besides which, we'd reach a much larger audience and we'd make a lot more money. I was only worried about censorship, because the screen guild had been particularly free with regard to sex up until then. We didn't have any problems, except that it was banned in Albany, Georgia. The case went to the Supreme Court, which ruled nine to nothing in favor of us. But it was the first script in many years that went to the Supreme Court on obscenity prosecution. The use of language and the subject matter were all very shocking for that time. But, with regard to writing for the theater as opposed to writing screenplays, I learned that, at least for me, the one is fun and

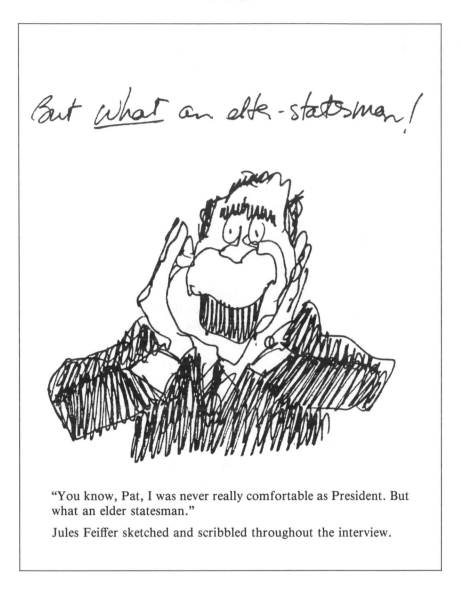

"You know, Pat, I was never really comfortable as President. But what an elder statesman."

Jules Feiffer sketched and scribbled throughout the interview.

the other is a chore, one is a natural and the other is a way of making a living. Screenplays will supply the funds. They pay you enormous sums of money even though no one will ever make them—they pay you in order to put them on the shelf, because by the time I write the screenplay, no matter how hard I try, it's just not badly written enough

or stupid enough to be made into a commercial movie. I work very hard to make it seem that way, but they are smart enough to see through me and see that there's an intelligence lurking somewhere beneath.

H.F.: Do you think that no screenplays that are commercial are intelligent?

Feiffer: Generally, there are very few. There have been a couple of surprising ones in the last year or so. *Tin Men* is a marvelous screenplay. There have been a few good ones, but I always view them with great surprise, because if they have any wit or intelligence, or any kind of perception and certainly any dialogue that makes you pay attention, it's hard to believe that I'm watching a film made in the eighties.

H.F.: What about the way you approach politics with humor? Do you write and draw your cartoons to make people laugh, or to spur awareness?

Feiffer: I don't really think about it. I don't think any more about being funny. That seems to be part of the equipment. It would be like thinking about using the English language. You're not constantly aware that you're speaking your mother tongue — you're just doing it. Humor is something I'm barely aware of. It's something that I know how to do, and I know that in cartoons it would be better to be funny than not, but I'm actually more interested in making my point than being funny. Then, if I've made my point and it doesn't have the irony I intended, or it's stupid in the middle, or too obvious, then I have to start concentrating on how to make this more entertaining. I don't believe in making a point by beating the reader over the head.

H.F.: Why?

Feiffer: Laughing starts getting to the point in a way that allows them to absorb it more quickly and more innocently than a frontal attack which they could resist.

H.F.: Speaking politically, do you think cartoons are the most effective form for conveying a message?

Feiffer: Speaking politically, I think nothing is effective. In my day and age, I don't know what is. For a while I thought Jesse Jackson might be . . . I truly don't think in terms of that. I think in terms of having a say, which can give comfort to other people who feel as I do. When I started out, I just saw cartoons as an outlet. This week I have a very angry cartoon about Ed Koch, which makes me feel a lot better; I hope it helps readers who feel the same way.

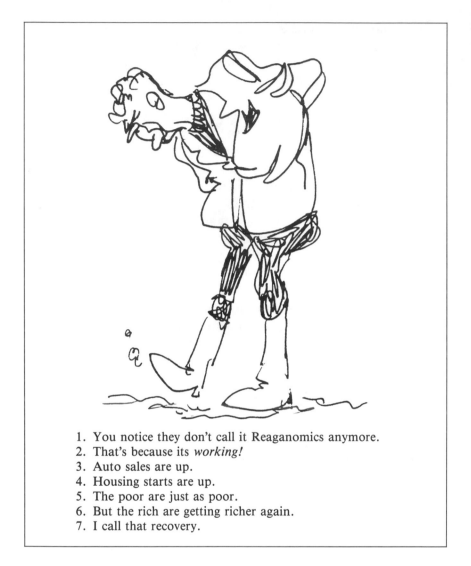

1. You notice they don't call it Reaganomics anymore.
2. That's because its *working!*
3. Auto sales are up.
4. Housing starts are up.
5. The poor are just as poor.
6. But the rich are getting richer again.
7. I call that recovery.

H.F.: Do you ever feel that in your cartoons you might get too bitter or too angry or you might overstep the bounds of the "funny"?

Feiffer: Yes. It should happen. The Koch cartoon is deliberately furious and deliberately offensive, because the person who it is addressed to, the mayor of New York, is a person who has no subtlety. To be understood by a Bulgarian you have to speak very loudly.

H.F.: In an article in *The Nation,* you talked about getting the

Nixon out of us, saying that America was mean and nasty. Do you think maybe there's still hope for us or do you still feel that way?

Feiffer: I think it's gotten even worse since the Nixon years — in the Reagan years — the mean-spiritedness.

H.F.: Why is that?

Feiffer: Reagan has made racism dignified and legitimate. By his ingratiating ways, his charm, his self-effacement, the twinkle in his eye, he has made the worst seem palatable, and has excused some of the worst instincts we have.

H.F.: Do you think anyone could be a good president?

Feiffer: Several. But they're all dead. There's no one I have to recommend. For a while, I was enthusiastic about the possibilities of Jesse Jackson, because I think the issue that most divides us still is racism. He represented a chance to change blacks' attitudes about their chances of succeeding in this country.

H.F.: In another article, someone said that you portray the "pseudo-educated" and "pseudo-sophisticated." How do you feel about that?

Feiffer: I don't think it's necessarily "pseudo." No one thinks he or she is "pseudo." My subject has always been the urban middle class, which by definition has gone to college, and that fits the definition of "establishment," by which I mean this nation's realtors of wealth and the managers of its future. I was interested in treating the lower portion of that, the outer fringes, who know they're going to have a successful future, but don't know if they're going to get laid. And who don't know how to deal with relationships.

H.F.: Do you mean my generation?

Feiffer: I mean all of us, whether it's my generation or yours — the people who are more equipped to have attitudes, than to truly know what they believe, or how to act on their belief.

H.F.: Do you think we get fed too many attitudes?

Feiffer: I think we get fed too much confusion, too much expertise.

H.F.: Why do you think none of us can figure anything out, when we're getting all this advice?

Feiffer: We're living in a very crowded place, in a very crowded time, with a very shaky economy and a very shaky social structure, and we're too easily moved from what we instinctively believe to what someone else pretends to believe.

H.F.: You don't think there's a solution?

Feiffer: Yes, but I think age is the only solution. After a while, you don't figure it out, you just get tired. There's too much information bombarding us. As far as news goes, we read more news than at any time in our history, and we seem to know even less and have no memory for what's been going on. And so with all this news, your generation doesn't know the music of the past.

H.F.: But take World War Two for instance—everyone tells us that we can't understand because we didn't live through it, so we can't possibly even try.

Feiffer: I think your generation is different, but the sixties generation not only couldn't understand it, they rejected understanding. The past was a crock. History was a crock.

H.F.: Why do you think that happened?

Feiffer: Partly it was in response to something very real. They saw all the hypocrisy in their society and they assumed that since this came from the people who were in charge of them, they should utterly reject them. That was a mistake, that assumption.

H.F.: When you were at Yale why did you teach there?

Feiffer: Only because they asked me. I said as long as you're not looking over my shoulder I'll do it. And I had certain friends who were writers and who also taught; it was tempting, so I took the class and I hated it. I should never have done it. I was very bad at it.

H.F.: You didn't like it because you were bad at it?

Feiffer: Because I was bad at it and they were bad at it. I think to be a good teacher you have to be dedicated to the point of taking students who are essentially passive and finding ways of invigorating them and instilling in them a desire beyond their normal desire or curiosity, to engage them.

And I had some very talented playwrights in my class, among them Christopher Durang, but except for Durang and one or two others, most of them simply wanted me to tell them stories about the theater, or to attack the Yale administration. They were full of self-pity about the lot of writers on campus.

H.F.: When was this?

Feiffer: Nineteen seventy-one or nineteen seventy-two, I believe. When we ran out of material, I could figure out no way of getting them to offer new material or of assigning material. They had other things

to do and I was arrogant enough to think that if they wouldn't take advantage of my being there, I was not going to nurse them.

H.F.: Do you think that's the nature of students?

Feiffer: I think that's the nature of students, but a good teacher, and a real teacher, and a natural teacher feels challenged by that and has ways of dealing with it head-on. But for me, as I wasn't a teacher, I just withdrew, with hurt feelings.

H.F.: You have a new play out?

Feiffer: I have a play that's being planned for New York that was supposed to go into rehearsal this spring, but it'll be next spring. And I've got a play in Houston and one in Chicago. One is a production called *Feiffer's America* in Chicago. The other is *Carnal Knowledge*, which was written as a play, and that just opened last week.

H.F.: So are you overseeing both of them?

Feiffer: I was in rehearsals and previews, made changes, gave notes.

H.F.: You never sit down and tell them how to do it? You don't have an idea of how it should be?

Feiffer: No. You know how it shouldn't be. You know what's wrong. That's something different. Most of my directions are to do with what's wrong, not what's right or how to achieve what's right.

H.F.: What about Fred Astaire? Why do you admire him?

Feiffer: As a boy, I grew up loving those musicals. And as I grew older he became a symbol of elegance and style and a sense of effortlessness that actually took great effort and great work. I shoot for that in my own work.

H.F.: Do you think you achieve that?

Feiffer: I don't know. I hope. In cartoons, and particularly in theater, I would love to write a script where the scenes and dialogues themselves seem to be written almost effortlessly, just to have appeared on the page. With no sense of the writer's mind. That's what I hope for — to get anywhere near that.

H.F.: Do you think we lack people like Fred Astaire now?

Feiffer: Yes. I think so. There's no one like him. There are geniuses, but there aren't heroes.

H.F.: Is that because he was so civilized?

Feiffer: Yes. The urbane quality, the sophistication, the charm, the grace, the facility. The only word for it is elegance. I think that in

doing your work, after a while that's the only direction you go in—of trying for elegance in which to simplify, to reduce the detail to bare basics and just have it happen. And at the same time you want everything in there that you need. I like it when I can do more and say less.

Hanif Kureishi

A Londoner, But Not a Brit

Two of the most respected and controversial films made in England in the 1980s, My Beautiful Laundrette *and* Sammy and Rosie Get Laid, *were written by a young south Londoner of Pakistani heritage, Hanif Kureishi. The films center around the screenwriter's vision of Britain, especially tension-fraught London, which, as Kureishi himself points out, is uniquely personal in its focus on race, sex, and the non-glamorized aftermath of Thatcher's politics.*

Kureishi's first film, My Beautiful Laundrette, *enraged the Pakistani community through its linking of homosexuality to racial identity, while* Sammy and Rosie, *by focusing on Britain's rarely-depicted hippies, punks, crazies, and indigents, starkly exposed England's underbelly. Kureishi is one of a handful of British screenwriters and directors attempting to change the stereotypical British film as epitomized by* Masterpiece Theatre. *This younger generation of British filmmakers focuses on the class and racial barriers that continue to divide England.*

Kureishi grew up in London. His education in drama included training at the Royal Court Theater and months of theatrical experimentation with friends and fellow actors. He once said, "My aim in life is to get as much filth and anarchy into the cinema as possible." His films have been laden with both. Kureishi's works provoke, astonish and forge exciting, new cinematic territory. In 1990, he published his first novel, The Buddha of Suburbia, *proving his reckless realism dazzles just as brilliantly from the page as from the screen.*

Kureishi visited Yale as a Chubb fellow in November of 1988. For two days, he was on campus answering questions about his films, reading from his then-unpublished novel and deriding Thatcher's England. One night after his opening remarks at a showing of Sammy and Rosie Get Laid, *he and Elyse Singer went to a local bar to discuss British filmmaking and theater, the problems of portraying minorities and growing up in London in the sixties.*

Elyse Singer: Has the reception of your films been different in the U.S. and in England?

Kureishi: Oh, the critics are much kinder in America. I don't know if that's true with all films, but in England they sort of think I'm being

horrible about England. So on the whole, American critics are gentler and they're less involved. When *Sammy and Rosie* opened in England it got attacked incredibly by the right-wing press who thought we didn't appreciate the advances made by Thatcher, and Thatcherism itself.

E.S.: Can you tell me a little bit more about Section twenty-eight?

Kureishi: Section twenty-eight is a law which makes it illegal to represent homosexual and lesbian people as existing "in a pretended family relationship."

E.S.: So your movies can't be shown in England?

Kureishi: They can't be shown in public functions, i.e., that are funded by the government, such as schools, libraries. They can be shown in cinemas because they are private, but they couldn't be shown in publicly funded assemblies. Also books, any work which depicts gay or lesbian people can be banned, can be prosecuted in Britain. It's a horrendous, fascist law.

E.S.: What kind of effect do you see it having on English filmmakers?

Kureishi: I hope it will encourage them. People are very angry. People like Derek Johns, for example, are really fed up with it. But it's just part of the wider censoriousness that there is in Britain at the moment in all areas of British life. For example, the banning of certain trade unions. It's now illegal to do interviews with members of Sinn Fein and of the IRA. The BBC has been attacked for the various film reports it made recently about the Falklands. This is Thatcherism. I mean I recently went to the party conference in Brighton and I wrote a long piece about it in *The New Statesman*. They have been in power now for almost ten years and they have been a revolutionary party, in the sense that they've changed not only the bits and pieces, but they have fundamentally changed British life.

E.S.: Do you consider yourself a very political person?

Kureishi: Well, yes. A political person rather than a political writer really.

E.S.: You canvas...

Kureishi: Yes, I get involved. It's due to the fact that Thatcher has politicized a lot of people. For example, people like me who would be sort of decent liberal people who would want to stay at home and watch what you want on television, smoke dope and so on. What she has done is so extreme that you have to sort of come out and say: "We're going

to have demonstrations. We're going to talk about this." The tradition that I come from in Britain is really the Royal Court Theater. It's really a tradition of dissent, of making plays and films and stories which are arguments about British society.

E.S.: In *Sammy and Rosie* there's a shot of the marquee of the Royal Court Theater — in Caryl Churchill's *Serious Money*.

Kureishi: Well, that's the theater I come from as well. I suppose we're interested in making films and plays and stories about relations between men and women, black people and white people, and class, and showing how all of these elements affect personal relationships.

E.S.: So, you're interested in the personal relationships which reflect society, which then affects personal relationships?

Kureishi: Yes.

E.S.: Are your films autobiographical?

Kureishi: In a way. I mean, in the end, all writing, all fictional writing is emotionally autobiographical if not strictly autobiographical. What I mean is you invest your own passions, your own feelings, your own way of seeing the world, your own relationships, your own traumas into your work. I mean I never ran a laundrette and I never had a gay relationship with someone like Daniel Day Lewis.

E.S.: Is there any one character in either *My Beautiful Laundrette* or *Sammy and Rosie* which is closest to you?

Kureishi: Well, the father and the uncle in *My Beautiful Laundrette* are based on two uncles of mine. The character Rosie is based on a woman I used to live with, although she hated the film. But you do look very closely to people you know to try to construct characters around them. Most writers do that.

E.S.: Tell me about growing up in the suburbs of London?

Kureishi: I grew up there even though I wasn't really a part of it — I grew up in the sixties. And in a way the main influence on my life in Britain was America, because of the things that were happening here, the civil rights movement, the women's movement, gay liberation, the role of drugs, what was happening at Kent State, at Columbia. All of that was what we looked to because that was what was happening and everything that happened in Britain happened afterwards.

E.S.: The second British invasion of music was really America-influenced.

Kureishi: Well, all rock 'n' roll comes from blues. I mean The Rolling Stones are really sort of souped-up Chuck Berry.

E.S.: Are there American writers that have influenced you?

Kureishi: Well, a writer that meant a lot to me, and was very important to me was James Baldwin. He was a great example to me because not only was he a writer, a black man who became a writer, but he was involved politically as well. Mailer is the same, in a way that writers say like Roth and Updike are not involved and I liked that they lived public lives and were writers.

E.S.: Didn't Roth offer you support?

Kureishi: Yes, he was very, very nice to me after *Laundrette* came out because I was attacked by a lot of Asian people who said, "Why are you saying all of these horrible things about Asians when we're being attacked racially as it is?" And he said, "Oh, the same thing happened to me when *Portnoy's Complaint* came out. People who were Jewish said, 'Why are you saying that we are horrible people? Why can't you say nice things about us?'" And of course, he was married at the time to Claire Bloom who introduced me to him and I thought it would be wonderful to have her in something . . . and we did in *Sammy and Rosie*. He also said something else to me as well. He said that I should give up writing films, that I should write stories.

E.S.: You are working on stories now, aren't you?

Kureishi: Yes. I'm going to publish them in the fall.

E.S.: A lot of the same actors were in both of your films. You seemed to have formed a community of actors.

Kureishi: Well, they were a lot of the actors that I worked with in the theater before for five or six years in the Royal Court and other places and none of them really got much work because black and Asian people didn't get and still don't get work in British television. When I grew up, you never saw black and Asian people on television. So I thought the only way to get these people any work was to write stories for them, which is what I did.

E.S.: How did you get your start with *My Beautiful Laundrette?*

Kureishi: It got made because Channel Four wanted to do a film about Asian people in Britain and because they knew my work from my theater writing they came to me and asked me to do it.

E.S.: Was it already in the works?

Kureishi: No. I thought the theater was this pure medium where

people with real integrity worked for no money. Films were where you worked as a sort of whore to get money. So I wrote this film and I thought, they'll never make it. It was too crude and then they made it as I wrote it.

E.S.: And then you were nominated for an Oscar?

Kureishi: I know, it was incredible. We were so innocent then. We just made it. We made it for television on sixteen millimeter film. We didn't have enough money to lay out. We made it in six weeks without rehearsing.

E.S.: So a lot of the movie was improvised?

Kureishi: Yes.

E.S.: How were you able to get Daniel Day Lewis?

Kureishi: We only gave Daniel a part in the film because of his hair. He came to see us when he was in *Dracula* and half of his hair was blond and half his hair was black, and he looked very frightening. It was between him and Gary Oldman. And I said, "Oh, it should be Dan, because his hair is so..."

E.S.: What about the homosexual relationship in *My Beautiful Laundrette?* Had that been something that you intended from the beginning?

Kureishi: No, originally it was going to be a buddy-buddy film about these two friends, one who was black and one who was white. But then I realized when I had written a lot of it, that the only way it could work would be if this friendship was incredibly strong. It wouldn't work if they were just mates. You wouldn't see why they would want to be together and why they would withdraw from their own communities to be together. So, we started the kissing.

E.S.: Was that the main reason the Pakistani community was against the film?

Kureishi: Yes. I only put it in to make the film work. I didn't think I'd write a film about gay people. I thought, "How do I make this film work?" So I put it in and realized suddenly that the film would work.

E.S.: Do you think the Asian community is more critical of homosexuality than say, whites or blacks are?

Kureishi: Well, the problem is the Asian community is so rarely represented in the cinema and on television that they felt that when they were represented in the movie as gays, they said, "Why were they shown doing this?" So they got a bit pissed off, quite understandably.

But it's true that Islam is not a religion that faces kissing between boys.

E.S.: You have a lot of strong female characters in your movies.

Kureishi: Well, you hire all these people, these actresses, and you want to give them good parts. The parts for women in my films are not as good as the men's, but you try to make them good.

E.S.: It seems that the generational conflicts are as strong as the sexual conflicts.

Kureishi: Yes, that interests me very much, because it is my father's generation. They came to Britain in the fifties and sixties really to make money, settle their families, and maybe to go home later. And they never did. And they gave birth to all these kids who were Indian or Pakistani in one sense, but in another sense British, like I am.

E.S.: So you call yourself a Brit but not a Londoner?

Kureishi: A Londoner, but not a Brit.

E.S.: I noticed there were a lot of triangles in *My Beautiful Laundrette,* for example with a man, a woman, and a father. Is that a tension you're interested in exploring?

Kureishi: I don't know. Maybe. I just write and don't theorize about it.

E.S.: Do you work closely with Stephen Frears in the direction of your films?

Kureishi: Yeah, well, we did everything together. I mean, I wrote and he directed, but then we talked about things together. It's the only way that's fun to make a film. And he likes me to be around, to have someone to talk to. Also, if you're a director you're mostly concerned — when you're shooting a film — with technical problems. So it's often good to have someone else around who can talk to the actors, when you're the director and are actually concerned about the lights, where the camera's going to be, and what you're going to shoot tomorrow. So, since the director has very little time to work with the actors, often on a film that's what I will do.

E.S.: You once said that "My aim in life is to get as much filth and anarchy into the cinema as possible."

Kureishi: Oh, yeah . . . that was a stupid remark. But there's a certain respectability in British film that I suppose I wanted to react against. The British cinema, in the last few years, has been stuff like *Room with a View,* or *Handful of Dust, Maurice,* or *Passage to India,*

and then on television, things like *Brideshead Revisited, Upstairs, Downstairs.* It's an effete English quality these films have that isn't really to do with the England I know. I mean, England is horrible and full of drugs, just in the way that New York is, only British films show images of Britain in the past, full of respectable people who are wealthy and wear nice clothes and drink tea. So I thought, why does it all have to be so respectable? Why can't it be like the Velvet Underground, or something like that.

E.S.: Your films have dealt with a lot more working class issues than those films you mentioned.

Kureishi: Yeah, and they're rougher and they're ruder. And that's all I mean, really. I felt the British film industry was exploiting Britain's past. First there is the lie about the past, and second is the lie about what Britain really is. It's as if you made a film about New Haven, and it was all about Yale, and not about what goes on around the corner.

William Kennedy
The Singularity of Fiction

William Kennedy, who was born and raised in Albany, New York, divides his time between the brownstone rooming house in Albany where "Legs" Diamond was shot and an old farmhouse in the hills east of the city. The always flamboyant, often endangered, mythical characters of his novels, The Ink Truck, Legs, Billy Phelan's Greatest Game, Ironweed, *and* Quinn's Book *also inhabit Kennedy's wonderous world of Albany.*

Kennedy was born in Albany in 1928. He graduated from Siena College in 1949 and embarked on a career as a journalist. Working at various newspapers in upstate New York, Puerto Rico and Miami, he received many journalism awards. From 1959 to 1961 he was the founding and managing editor of the San Jose Star *in Puerto Rico. After the publication of* Legs *and* Billy Phelan's Greatest Game, *with neither receiving great commercial success, Kennedy was unable to interest a publisher in* Ironweed. *They found the novel, which explored a bum's spiritual and physical meanderings, unmarketable. It was not until Noble Laureate, Saul Bellow, read the book and recommended it to an editor that it was accepted for publication.*

Ironweed *was marketed as the final book in the "Albany Cycle," which included Kennedy's two earlier novels. Its brilliant depiction of a homeless man, Francis Phelan, was quickly heralded as an example of "the central eloquence of every human being." In 1985, Kennedy received the Pulitzer Prize and the National Book Critics' Award for* Ironweed.

Melissa Biggs visited Kennedy in Albany in the winter of 1989. After ushering her into the warmth of his library, he excused himself. "Just have to finish something up," he said. And he ducked back into his study to tap out another paragraph on the typewriter before settling down to the interview.

Melissa Biggs: I've read that your idea of novels working as cycles extends beyond the Albany cycle of *Legs, Billy Phelan's Greatest Game,* and *Ironweed.* Could you explain your idea of a literary cycle?

Kennedy: Well, the word cycle was my choice because I knew I wasn't heading toward a trilogy or a quartet or a quintet. I didn't know what I was heading toward, but I was working on the assumption that

this was a group of novels, number unspecified, that would be related. It was my idea to do that fairly early on. I wrote two novels that were never published, and at the time of the second novel I was thinking seriously about this concept of interrelated stories. Back even to the sixties, my notes all point to that idea of developing cycles. It didn't quite work that way. The first novel I wrote seemed like a separate work. It had its own dynamics. But thereafter when I wrote *Legs,* I could see that there were connections both backwards and forwards with other local characters. *Legs* was the first novel in which I really used Albany by name and also used genuine historical figures like Diamond himself and his lawyer, who was actually a composite of several lawyers and other historical characters, and real street names and place names, because I was dealing with serious history. I mean I was dealing seriously with actual history that was very well known.

Out of that book came the people of *Billy Phelan.* At that point, I understood the political dynamics of the city fairly well. I'd been writing about it for some years as a journalist, and then I began to think about it in a different way and I decided to write a political novel. I took some of the characters out of *Legs* and I moved it forward in time. In *Billy Phelan's Greatest Game,* which was that political book, or more political book, I created Francis Phelan. I had created him back in the earlier unpublished novels. I had created the whole Phelan family. Now I just took him out of that earlier novel and *Billy* and put him into a totally new shape and form with new attributes in *Ironweed.*

And so I had three books that were somehow connected. *Quinn* turned out to be a kind of ancestral book, which was the look backward in time toward the origin of the things that I had been writing about. So that was my rationale and remains so today. I'm working on a book now that takes place in nineteen fifty-eight and you'll recognize some of the people.

M.B.: You once wrote that writers are empowered by the spirit of their age. As you set your novels in earlier eras, how do you see the spirit of this age working in your books?

Kennedy: In writing that, I was talking about the way writers work and think. Writers are not scholars, sometimes they are, but generally they are not even when they are scholarly. If they are great fiction writers, a writer like Saul Bellow or such a scholar of the world as Henry James, you don't look to them for scholarship. You look to

them for the power of real characters portrayed on the page fully fleshed in their minds and in their bodies and in their spirits and so on. And these people who become writers are somehow imbued unconsciously with what's going on in their age, in their own particular times or in the history that precedes them.

You think of a writer like Faulkner, who we now think of as personifying the South, portraying the enslavers and the plantation aristocracy and the kind of white trash figures who rise in the world as personified in the Snopes family, and you see in them the decay of the aristocracy and the decline of the families and the changing South constantly portrayed. Well, Faulkner was not a scholar. I mean, he certainly was a scholar of a kind, but what he was talking about was his own time. And now when we look at it we see how true he was to it. But he wasn't a man who was obsessed with reading all of the books about all of the Civil War battles and all of the slavery accounts. He knew it in his bones. And it comes out in the working out of the story and in the minds of the characters — what is going on in the world.

When I wrote *Quinn's Book,* I looked back to the middle of the nineteenth century. The book starts in eighteen forty-nine and goes to eighteen sixty-four. It encompasses slavery, the working of the theater, women in the theater, the sensual dimension of women as public attractions, the sex goddesses, the ethnic battles among the Irish and their antagonists, who were many, the rivalries between the Irish and the blacks, the clandestine groups that existed, the Knights of the Golden Circle, secret societies, the Underground Railroad, the rise of the Dutch aristocracy, the rise of the English moneyed classes which controlled so much of the manufacture and culture of this country.

I looked back at all of these things and when I discovered what was going on in those days, I saw the absolute parallels to what is going on today. I mean if you look at what is in the movies, it is *Mississippi Burning,* and the secret societies and the Klan again and *Betrayed,* the Costa-Gavras film. You can look at the clandestine operation that happened with the Contras, the Iran-Contra scandal. Take a look at the constant emergence of the ever more daring or sensual attitude of films and theater. Nudity on the stage began in this country in about eighteen fifty-five with a woman in a body stocking who looked like she was naked. This actually happened in Albany. Adah Isaacs did ride on the back of a horse in a body stocking as Mazeppa.

M.B.: The way Maud did in *Quinn's Book*.

Kennedy: That's just one element of Maud. Maud is a composite. Maud is an invention. I drew on so many of the women of the nineteenth century who were somehow reflective of significant behavior. Anna Cora Mowatt was an actress who became ostracized for her public appearances as an elocutionist or a reader of poetry, something that a proper Bostonian woman could not do. So she was bitterly scandalized, but did a lot for women and wrote very eloquently about her life. Anyway, that was another contribution to Maud.

So the idea of combining the ages, well, you can't embody the past entirely; you're not a part of it. All of your thinking is created in this time and place and whatever you're using has to be a metaphor for what you're feeling, what you've learned, what you understand about life. And so I think of *Quinn,* even though it's a novel that ends in eighteen sixty-four, as a very modern novel in style and attitude. Even though it uses an antique language, it's not an antique language that corresponds to anything specific in the nineteenth century. It's not like James. It's not like Poe. It's not like Melville. It's like me.

M.B.: Do you think you have a responsibility as a writer?

Kennedy: I don't feel that I have a didactic responsibility. I feel a moral fervor, but I don't consider it a responsibility. I think when you get into that category you become too prone to propagandizing to decide that you are in possession of the truth, therefore you must spread the gospel, like Jerry Falwell or Jim Bakker. I don't feel that writers do that. Writers tell stories and tell the truths about their time in ways that are extremely responsible because they are a) accurate and b) real.

I mean there's nothing more wonderful than reading *The Great Gatsby* or Kate Chopin's *Awakening* or *Bartleby*. And John Cheever's stories and Raymond Carver's stories, what do these tell us about the responsibility of the writer? I mean where is the responsibility in F. Scott's Jay Gatsby? The fact that it's so illuminating. Fitzgerald felt the responsibility to be a great storyteller and to use language to the best of his abilities and to perceive the world around him with as much accuracy and insight as possible and that's why he wrote so well. So I think the writer's responsibility is chiefly to himself, to design himself in his work as something that is as truthful to human behavior as he can, as interesting as he can possibly be. I think the writer fails in his responsibility if he writes a boring work that nobody wants to read.

M.B.: Do you think the writer's job is more difficult today with society's visual reliance on film and television?

Kennedy: I don't think the writer's job has changed. I think his audience is somewhat diminished, although you wouldn't think so looking at the bestseller list and seeing how many books are being sold today. It doesn't seem like we are in a state of decline, but television is now beginning to proliferate and I don't think that it gets better. I switch the television dial every night when I go to bed trying to find something that I want to watch and it's very difficult. Every once in awhile there's a good film. Every once in awhile you see Bill Moyers talking to somebody and making a great deal of sense, but that's a rare thing on television. Most of the time it's trendy music or sappy soap opera or ridiculous, and sometimes very entertaining, sitcoms and old movies that are sometimes great and sometimes unbearable.

I still think that the intelligent public, at least, are going to turn to the book. I can't believe they are ever going to be able to do without it, because you can't watch television in solitude and focus intelligently. I mean if the decline of our intelligence becomes so rampant that everybody stops writing books and reading books and just watches television, we're going back to the Pleistocene Age.

M.B.: Has your work in film affected your writing?

Kennedy: It hasn't affected the way that I write that I know of. I certainly don't write novels for films because that's silly. If I want to write a film, I'll write a film. But it's given me access to certain worlds that I have not lived in before and it's a good sport. I guess my name is better known because of *Ironweed* and the film made from it. I probably sold thousands of books that I would not have sold had the book not been made into a film, though it did extremely well independently of the film. I would never confuse the two genres.

I would say that I have been influenced all my life by cinema and by television. I've grown up in the whole television age and I was born right on the cusp of the age of talkies. So everything that I absorbed from a very busy lifetime at the movies has influenced my work. And you can't help but be beseiged by visuality, by the force of the film age, so my books, as a lot of people have noted, do have a very visual quality. We don't write like writers of the nineteenth century. We are far more visual than they were. They would go on for pages describing something. We don't have to.

M.B.: Do you have a writing routine that you follow?

Kennedy: I just write every day. Sometimes I go away, but I take what I'm working on with me, to read and to rewrite. I realized a long time ago that concentration really makes a work work. I interrupted myself in nineteen eighty-three writing *Quinn.* I got a call from Francis Ford Coppola to write *The Cotton Club* and it was a great deal of fun for six months. When I came home, I picked up *Quinn* again and to figure out where I was I had to start from scratch. You must stay with the words. You must keep it in your imagination, keep it alive, keep all of the nuances fresh. It's very difficult to write fiction and keep all of the threads together.

M.B.: What do you see as the greatest challenge facing writers today?

Kennedy: The greatest challenge is getting published.

M.B.: I thought that after the difficulties you had getting *Ironweed* published that might be your answer.

Kennedy: There are some good editors out there. But it is hard to find a good editor that is on your wavelength. People in the publishing business like everywhere else need to make money. That's the *Good Housekeeping* seal of publishing and it keeps publishers at work. I'm not saying that a book shouldn't make money. But there is a sense of responsibility toward the financial aspect of publishing, but there is not a universal responsibility to rescuing the highly qualified, underfed writer.

I must say in another context that, in general, the unknown is a little better off than the writer who is trying to get his second or third novel published. Because again it goes back to the money. If you haven't been published you might be the next Jay McInerney or Scott Fitzgerald. But if you've written something, for instance, like *Billy Phelan,* and it hasn't made a whole lot of money, they will look at you with a warier eye.

In the old days a good writer would be able to build up a reputation just by being published as a normal function of distribution. Magazines were publishing everything that writers would write. The shelf life of books was much longer. It wasn't the same kind of business as it is today. Now everything is speeded up and it's hard to get the focus.

M.B.: Your publisher Gerald Howard said that much of the sense of suffering in your books comes from your Irish Catholic background. Do you see yourself, in any sense, as an Irish-American writer?

Kennedy: Yes, of course. I couldn't be anything else. That's exactly what I am. I didn't know I was so Irish and I probably wasn't so Irish until I started to write. I have a friend, another Irishman, who is very suspicious of me for having become more Irish than I used to be. He doesn't understand it. I'm not sure that I do, except that I have accepted that I grew up in an Irish Catholic neighborhood, though I didn't really feel that Irish. I felt very American and I knew I had some Irish connections but I never asked about them. I wore a piece of green on my lapel on St. Patrick's Day and that was about it. Maybe you sang some Irish songs, "My Wild Irish Rose."

I'm an Albanian writer as well. I'm a product of this city. I'm a product of this state and the Western world. I was raised a Catholic. I know very little about being Presbyterian or being a Jew or being a Muslim. I know I could not write about those things. The things that shaped me are what I write about and I'm really not interested in being Irish or Catholic or Albanian, except that these forces, the religion, the place, the ethnic heritage, my profession as a newspaperman, my major in English, these things shape you. And I reflect those things. I reflect growing up as a child of the movies. I think that I am always looking around to discover what the world is doing to me and to my friends and people I don't know who I value or who I find interesting to study and people I invent. And I try to rediscover the forces that might have played on them. That's what this new book is all about. That's what *Quinn's Book* is all about. This new book is more direct in a certain way about a certain inheritance.

But I don't think of myself in a category. I don't think of myself as a hyphenated writer, the Irish-American. I think of myself as a writer who's using these materials of Irish-American life to partly form an existence. I felt like an anonymous citizen of the world in my early short stories. I was a tourist when I was in Puerto Rico, just another Yankee in the subtropics trying to find out what to do with myself, how not to be bored. I think that the best kind of writing comes out of a sense of identity with a heritage and with a place, whether it's Dickens and Cockney London, or Melville and the sea, Joyce or O'Neill. I mean you don't think of any of these people as ethnic writers. It's not something any serious writer would aspire to, no more than he'd aspire to be a local colorist. It's a diminishing title for a writer. I wouldn't say it's demeaning, but it diminishes the ambition.

M.B.: The protagonists in your books are often outcasts of society—like Legs Diamond and Francis. Do you see them as a form of American hero?

Kennedy: I wouldn't call Legs a hero. He certainly wasn't a hero, but he was a celebrity and that was fascinating to me. People did like him and people make gangsters heroes in a way. I was in a restaurant in New York a few weeks ago and the owner told us that John Gotti, probably the most famous Mafia man today, had eaten there recently. And he had sat with his back to the window; he was so sure of the FBI men following him that he wasn't nervous. That sort of flamboyant behavior, that was one of the things that made Legs Diamond the spectacular figure that he was. He was as much of a celebrity as a rock star, even more than a rock star. He was almost a superstar. *The New York Times* devoted page one and two to his obituary and *The Daily News* devoted miles and miles of their paper to him. His wife sold her memoirs to the tabloids twice and his mistress became a famous stripper, all using his name. And his legend goes on; I mean there's a version of his story on Broadway now. So that's not exactly focusing on a hero, that's an extreme figure. Extreme is always the word that I come back to. A man who will take life as far as it can go to survive. Billy Phelan perceives his own courage as inviolable and refuses to violate it even for the bosses of the time. Francis Phelan is an extremist for a totally different reason. He is a survivor. You can call him a hero but I would call him a kind of warrior figure. Billy is a warrior. Legs is a warrior. Quinn is a warrior. They all struggle and fight against themselves, if nothing else, against tides that are very strong against them, against wars in their own minds and in their own societies. So, in a sense, they are a form of not heroes but extreme figures who are willing to go to the limit.

M.B.: Often women in your books, I'm thinking particularly of Helen and Maud, seem to inhabit a higher spiritual plane than men. They have an otherworldly aspect to them. Do they represent particular feminist views you hold?

Kennedy: Helen otherworldly?

M.B.: There's something very spiritual about her.

Kennedy: She is a very serious-minded woman who has taken her life seriously. I don't find any mysticism or otherworldliness about her. I think she is a very realistic human being who looks at the spiritual life

of those around her and herself. She won't confess the things she doesn't think are sins. This is not what the church says. This is not what otherworldly dogma is all about. The otherworldliness may come from a spiritual set of values that she has.

M.B.: She seems more spiritual than the other characters in her world.

Kennedy: Well, Francis was spiritual in the sense of his awareness of his own soul and to some degree of trying to hear the echoes out in the deepest part of the self. That's why he has come home. That's why he's survived. That's why he's able to achieve this sort of redemptive return to his family.

Now Maud certainly has a spiritual dimension, in that she is able to talk to spirits. And yet she addresses her spiritual dimension by denying it. She says there are not spirits, only noise. She's like a precursor of the *Three Faces of Eve* or *Sybil* or these multiple personalities in psychiatry. Spiritualism, in that time, was very much an important part of theater, an important part of women's lives. Children were spiritualists. It was something that was in the air that has never been very satisfactorily explained by any of the books that I've ever gone through. They just dismiss it as one-tenth inexplicable, nine-tenths fraud. But you had a great many good people of that period looking at people like Maud unable to explain them. Maud herself rejects it as noise out there.

But to get back to the question of feminism, I think that it's a desire not to adhere to any formal doctrine. It's the desire to create a woman who seems to be real to me, who seems to embody the complexity, the contradictory elements, the career elements, the feminine elements of the women I know. There are many facets of women that need to be represented. Helen was a prototype for that and a figure with all of those properties, except for the extreme spiritualism that is represented in Maud. But Helen certainly has the complexity, and the feelings and the intelligence to look at the world around her and evaluate it to find her place in it. She knew where she was and where she wanted to be. And she didn't want to cop out of making her own decisions.

M.B.: Often the families in your stories are fragmented. Do they represent the modern demise of the traditional family?

Kennedy: The book I'm writing now is totally about family. It's a family that has stuck together so traditionally that it's created another

whole set of problems for people, closeness for example. The strong influences one family member asserts over another.

I think the Phelan family has an integrity. Billy is there. Peggy is there. Denny is there. Annie is there. George is there. That's five. Francis went away, but Francis came home again. The Staats family came from the Middle Ages into Albany and carried the line forward. The FitzGibbons are a line of entrepreneurs . . . Family is just an excuse for proximity. Home is a place where you go because they can't throw you out, but that's not entirely true. I think that when you look at my work you can't hold forth anything specific about fragmentation, for instance, or extremism, or anything until I'm finished. When I'm dead and I'm not writing anymore then somebody can look at it and say, well, he did this and he did that and he didn't do this. But now I'm still working on it. Let's see how it comes out.

M.B.: You've said that good fiction singularizes life. What did you mean by that?

Kennedy: We're sort of used to sermons and generalities and bromides and things that put us into categories and tell us how we are like everybody else, which is not very true. Everybody is not like everybody else, not in our brains and in our psyches and in our habits and we should celebrate that difference and cultivate an attitude that will express that singularity. Fiction seems to me to be better equipped than anything else, because very often, and since you asked the question about film, if you look at the movies one cop hero is very like another cop hero after awhile. The genre demands certain behavior. But in serious fiction, if you look at a character like Jason Compson in *The Sound and the Fury* or Ahab or Leopold Bloom or Gatsby, you see these characters are singular. They are not like anybody else. Bartleby is not like anybody else in the world. And they tell you something about how people become singular and how one's likely to move into a particular condition and discover that you are not like another. If you are Bartleby you have to die. If you're Bloom you have to smile. I mean look at Beckett. However gloomy it gets, there is always a joke right in the middle of the mud.

Singularity, that's what I mean. In a piece of writing, the world can be created, but in film, in theater, and in poetry, there are serious limitations on the actuality. There are sets or the absence of sets, like in *Our Town*. There are the abstractions of set designs, or fanciful costumes,

or masks, and you can certainly get a lot of good talk in an intelligent work of theater, but it takes the fiction writer to really represent the complete world and its singularity, in all elements of its singularity.

A work like *Ulysses* puts you suddenly into an entire universe. You get Molly and her lover and the singing and the dead child and the husband and the husband's full day and you're in that universe. What film has ever been able to do that? What theater piece can do that? Even if you're talking about Shakespeare, he's left it to the imagination to find out what Othello looks like. It's a totally different world than fiction. There may be a singularity to my work and there may not, but I could never have done it in any other medium.

Susan Minot
One Writer's Beginnings

In 1983, while working toward her M.F.A. degree at Columbia University, 25-year-old Susan Minot had her first stories published in The New Yorker *and* Grand Street. *Three years later, her novel* Monkeys *was published to rave reviews and great sales.* Monkeys *was lauded on the cover of* The New York Times Book Review, *accorded literary awards in Europe and translated into 12 foreign languages. Anne Tyler has called Minot "one of the most impressive new arrivals on the literary scene."*

Raised in Manchester, Massachusetts, Minot began writing in her teens. She wrote sketches and occasional stories. At Brown University, where she earned a B.A. in 1978, Minot studied writing with R.V. Cassill. Minot now lives in New York with her husband and teaches at the Columbia University Writing Division. Her stories have been selected for such distinguished anthologies as Best American Short Stories, Pushcart Prize IX, The O. Henry Awards, *and* The Norton Anthology of Modern Literature. *Her second collection of short stories,* Lust and Other Stories *was published in the summer of 1989.*

When first approached by Melissa Biggs for an interview, Minot replied that she was working on her new book. "Maybe next spring," she wrote. In the fall of 1988, with the book almost finished, she consented to an interview. Biggs found that by incorporating her interview information and impressions with Minot's background and excerpts from her work she could better illuminate such a new and elusive writer. For this reason, the interview appears as a form of profile rather than in a question-and-answer format.

At 27 Susan Minot published a slim book of short stories entitled *Monkeys*. Seven of the book's nine stories had been previously published in *The New Yorker* or *Grand Street*. The stories cover 13 years in the life of the Vincent family. A distant father with a drinking problem, a loving, Catholic mother, a little out of place on Boston's north shore, and seven of their children (the monkeys) in their various stages of infancy and adolescence make up the cast of characters. Minot says the question of autobiography is touchy.

The glowing review of *Monkeys* in *The New York Times Book Review* described Minot's talent: "Not since J.D. Salinger has an American writer so feelingly evoked the special affections and loyalties that may develop among children in a large family, and there are passages in Susan Minot's *Monkeys* that may also remind one of Faulkner's *Sound and the Fury* when the Compson children attempt to decode the strange perplexities of the adult world."

Minot sketches the family in its continuity and in its transition through seemingly ordinary events — a Sunday picnic, a Thanksgiving dinner, a party. Then two-thirds of the way through the book, the mother is dead. One day on her way to the market, the mother's car was hit by a train.

"Hiding"

A sailboat in an inlet sketched in black pen adorned the first letter I received from Susan Minot. "Thank you for the invitation to be interviewed," she wrote. "I'm anxious to finish a next collection of stories. Perhaps after I've done them — with luck by next spring — I'll feel more willing." She types her letters and stories on an old typewriter. When she tried using a computer, she found that the words disappeared when she edited. Often her once-edited words turn out to be what she finally keeps, so she went back to the typewriter and a red pen.

A lily in thin, gray brushstrokes ran down the right hand margin of the letter I got from Minot the following spring. "I can't imagine why you'd want to interview me since I've only written one book, and a slim one at that, but if you really think you can get something interesting out of me, then I'll let you try." After an exchange of messages on each others' answering machines, we finally made contact. "How about lunch tomorrow?" she asked. "I have to take a break from writing." We agreed to meet at a restaurant near her apartment. "It's the only decent place around here, but the name is ridiculous — Positively One hundred and Fourth Street."

The *New Republic's* review of *Monkeys* was titled "The Art of Omission." Ann Tyler said Minot's work resembled the art of drawing an object by drawing the space around it. The first chapter of the book, "Hiding," in which a Sunday's activities culminate in Mum and her "monkeys" hiding in the linen closet while Dad goes on an errand, sets up the whole book. The story ends with the father coming home, shouting "Anybody home?" and sitting down before the TV. Adams

wrote: "All that's wrong with this family (and all that's right, as well) is laid out for us ... but it's laid out solely by inference."

> We climb out of the closet, feet-feeling our way down backward, bumping out one at a time, knocking down blankets and washcloths by mistake. Mum guides our backs and checks our landings. We don't leave the narrow hallway ... Lingering near the linen closet, we wait. Mum picks up the tumbled things, restacking the stuff we knocked down, folding things, clinching a towel with the chin, smoothing it over her stomach and then matching the corners left and right, like crossing herself, patting everything into neat piles. — From "Hiding"

"Allowance"

This fall Minot writes every day, as she is not teaching. Last year a friend at the 92nd Street Y asked her if she would give a fiction class. Since then she has also taught at New York University and next semester will move to Columbia. When she has a class at night, she mentally prepares all day. The greatest difficulty is to know when to praise and nurture and when to criticize honestly. "Because," she says, "you're dealing with such tender egos. Budding young writers are tender egos." Having been a student of writing, she knows.

Minot grew up in Manchester, Massachusettes, on the north shore of Boston. After attending Concord Academy, she went to Brown University where she majored in creative writing and took art classes. She planned to go to Europe after graduation from Brown, but then her mother died. She went home to take care of her nine-year-old sister. For a year, she lived the life of a housewife; cooking, cleaning and grocery shopping filled her days. Then she moved to Boston and worked part-time as a carpenter.

After a few months, Minot moved to New York and decided to enter Columbia's writing program. "I was sort of embarrassed to be going to writing school," she says. "Instead of something more serious." The Columbia writing program awards a Masters of Fine Arts degree after a two-year program in either fiction or poetry; Minot enrolled in fiction. "Not expecting much from the program," she says, "I was mildly surprised at how much I got out of it." The heart of the program lies in the four workshops. "In one of them the teacher hated my stuff. But that was good because I had to defend it — to articulate why I liked what I had done."

From the age of 13, Minot had been writing stories as a private

endeavor. She hid them in a cubbyhole in her desk. In her first classes at Brown, she was scared of threatening the privacy of the stories — of changing the nature of what the stories had always been. "Columbia was really good for me because I had been writing for so long," she says. The stories brought out of their isolation, enabled Minot to see the direction of her work. "It was also good to be around literate people," she says. "I mean I had literate friends, but obviously not with the same consuming interests."

> "Still." Delilah waved away smoke making a sour face. "Anyway, why don't you use your own money?"
> "I would," Caitlin said. "If Dad would just give us a regular allowance."
> "He gives you money whenever you ask him," Sophie said.
> "Right," Caitlin said with a knowing look. "*You* ask him."
> "We're not meant to bother him," Delilah said.
> Caitlin and Sophie both rolled their eyes. "Thanks, Delilah," they said. "Thanks for the information." — From "Allowance"

"The Navigator"

Six years ago, Minot sent a story to a friend who was a reader at *The New Yorker*. "I think the way it used to work was if the reader chose a piece out of the slush pile, the editor above read it. Then they showed it to the other editors and they all wrote opinions on it and if they were unanimously in favor, it went to Shawn, the editor. Anyway, the story wasn't right for them, but my friend suggested this new magazine called *Grand Street*."

So Minot sent the story to *Grand Street* and they wanted it. "Much to my astonishment," she says. A few months later, the same friend heard that the editor of *Grand Street,* Ben Sonnenberg, needed readers. "At first he was cagey," she says. He told Minot they didn't have any jobs open, but he would like to meet her. At their meeting he gave her some stories to sift through. On the basis of what Minot gave him back, she was hired. "At first it was on an hourly basis and then three days a week. I'd go in and read and pass on what I thought was good to him. Ben rescued me from the Beach Café, a restaurant where I was waitressing," she laughs. As the dedication of *Monkeys,* "To my family, to the memory of my mother, and to Ben Sonnenberg," attests, her gratitude goes beyond rescue from the Beach Café. He has also helped edit her second book of short stories.

After her story was published in *Grand Street,* Minot sent another story, "Thorofare," to *The New Yorker.* They bought it. One night at a cocktail party, a friend introduced her to the publisher Seymour Lawrence as having just sold a story to *The New Yorker.* The party moved to dinner, and Lawrence asked her to send him some stories. "Who knows? I could give you a book contract," he joked. She sent him three stories that are now part of *Monkeys.*

The original contract was for a novel, but Minot didn't like that, so Lawrence crossed it out and wrote "work of fiction." "I felt comfortable with that," she says. To enable her to stop working at *Grand Street* and move out of the back room she was living in, she arranged to be paid monthly.

"*Monkeys* was hard to write," Minot says. The fact that many of the stories were originally published in *The New Yorker,* a magazine "friends of [her] parents read," made it more difficult on her family. "But it would have been harder to live with myself, not to write it," she says.

> Some heads jerked toward Dad; some looked down. Above them, Dad was facing the root screen, his back to the family. Mum didn't move, lying on the life jacket, eyes hidden behind her sunglasses. Sophie hugged her shins and bit her knee. Gus's neck was twisted into a tortured position; he glared at Dad's back.
>
> Dad then turned around. He gazed with an innocent expression out over the snaking water. If aware of the eyes upon him, Dad did not betray it, observing the scenery with contentment; nothing more normal than for him to be standing in the shade at a family picnic holding a can of beer. He twisted the ring from its opening and, squinting at a far-off view, stooped to lap up the nipple of foam at the top of the can.
>
> The silence was no longer tranquil. — From "The Navigator"

"Party Blues"

Minot sees the linking of her work with that of Tama Janowitz, Bret Easton Ellis and Jay McInerney, the so-called Literary Brat Pack, as a journalistic creation. Journalists need a structural gimmick to organize their articles around, so they look for, and often invent, packaging ideas. "There are some similarities," she says. They are all in their twenties and thirties, living and often writing about New York. "And," she adds, "what is popular *is* representative of something, but never in so logical a way."

When *Monkeys* came out in the spring of 1986, Minot didn't expect it to be as well received as it was. Dutton/Lawrence first printed 6,000 copies and then, when *Monkeys* was reviewed on the cover of *The New York Times Book Review,* did a second printing. "I was wary," she says. She was familiar with the publishing world from working at *Grand Street* and knowing editors. "Its success mainly meant I could stop working and write." A lot of doors seemed to open; she decided to go to Paris to get away from the attention.

Success bears many gifts, some which Minot may more aptly call burdens. Aside from the loss of privacy which publication brings, she notices that people treat her differently. "Your friends, especially," she says. "People think they might be in my work so they act aloof, distant." Minot also acknowledges the loneliness implicit in the writer's calling. "Thomas Mann said you choose between the life of pleasure and the life of accomplishment. Or some variation of that. Maybe it's between pleasure and, perhaps, a deeper gratification. For me, writing is the key out to the world. If you can get this done, you can go out and enjoy things. Writing allows you to live."

> It wasn't late but the party was in full swing. Sophie could see the effects already—a rip in the canvas lawn chair, the begonia toppled over on the piano. Someone had been putting out joints in the Canton china. Sophie's boyfriend, Duer, had disappeared and she was on her second gin. She felt a bit off, despite the exuberance filling the house, despite the band's buoyant percussion. On her way upstairs, she passed someone carrying one of the good wine glasses. The door to their parents' room was at the top of the hall. Sophie went to it. She closed the door behind her and was in the dark, quiet now with the rug. The chaise was a pale island; in the deeper darkness, still invisible, the huge bed. —From "Party Blues"

"The Accident"

Last fall, while working on her new book, Minot decided to get away from New York. She went to Italy to live in a small village. "I felt the normal rhythm of things again," she says. She worked on her stories and kept journals. While driving back to Paris to return her rented car, she stopped in Milan to have dinner with a friend. During dinner someone broke into the car and stole everything. They stole the French Prix Femina award prize money she had just received for *Monkeys*. She had a plastic bag with stories in it to take with her on the plane. They stole that too. "At home when I went to work, the finished stories came back

again. I had worked so hard on them that I knew them word for word and recreating them saw the larger brushstrokes. But the three journals were gone, one of which I wrote over two weeks of not talking to any-one."

> Then from Sherman came a kind of wail, a hollow cry like something heard on a marsh, and he looped around at the waist. Delilah tried to calm him, her hands fluttering around as if she were chasing after a bird that had gotten in the house. Caitlin let out a sob and clapped her palm over her mouth, staring at Sherman.
>
> Chicky looked at her. It was like when their mother died. When you first heard the news, when it first hit you, it was like that — you couldn't breathe. It was as if the Devil had appeared for an instant, and you couldn't breathe. — From "The Accident"

"Thorofare"

The restaurant Minot picked for lunch, with its pastel-colored walls, palm trees and ceiling fans, had a tropical atmosphere. When she finished her lamb sandwich and I my tortellini, we talked for awhile over tea and coffee.

Minot told me that she was married this summer. She wears a simple gold band on her ring finger. Her husband writes screenplays and directs low-budget films at the moment. He can't make *Monkeys* into a movie, as it has been optioned to United Artists. Minot says that the screenplay is very different from the book. "It's California-like and the father drives a Porsche."

In three weeks, Minot will give the manuscript for her next book to her publisher. Entitled *Lust and Other Stories,* it will come out this spring. "It's about young men and women," she says. "I may get attacked by men for it, as it's only from a woman's perspective."

When we got up to leave, it was pouring rain outside and she offered to walk me to my bus stop under the shield of her umbrella. I thanked her for her offer, but said I'd get wet in the wind anyway. So we parted in different directions, I to my Broadway bus and she to her typewriter. Waiting in the rain, I remembered why she said her new book was important. "It's important finally, because it's about how the human heart works," she said.

Andy Warhol

Warhol Talks — Or Does He?

When The Yale Vernacular *asked the director of the Whitney Museum, Tom Armstrong, for his opinion of Andy Warhol, he replied: "Andy Warhol is the quintessential enigma in an age where the enigmatic aspects of daily life have become the routine."*

It was Andy Warhol's Pop Art revolution that created the age Armstrong describes, by investing the aspects of daily life with a sense of the enigmatic. More than any other "serious" artist, Warhol obliterated the levels between high and low art, between the fine arts and everyday sights. His silkscreen reproductions of Coke bottles, one dollar bills, Campbell's Soup cans, and Marilyn Monroe initiated the glorification of American popular culture. In a century of mass production, Warhol celebrated the banalest of images; and, as his art venerated the country's most common grocery items and ubiquitous sex symbols, it endowed them with a new mysticism.

Born Andy Warhola on August 6, 1928, he grew up in Pennsylvania in the industrial city of McKeesport. His parents were immigrants from Czechoslovakia, and Warhol barely managed to earn enough money to send himself to Carnegie Mellon. Upon his graduation in 1949, he moved to New York where he illustrated for magazines, department stores and advertising agencies. In the mid—1950s he turned away from the commercial arts toward painting and printmaking. When Warhol abandoned the paintbrush for mass production techniques and began experimenting with films in the early sixties, he attracted many followers. Seen by some as a visionary and others as a quack, Warhol became a cult figure and the father of Pop Art. His impersonal images which critiqued American consumerism became the ideal form of Pop Art.

Warhol's popularity diminished somewhat in the seventies and eighties, though his work still garnered high prices and his late-night antics were duly noted in the press. The editors of The Vernacular *were told they could probably get an interview with Warhol in the winter of 1987. However, after reading interviews with him full of such comments as, "I make it all different all the time I'm asked," and "The interviewer should just tell me the words he wants me to say and I'll repeat them after him," they decided that an interview previously published at Brown University was as lucid a view of Andy as one could get. The day after* The Vernacular *published the interview, Warhol died in New York after complications in surgery, beginning one era with the end of another.*

Andy Warhol

We spent thirty minutes with Andy Warhol. What a scene. He may have set art trends in the 1960s and given new meaning to the word "celebrity," but he had tremendous difficulty completing a sentence. Basic subject-predicate constructions evaded him. Ums and Uhs predominated his most complex comments. Whether it was just a bad day, an overwhelming lack of personality, or one of his games, Andy Warhol confused us.

"I don't have anything to say" he remarked in a rare moment of polysyllabic lucidity.

We met him at 3:30 p.m. at The Factory, his art studio on 33rd St. and Fifth Avenue. After we buzzed and gained entry, we were largely ignored by his entourage, which included a middle-aged female secretary, a couple of Young Blonde Men, some European guests, and a fashionable woman in a silver skirt. Andy paid us no heed and continued talking on the phone for about ten minutes. He stood there, chatting away, in his black pants, black turtleneck, black shirt and running shoes. His stringy white hair was limp and probably fake. His black glasses frames contrasted his pale skin.

We examined the foyer of the studio, a cluttered collection of what Andy called "junk": a huge self-portrait painted like a jigsaw puzzle; a dead stuffed lion and Great Dane; a couple of broken wooden chairs; and an old refrigerator featuring graffiti art.

Andy finally completed his phone call and meekly greeted us. His handshake was limp. He suggested we sit at the front of the foyer, right next to the door, because it would be quiet. The locale was hardly serene. Andy's quiet voice was frequently drowned out by the honking cars passing by, visitors coming and going, the hammering of an assistant at work on an art project. The noise was so cacophonous, the environment so distracting, that it was difficult to make sense of Andy's comments.

We began by asking him about his collection, having been told that Andy collects jewelry, clothing, ceramics, stuffed animals and many other things. Andy pooh-poohed us.

"I don't collect jewelry ... No, I don't have any collections, just junk."

Because Andy has written about how he loves being famous, we asked him to describe the ideal profile of Warhol. "Oh, you'd have to ask me where I was born, what day I was born, what school I went to and what paintings I painted, what color is my favorite color."

We decided to skip his questions and ask some of our own.

Do you still think you're shy and awkward?

"Yeah," which he followed with silence.

What about the idea of celebrity and fame? You seem to enjoy writing about that?

"No I don't. Well, I don't know. You get a book to do and you just have to put words to a picture."

How should we become famous?

"Well, you could both become prostitutes."

How do you stay hot?

"I don't know."

What are you working on now?

"Just everything, things. The TV show and the magazine. Do you ever read *Interview*?"

We answered affirmatively and asked him how involved he is in the magazine which he publishes.

"I go in and scream a lot. That's about all I do."

Do you have a lot of input into who gets interviewed?

"I give out about twenty-five names. Anybody I know I want to be on the cover."

Who would you like to interview?

"Oh, Donald Duck." Then he paused and added, "No."

We decided to change the subject.

What do you do on a typical day?

"I start out thinking about everything I did the night before, watching *The Today Show,* getting ready to pass out fifty *Interviews* on the way to work. So I get stopped on the street, and I give out *Interviews,* and I stop in the different stores, and I walk thirty blocks. And I get there and there's, uh, like fifteen people here at lunch."

He continued: "I just walk up and down the stairs mostly, all day long. Work on Saturdays."

Throughout the interview, Andy had trouble generalizing about his life. When we asked him what he thought about video as an art form, he told us he had just visited the Museum of Broadcasting, and that it had reminded him of a restaurant he wanted to start where everybody would eat TV dinners.

Are you afraid of talking to people?

"No, I just don't want to." He told us he recently went to a party and pretended he had laryngitis.

And when we asked him what he did most evenings, he announced he was attending a screening of *Ginger and Fred,* Federico Fellini's new film. Hoping for more insight into his nightlife, we again asked how he usually spent his evenings. Again, he told us that he would be attending the screening of *Ginger and Fred,* "and I think a party for Fellini at some restaurant," he added.

Do you like parties?

"Uh, no, but they put you on a bus and it's easy to get there . . . I just go there to eat. Take my vitamins."

He was equally unenthusiastic on the subject of art. When we asked him what he liked about new artists such as Keith Haring and Jean-Michel Basquiat, he responded, "Maybe it's their personalities."

Are today's artists any different from your generation?

"Oh, it's not any different. The kids this year are just like the kids in the sixties."

Which time period do you prefer?

"Oh, no. I like it right now."

We decided to ask him his favorite color. "Black," he responded. Then we decided to tackle the question of his age, which some say is fifty-five. When we asked him if he really is fifty-five, he said, "No, that's not accurate. I was born in 1955."

That would make the white-haired Andy Warhol, a seminal figure in the 1960s, exactly thirty-one years old.

Perhaps the entire interview, like his last answer, was a big put-on. Maybe an honest interview with Andy Warhol would be less interesting. By answering our questions awkwardly, often unintelligibly, he remained an enigma.

Like his art, he manufactured his answers for the moment. Maybe he is the Famous Amos of the art world, a muttering, doddering crucible of emptiness. Or maybe he is some kind of genius, who bores easily and recreates himself with each interview. For all his incoherence, he *was* friendly.

When we finished the interview and he didn't have to answer our questions, Andy became more animated. Unsolicited, he autographed photos of himself for us, then gave us multiple copies of *Interview,* all of them bearing his signature. He was glad to pose for photographs and seemed disappointed when we announced we'd taken enough.

As we were leaving, we asked him if we had forgotten to ask anything. He smiled.

"Anything you forgot, just make it up."

Calvin Trillin
Word Portraitist

Calvin Trillin has been called the finest reporter in America. He has also been hailed as America's funniest columnist. From his gripping "U.S. Journals" for The New Yorker *and his syndicated column "Uncivil Liberties" to his "tummy trilogy" of food guides, Trillin has perfected the art of chronicling America.*

Born in 1935 in Kansas City, Missouri, Trillin lived there until he went to Yale in 1953. After graduation, he served a term in the Army before joining Time *magazine. When he became a staff reporter for* The New Yorker *in 1963, Trillin produced a highly acclaimed series of articles called "U.S. Journals." Every three weeks from somewhere in the U.S., he would send a piece to his editors at* The New Yorker. *His subjects ranged from the murder of a farmer's wife in Iowa to a five-foot-two, frosted blond police-beat reporter in Miami. In all of his writing, Trillin displays an insightful point of view, an ironic sense of humor and a masterful talent for weaving facts into a compelling story.*

His weekly humor column, "Uncivil Liberties" first ran in The Nation *in 1978, and since 1986 has appeared as a nationally syndicated column in hundreds of papers. The fourth collection of these essays,* Enough's Enough, *was published in 1990. As the author of three books on American dining and two novels, Trillin's fields of writing are amazingly diverse—food, fiction and fact.*

In the winter of 1989, Brian Edwards joined Calvin Trillin at home, fresh from his one-man show at the American Place Theatre in New York. They spent a late afternoon talking about writing and the country Trillin has covered for over 25 years.

Brian Edwards: How important is that first paragraph, that first sentence, to your piece?

Trillin: In the first paragraph it seems to me you're pointing which way you're going to go. For instance, in one of my pieces, if I'm going to be in the piece, I'm in the first paragraph. If there's going to be an "I" anywhere, it's probably going to be in the first paragraph, maybe in the second paragraph, but not much past that. It seems to me kind

of jarring to be going along in a piece thinking it's in the third person and suddenly having an "I" jump up at you. You start to wonder, "Who in the hell is that?" So, it's the very basic question of whether the piece is in the third person or in the first person. The tone of the piece gets set very early. Or if it's not, then the piece is like one of those Hollywood movies that always seems to be four movies thrown into one. I do think it's very important. I do a draft, before what could be called the rough draft, which unfortunately is called, around here, the "vomit out." I started this when I used to do these pieces every three weeks for *The New Yorker*. Maybe I've always done that; I don't know. I only do it for non-fiction. I don't do it when I'm writing a column or fiction. What happens is that I get home and I have all these notes, maybe clippings, and documents and I just sit down and kind of write the story without looking at them the first day. I don't mean that I have any rule against looking at them; I just don't need to look at them. It starts out in English, kind of, but it degenerates fairly quickly. I've always lived in terror that somebody would see one of these "vomit outs." When I used to write more at *The New Yorker,* I was always imagining that the cleaning ladies would find one of these things and then read them to each other. And cackle: "He calls himself a writer!" The really good remarks would cause them to beat their brooms up against the desk like those hockey players do from the penalty box.

B.E.: Does this help?

Trillin: I'm not quite sure why I do it, except that I think it takes a kind of an inventory of what I have in my mind that I want to say. It shows me the direction I can't go. "Well that's not really going to work, that way." Or, "If I do that I won't be able to get in this and that." So, I think that even though I'm all for starting, I don't think there's any minimizing how important the beginning is. And some pieces more than others. In the one I just finished, I picked a place to start just because I wanted to write that right then. I believe in the Edna Buchanan story [*The New Yorker,* Feb. 17, 1986] the first sentence is something like, "There's some difference of opinion in the City Room about which of her leads is classic Edna." Well, to me that was the way of jumping on the story. It's already moving a little bit. Because already, by saying that, you imply a lot of things about her: that people think of her leads as either classic or not classic, that there's a kind of "Edna lead," that people talk about her. It also gave me a chance to

show some of her leads, which are some very distinctive and interesting parts of her writing. And to describe right away, a couple of things about that sort of writing that I would hope would interest people to go on further.

B.E.: I've noticed that you often write about writers — part of the story in particular — or you incorporate the local newspaper into your telling of the story.

Trillin: I think the local newspaper often may be a part of the story in the town. Either in the way the information gets to the people locally or the argument about what ought to be printed.

B.E.: I find it particularly captivating when you've started your piece with a discussion of the writer's own leads, as you did in the Edna profile. Your reader gets caught up in the problems of writing and publication from the start.

Trillin: I remember I did a piece once years ago on something called the Watts Towers in Los Angeles. This was before Watts was a known place, and it was almost literally unknown. It was before the Watts Riots, and Los Angeles was so big nobody had ever been there. So there wasn't much on the Watts Towers. It was just this kind of odd thing that some people had hear of and some people hadn't — you couldn't track that according to anyone's seeing a television piece on oddities or something like that. And so, the first sentence was something like: "If you do a piece of art and you don't label it 'art,' it causes all kinds of problems." I wasn't quite sure why I used that, but then I realized it was an attempt to put aside the question of art, whether this was art. We're just going to assume that. One guy who was kind of a masoner built it and then he abandoned it, producing a lot of arguments about it. So I think there are some kinds of lead sentences that have almost strategic reasons, tactical reasons. But I think the most important thing is the tone and the direction you're pointing in, the structure of the piece. You have to start somewhere and this is where you're going to start and that's where it's going to go.

B.E.: How much freedom does *The New Yorker* give you to do what you want? To write how you want to?

Trillin: I have to say, I differ in this a little bit because those pieces appear in *The New Yorker*. One of the odd advantages of *The New Yorker* is that it doesn't have headlines, drop headlines, cut captions under pictures; it doesn't have any pictures. It doesn't have a publisher's

letter saying: "See the rather interesting murder story on Emporia." You don't know there's going to be a murder when I start, and I don't have to tell you until I want to. That's not true if I worked on a newspaper, or *Life* magazine. There would be a picture of the minister's wife and it would say "Was her death an accident?" underneath it. That happened to be a sentence, when I did the piece, that I just wanted to get by very quickly. That she had died. At *The New Yorker,* because of the way the magazine is organized, you can tell stories at your own pace. You can reveal part of the story when you think is the best time to reveal it, which is a distinct advantage.

B.E.: It's just the words.

Trillin: And nobody else is going to give it away. Not the photo editor, not the layout guy, or the guy who pulls something out of the story and gives away the best line. That doesn't happen. It's just your words. You don't have any photographs to worry about. Some people would say, "Oh, that's a disadvantage." It gives me a tremendous advantage, particularly with the kind of story that I sometimes tell. And I don't think it's any coincidence that that sort of writing was invented at *The New Yorker.* "Invented" is a strong word; let's say "flourished" at *The New Yorker.*

B.E.: Why do you think that?

Trillin: If I had written that same story for a newspaper, some guy on the desk would say, "Wait a minute, you're saying here on the one hundred twenty-eighth graph that woman was probably killed? That's crazy. You've got to come up front with it." A lot of the features that are done for *The New Yorker,* if I did them for a newspaper, I'd have to justify my existence there. What am I doing there? Why is this national magazine at this labor dispute or this argument about a shopping center in a small town? I'd have to have some paragraph about either: "This is symptomatic of the dislocation of shopping centers in many communities across the country," or "Nobody can remember a situation dividing a place this much in such-in-such or so-many years." This is the equivalent in a newsmagazine of what we used to call a kind of "billboard" paragraph: the third paragraph of a cover story in *Time* or *Newsweek* — a back of the book cover story. If you have the Secretary of State on the cover you don't have to justify it; it's assumed that it's okay. But if you have, say, the conductor of the Cleveland Symphony, then you have to say in about the third paragraph: "Other conductors

make more money, other conductors have been at it longer, other conductors are more famous, but no conductor so symbolizes the new something-something that has come over America than this one."

In a way, the luxury I've had at *The New Yorker* is not having to claim that the pieces are anything other than what they are. That they're not a symbol of what's happening here or a typical situation of what's happening there. This is what happened in this place, period.

B.E.: Do you think by writing such large-scale pieces about ordinary Americans, you're producing a type of Andy Warhol "super-hero" portrait?

Trillin: I don't think of them as being either known or not known. And as it turns out, they don't get an awful lot better known by being written about by me anyway. People get well known in their communities if their hometown paper writes about them or if they're on *Sixty Minutes*. Not if they're in *The New Yorker*. That's not completely true across the board, but in general, it wouldn't make an awful lot of difference in people's lives whether I wrote about them or not. There are examples of people who because of the attention that maybe somebody else has done something, or somebody made a movie, but that's very rare. The other thing is that I've never been drawn to stories by either the importance or lack of importance of the people in whatever hierarchy existed in town.

There's a little bit of a tendency, which I think is gradually changing in American journalism, particularly newspapers, to judge your own importance by the importance of the people you've interviewed. This is a long tradition in American reporting, so that you're constantly seeing the memoirs of *The New York Times* bureau chiefs saying: "two senators, but seven presidents" or "he interviewed two hundred forty-eight chiefs-of-state of countries and was lied to by all of them." I don't think that magazines, particularly a magazine like *The New Yorker,* are as locked into that. But there definitely used to be a feeling at *Time,* and this is certainly true of big, national newspapers, that government and politics were "man's work." And the other stuff was "okay." So what I'm doing is a different sort of reporting.

B.E.: What you're writing seems a lot more timeless than political reporting.

Trillin: Well, it does seem to me that a lot of the stuff I've written I'm sure dates in the same way that a story on who's going to win the

senatorial race dates, in the sense that issues pass. What it seems to me more than that is that it's different every time: a different story; a different situation. In the fifteen years, I did pieces in *The New Yorker* every three weeks, I would be in Tennessee on a murder story; then three weeks later I'd be at a catfish festival; then three weeks later, I would be doing a story on some farmers in Iowa. For me it was just more fun *(Laughs)* than the other sort of political stories. Almost all reporters hate government and like politics. Because government is simply boring. I always thought that the dirty little truth of the whole thing was not that absolute power corrupts, but that government is boring. And local government is the most boring of all. But it's generally true. And that's why the names of cabinet secretaries after awhile just fade away during an administration, unless they get indicted or something like that. The naming of them engages reporters, because that's politics: who's going to get it, which faction is going to be satisfied. But once the guy is actually running the Department of Health and Human Services, that's the end of it. I mean nobody writes about that. That's why around this time in an administration, you start seeing stories about who's going to run next time. Otherwise, he's going to have to write about the Labor Department — and that's horrifying.

B.E.: And you avoid both?

Trillin: The difference with me is that I find both of them not particularly interesting. It's really a personal quirk rather than a philosophy. I don't like horse racing either. Not that I don't like it, but I never got interested in it. I suppose if I had, I wouldn't understand how people couldn't be interested in it. In politics, which is covered almost as completely as a horse race in America, they love talking about the same kind of material every two years. For political reporters, what people are like in a town in Iowa is important only to the extent of how it indicates the way they might vote. For me, the way they may have voted in some election is interesting only to the extent that it indicates what they're like. Because I'm often looking for some: "What sort of place is this?" So I get interested in it in this kind of backward way. I never care who wins. In however many of those pieces I wrote every three weeks for fifteen years, I probably wrote half a dozen stories about elections, maybe fewer than that. But I always wrote them after the election was over. So my record is perfect. I've never been wrong. I wait until the polls close.

B.E.: That's why I say the pieces are timeless. It doesn't matter who was president.

Trillin: Yes, that's usually true. I wrote a story once about a murder in West Chester, Pennsylvania. And it was right at the time—I don't remember the date of it—when people had become horrified by their children who they thought were either hippies or peaceniks or mad motorcyclists without haircuts and without any respect at all. The killing was of a guy off a roadhouse by a guy who summed up all these people for most. He was a kid at the local college, he was a biker, he was out on bail for having shot somebody else. And then, the chief of police said, "He is actually an undercover policeman, although recruited from being a biker and leading exactly the life as all this." That was really a time slot. People don't really think that way anymore about their kids. People have either resigned themselves to the situation *(Laughs)* or the situation has changed. That was in a kind of panic time. And everybody, I'm sure—as sure as you can be about how people really feel—that there was a tremendous feeling in that town that maybe everything wasn't as bad as it had seemed. I mean here was this boy—this slob of a biker, probably a dope addict—who had thrown off his greasy motorcycle jacket, and was then referred to as an honors student. Even though he himself made no claim *but* that he was anything but all of those things, when he was recruited by the police. Nobody was even claiming that he was this person who had taken on this role as an undercover man. And of course it turned out later that there were all kinds of problems. But what I'm saying is that the context of a story like that is often the place, but also often the times. I think they are often tied to the way people are feeling in that particular time and that particular place.

Arthur Miller
After the Canonization

Arthur Miller might not appreciate the titles of fame most often attributed to him—one-time husband of Marilyn Monroe and America's "intellectual" playwright. Though briefly married to Monroe in the late fifties and the author of some of America's most cerebral theater pieces, Miller prefers to see himself as merely a playwright tackling social issues of the times.

Born in Manhattan on October 17, 1915, Miller's family moved to Brooklyn during the Depression as a result of his father's economic losses. When he graduated from Abraham Lincoln High School in 1932, Miller's parents couldn't afford to send him to college. He worked for two years in an auto supply warehouse and earned enough money to go to the University of Michigan. Upon his graduation in 1938, Miller was briefly involved with the Federal Theater Project.

Though his first play, The Man Who Had All the Luck, *was not a great success, his second play,* All My Sons, *won the Critics' Circle Award in 1947. In 1949, he won the Critics' Circle Award a second time for his now classic,* Death of a Salesman. *Hailed as the first true American tragedy,* Death of a Salesman *explored the American dream and its ultimate delusion.*

In 1957, Miller was put on trial and found guilty for contempt of Congress because he wouldn't name writers who attended a Communist meeting in the forties. The sentence was later overturned, but Miller's play, The Crucible, *is one of the finest works produced in reaction to the McCarthy hearings. Among the many awards Miller has received for his plays are the Pulitzer Prize, and the Obie and Emmy Awards. In 1988, Miller published his autobiography,* Timebends.

Brian Edwards wrote to Arthur Miller, whom he describes as "canonized," asking for an interview in the spring of 1989. And yet, Miller's return letter consenting to the interview still shocked Edwards. "Most of us don't think of Arthur Miller as one of the living," he explained—an exclamation Miller himself has heard many times.

Underneath the bursar bill in my Yale Station box was a small gray envelope, my name and address typed faintly on the front. I turned the envelope over. Two words—"Arthur Miller"—starkly announced the sender, no return address. I immediately remembered the letter that had been sent to

me (and half a million other magazine subscribers) by "Jimmy Carter," who had generously given his name to a charity organization. But the signature on this gray stationery was from a real ballpoint. The brief letter seemed the queerest oddity, although I had written Miller to ask for an interview.

Most of us don't think of Arthur Miller as one of the living. Even he admitted in a 1980 interview that people often say to him, "Gee, I didn't know you were still alive!" It's hard to believe that anyone so canonized could still be alive; how many of us left high school without reading either *Death of a Salesman* or *The Crucible?* But Arthur Miller is not only just 74 years old, he also lives under 45 minutes away from New Haven.

Inescapably a dramatist, Miller was equally concise in his letter and over the phone. He wastes no words while still being very friendly and approachable. When I called, he answered, and with his distinctive Brooklyn accent conveyed only what needed to be said. I called to make an appointment for the next weekend. "Yeah, that ought to be fine. Call me next Friday. Same time."

Next Friday he was out. On Saturday at lunchtime, I called and stated my name. "Can't do it today," he responded after a five-second pause. "Maybe tomorrow. Call me tomorrow. Same time." The next afternoon at two, Miller decided after a pause, "Can you come over late this afternoon?" On my way.

Later, Miller apologized. He didn't mean to put me off, he said, but he had just finished filming a movie that same morning. Yes, Arthur Miller still writes. Though we associate him most readily with his great plays of the forties, fifties, and early sixties, Miller has produced and published new work into the late eighties. Most recently, his 600-page autobiography *Timebends* was released in 1987 and two short plays were published under the title *Danger: Memory!* in 1986.

We talk for a short while in Miller's small studio, just a dozen yards from his house. The beautiful hills of western Connecticut surround this peaceful room. As I entered the studio, a friend of Miller's was talking to him. As the friend left, Miller handed him the book about which they had been speaking, "Take this. You'll enjoy it," Miller said, "because he's honest."

Miller turns to me and asks, "What would you like to talk about?" We talk first about the stereotype of Arthur Miller as a strictly naturalist playwright. "They're one hundred and eighty degrees in the wrong direction about that," Miller responds. I point out a few plays that would seem to break the myth. "Any of the plays would ... It's interesting that the misunderstanding exists only in America."

We speak of the man with whom Miller is often grouped in college courses, Eugene O'Neill, not as a literary influence but as American precursor. Miller points out that O'Neill encountered the problem of presenting tragedy to an American audience, an audience that wants to be entertained in a happier mode. He attributes the paucity of O'Neill productions to this disinterest in viewing tragedy. The connection to his own work is implied.

Brian Edwards: And now we read O'Neill more than we see him. I read in an advertisement for the new Library of America edition of O'Neill's plays that "Eugene O'Neill wrote his plays to be read as well as seen."

Miller: He wanted the immortality, no doubt, that books could give. But I tend not to believe him. You do make more money selling the books. You see, when I started out, the only publisher I know of that published hardback copies of plays was Bennet Cerf [editor of Random House]. That's all changed. I don't know what made it happen. Maybe it was the proliferation in the fifties of courses — university and college courses — in the theater. When I went to college, the theater was not regarded as a form of literature, incredibly enough.

B.E.: How do you ignore Shakespeare?

Miller: Well, Shakespeare was Shakespeare. And you would read Ibsen. Maybe the plays of Chekhov. But that was it.

B.E.: In your introduction to the two-act version of *A View from the Bridge,* you state that you were much happier with the British production of the play than you were with the original New York production. You claim that the inability of the British actors to reproduce "the Brooklyn argot" enabled them to get away from naturalism, and closer to your meaning.

Miller: You see, the reason I was so happy with the British production of that play was — it was directed by Alan Ayckbourn who was a farceur. He had done dozens of play, comedy. Many of them farces. But he's very aware stylistically. Farce is an element of style. And so the play was given a production as though it were a. . . . Since they could not handle a Brooklyn accent, that route to naturalism was gone from the start. What you were left with was the spirit of the work. And the last fifteen minutes of that production were positively terrifying.

B.E.: Didn't you have a crowd on stage?

Miller: No, it wasn't a crowd. They had some. It was simply the attitude toward the work. That the whole world was falling down. You can get to that level of feeling by nitpicking acting. They had a grandeur in it that came out of their own classical training, because they are trained in classical theater. In the art. And it was breathtaking. Now, there will be another production of that play in New York in the next two years. I can't tell you who will be in it, but I'm hoping that the same sort of breadth will be there.

B.E.: You've stated that before writing *The Crucible* you realized that no writers had dealt with the period of McCarthyism. Do you often feel a responsibility to document the feelings of the particular time period in a play?

Miller: Well, there is a responsibility involved. But it's also that it's a tremendously interesting social phenomenon. When a society makes some kind of decision that it's going to abrogate the rules of civilization in relation to some part of its corpus, that's interesting. And what it reminded me of was the numerous times in history that that has happened. Not just the Communist and Nazi times in Russia and Germany, but in our own civilization. It's against that abrogation that all our major premises are set: the ten amendments to the Constitution. It's because whoever wrote those laws and rules knew — or that group of people knew — that there is a strong tendency toward anarchy in people. Especially when they're in a state of panic. Which, in my opinion, was the condition of McCarthyism. Brought on by very clever political maneuvers. Nevertheless, it was a moral panic.

B.E.: This sense of panic or anarchy seems to run under much of your work.

Miller: The feeling that civilization is pretty thin, yes. I think that's in everything I've ever written. That the violence is only a sliver, a thin piece away.

B.E.: You've said that you admire Harold Pinter among your contemporaries. There's an interesting relation between the way you both write. Pinter's economy of language strikes me as similar to the way you use language. You both create a unique environment with your dialogue. The language creates it own kind of world.

Miller: Right. I think that if you can't manage that somehow, the conciseness of the play doesn't exist. See, it's an illusion — which, of course, none of the critics are aware of — that good stage dialogue is somehow a mirror of ordinary speech. If it were, it would bore you to death. You cannot, you would not have space on stage to tell a story. Even the simplest of stories. But, look, this has been the trap that has sucked in writers as good as Henry James who couldn't understand why his plays didn't succeed. They're not dramatic works. And you can't explain it. As Louis Armstrong said when someone asked, "What is jazz?" He said, "If you have to ask me, you'll never know." *(Laughs)*

B.E.: J.L. Styan starts off an academic drama book by saying that dramatic conversation is not the same as ordinary conversation. Ordinary conversation is boring, repetitive, and doesn't advance the plot. But your dialogue does more than just concisely advance the plot. I feel that it's not just Brooklyn talk in your plays. Brooklyn talk put into the

dramatic mode. It's something very distinct. Not just the Brooklyn world, but your world.

Miller: Absolutely. Sure. You take any good play and try to tell its story in all its detail. That is, not only the events, but what is going on with the people as those events unroll. And just try to tell it in a narrative form. It would probably take five times as long as that play. The capacity of real dramatic dialogue to condense the feelings of the character speaking it, his knowledge while he is speaking it, the geographical spot on the earth on which he is standing, the time of the day, year, his age, what he's conveying to somebody else, what he's hiding from somebody else, etc., etc., etc. Dialogue is infinitely capable of this. Especially in English, which is a marvelous language for dialogue. But narrative dialogue — which is a perfectly respectable but totally different thing — has very many fewer burdens to carry because it's embedded in the prose which does most of the work.

B.E.: I like what you say about English. What in particular makes it so? Is it the ambiguity of English?

Miller: It's a very flexible tongue. We have a language which can express any class of person and still be contemporary. German, for example, has great difficulty with that. The French have more difficulty than we have: either it's complete *argot* or it's educated language. Our language is extremely flexible. And it's beautiful for that reason.

B.E.: Picking up on what you said about narrative prose, certainly a novel has to tell you everything about what's going on. But how important to the play is the plot? What makes the play "theatrical"? The playwright Thomas Babe says to get the premise of the plot out of the way before the end of the second page. He says that this way we can become involved with the people as the rest of the story unrolls. Is that not as true in novels, where the story may be more of the focus?

Miller: I tell you, the novel is such a varied form that it could be anything. I mean, you can get novels that do that. But there are novels also, like some of Steinbeck's shorter works or Bellow's shorter works that are constructed quite dramatically. They're not spread that way. I don't think that theatrical forms have quite as much liberty because they're bound by time much more than prose is. It's a dynamic form. We're sitting there watching it unravel. It's part of our own time scheme. Our watches are clicking away, ticking away as we're watching this. That isn't true when you're reading a book. Few books are read

from cover to cover in one sitting. The time element is separated. In other words, the reader's time and the book's time become quite different. In the theater, the audience's time becomes the play's time.

B.E.: You've got two hours.

Miller: That's right.

B.E.: I think you start off *After the Fall* by asking for two hours time. *Romeo and Juliet* starts that way too.

Miller: That play's going on in London next March with a great director. I hope to go over there and see that.

B.E.: Which?

Miller: *After the Fall*.

BE.: I thought you meant *Romeo and Juliet*.

Miller: Well, that's undoubtably going on there. *(Laughs)*

Robert Penn Warren
A Life of Writing

"A teacher is forced to clarify — or to try to clarify — his own mind on certain questions which are necessarily involved in the business of writing." So wrote Robert Penn Warren, the man who dared tackle the enormity of writing the definitive texts Understanding Poetry *and* Understanding Fiction. *The only person to have so well mastered the arts of fiction and poetry to win Pulitzer Prizes for both, he was well suited for the task. As a passionate teacher and pioneering critic, Warren brought to the job, not only his talent, but his love for instruction. Probably America's most adored contemporary poet, he became the first Poet Laureate in the U.S. in 1985. So giving and so gifted, he was well chosen.*

Born in Guthrie, Kentucky, in 1905, Warren often used the verdant rolling hills of his native state as the backdrop of his works. He entered Vanderbilt University to study electrical engineering in 1921, but literature soon layed siege to his mind. After graduating summa cum laude, Warren pursued graduate work at Berkeley and Yale before attending Oxford as a Rhodes Scholar.

For over 50 years, Warren devoted himself to the study and mastery of words, as writer, critic and teacher. The brilliant description and symbolism of his poetry established his reputation, while his novels, such as All the King's Men, *exploring greed and corruption won him thousands of readers.*

In June of 1989, Brian Edwards conducted probably one of the last interviews with Warren. Edwards wrote of visiting Warren: "I felt all the anxieties of a student meeting a great master. The first thing that struck me was how small he looked. The once-vigorous man was shrunken in his clothing, tiny and frail in the stuffed armchair. During all my phone conversations with his wife, I had developed an image of the dying poet in bed, unable to speak. Instead, Warren looked terrific to me. I told him so, and he said one word, in that quick speech of his: 'Survival.'"

Brian Edwards: It's a great thrill to be here because I've been reading your poetry —

Warren: Well, you're putting it very grandly. Have a see at the book there — [He points to *Complete Works of Thomas Hardy*]. Hardy's meaning more and more to me over the years.

B.E.: Why do you think?

Warren: I don't know. He's survived various tastes I've had. Changes. There's a sort of solidity about him, I guess.

B.E.: Do you think he's influenced you? In your later work?

Warren: I never think about that.

B.E.: I've always wanted to ask you what you thought of Harold Bloom's theory of poetic influence.

Warren: I'm very fond of him, a great admirer. I'm not sure what he means by the "anxiety of influence."

B.E.: Well, he mentions your precursor as T.S. Eliot.

Warren: Well, no, that's true. Eliot was a great influence on the whole world of his time, the generation just younger than he. He was certainly an influence on all sorts. Bad and good. The last person to realize something is often the one who's the most involved. You don't realize what your influences really are.

B.E.: Is "Red-Tail Hawk" representative of this struggle with poetic precursors?

Warren: I don't think that way. I just do them, that's all.

B.E.: Do you reread your poems?

Warren: Not very often, no. Sometimes I'll remember them, but I don't go around reading them.

B.E.: You've produced such an incredible amount of poetry. Was it a sort of need to do it?

Warren: Well, yes, if you want to call it "need." Desire. Impulse. "Impulse" is my word for it, not really a "need." Just a desire to do it. Simple as that.

B.E.: Was it difficult for you to balance teaching and writing?

Warren: It involved a bit of balance. One thing, I guess, was that I enjoyed the company of the students; they always had a freshness of ideas. It was great.

B.E.: I wonder what place criticism has for the writer. A lot of writers' criticism goes unrecognized. Yours certainly is. Do you tie it closely to your other writing or is it a different way of thinking?

Warren: I don't think about it.

B.E.: How do you feel about literary criticism in general?

Warren: It depends on who is doing it. There are good critics and bad critics; everyone's a critic in one way or another.

B.E.: The reviewer just happens to be published.

Warren: The reviewer takes his risks too.

B.E.: The better reviewer would.

Warren: He's another candidate to be judged.

B.E.: Does being educated in different theories take away from the study of literature itself?

Warren: I don't find so. To study the poem, it didn't bother me. As long as if there's a foolish thing about the poem, they say there is or vice versa.

B.E.: You haven't thought of your own criticism in a different way from your fiction or poetry?

Warren: No, they're about the same subject except in different ways.

B.E.: You've been writing poetry with a high stance long before becoming poet laureate.

Warren: Poetry was big for me from boyhood. My father scribbled at it, did his own scribbles long earlier, when he was younger than me. I came across them.

B.E.: He had never shown you them?

Warren: No. He decided that he didn't want to do anything about them. He didn't like them well enough, I guess.

B.E.: What did you think of them when you saw them?

Warren: It was very strange. I was very young. Suddenly I had a new feeling about him.

B.E.: Did you look at them again later?

Warren: Oh, a thousand years ago.

B.E.: What did that make you think about him? Was that a different feeling?

Warren: Another kind of kinship, trying to do the same thing.

B.E.: You think that's where it came from then?

Warren: I don't know how it was there; there was taste for it. My father read it to us, my mother read to us. At different stages of life, different kinds of poetry.

B.E.: Did your parents encourage you when you started writing yourself?

Warren: "Encourage" is not exactly the word. They assumed that was something you did.

B.E.: Returning to the idea of a poetic stance, you say it so beautifully in so many different places in your poetry, from recent work

147

to further back, when you speak of flying with the geese, of achieving this voice, speaking out, out loud or from a high spot, or rising with your voice. Is that the goal of your poetry, something you've been striving for?

Warren: I don't think of it that way; it just happens.

B.E.: Have you felt a development then, in your poetry?

Warren: In my poetry? You hope you've improved somewhere along the way. You have to quit sometimes.

B.E.: And have you quit?

Warren: Well, no.

B.E.: You're still writing?

Warren: Sure, off and on. *(Pause)* It's awfully hard now. Lately now, I don't know.

B.E.: Have you written since this *New and Selected Poems, 1923–1985?*

Warren: That's pretty late. Not many years ago. At my age, you see.

B.E.: In your essays called "Democracy and Poetry" you did a wonderful summary of American literature and your interpretation of the diminishing self and the need for poetry to instill a strong self. Is that fair to say?

Warren: I guess so.

B.E.: Then rereading some of your poetry, the essays helped me to understand, and with your novels too. My parents were born the same year *All the King's Men* was published.

Warren: *(Long laugh)*

B.E.: When you say that the poet needs to give us an idea of the strong self to help us separate ourselves from an idea of a mass mentality I compare Whitman, who certainly had ideas of a democratic poetry, and says the poet is the "equable man," the "complete lover."

Warren: He has a lot of balls, too. He talked a lot of balls.

B.E.: He took that stance, "What I assume, you shall assume." Is that similar?

Warren: I don't know. He didn't talk gospel all the time.

B.E.: But Whitman certainly wrote a strong self. Do you find yourself in a tradition with him and Emerson?

Warren: There are many traditions. I must say they aren't my favorite poets. I can't visit them.

B.E.: Harold Bloom, who loves to sum things up, says that Emerson is inescapable for the American writer.

Warren: You can argue that. I just don't think that way.

B.E.: What I get from your poetry is the idea of a strong self, its own entity.

Warren: I think that it's obivous that there's always a self-discovery involved.

B.E.: Reading poetry or writing it?

Warren: Both, if it's really read. Not just jabber.

B.E.: Do you feel you've left anything unwritten?

Warren: Oh, yeah. Thousands of things you wish you could have written, you didn't write.

B.E.: Just ideas?

Warren: Not ideas. You haven't written all the poems you really wanted to write. You just didn't get at them somehow. You don't even know what they were.

B.E.: Do you feel that? How do you know?

Warren: You just wish they were better, that's all. For example, it would be a very odd book if it couldn't be better.

B.E.: Would you get at them by changing them or writing new ones?

Warren: That's a good question. I could look inside that book for awhile and see things I wish I'd done differently. Practical things. Specific things.

B.E.: Words or lines?

Warren: Words or lines or images. That just didn't pan out for me, didn't show what I wanted them to.

B.E.: Are you happy with the amount you've written?

Warren: It's not a matter of happy; it's there. Same thing as being happy with yourself, happy with this, that, or the other. You can't just say I'm happy or unhappy. You just accept it.

B.E.: It's part of the world?

Warren: It just exists with you and there it is.

B.E.: Does each poem stand by itself or do they all need to be together? How do you feel about the single poem, by itself?

Warren: Let me put it this way. There are years of poems. Now, on the way, you have written individual poems. And you see somewhere along the way if they relate to each other, they are related. There's

a certain kind of self-consciousness. It's a form of growth, I guess, in a way.

B.E.: Do you feel that different periods of writing go together?

Warren: Yes, but sometimes they're at loggerheads too, I suppose. There are different impulses. Conflict of theme or interest in there somewhere.

B.E.: Do you like music, because when I read your poetry it's musical in a way. I have to read it aloud because it sounds so beautiful.

Warren: Thank God!

B.E.: But it's so rhythmic, it's a type of word-music. That's why I'm surprised.

Warren: The family had no musical sense; it must have come from all the reading aloud in the fmaily.

B.E.: It sounds like the impulses for your writing came very early.

Warren: It's hard to know. My early childhood was spent all alone a lot. Not with a lot of children. I was with my grandfather a lot, a veteran of the Civil War. I read a lot of history and heard a lot from him.

B.E.: So you think that was an initial impulse?

Warren: It was important to me.

B.E.: Do you have suggestions or prophecies of what needs to be done by the American poet?

Warren: Well no, I'm not a big advice giver. Poetry has survived us this long, for both bad and good.

Spalding Gray

Writing the Spoken, Speaking the Written

Spalding Gray is a raconteur and reporter, an actor and author, a theatrical experimenter and a therapist all in one. And sometimes, as in his movie Swimming to Cambodia, *all at once.*

Gray was born in Barrington, Rhode Island, in 1941. His parents raised him and his three brothers as Christian Scientists, and he recalls that they "had to work very hard in order to keep a hot line to God." After graduating from a boarding school in Maine, Gray attended Emerson College, where he discovered his passion for the stage. He went to New York in 1967, and began working in the theater. After his work in two experimental theater groups, the Performance Studio and the Wooster Group, Gray turned to monologues as his preferred form of creative expression.

His monologues simultaneously grapple with Gray's most intimate insecurities and the 20th century's most daunting dilemmas. Critics have faulted them for their incoherency and lauded them for their urgency and honesty. A set of six are included in his book, Sex and Death to the Age 14. *His experience acting in the movie* The Killing Fields *spawned, not only a new monologue, but also a movie and a book—all called* Swimming to Cambodia. *Gray published his first novel,* Impossible Vacation, *in the summer of 1990.*

When Gita Panjabi was preparing questions in anticipation of her interview with Spalding Gray, people teased her. They said, "Questions? You're preparing questions to prompt a monologist? You're wasting your time." They were partially right.

The following interview contains only fragments of the original transcript as Gray and Panjabi spent close to two hours "monologuing" in his apartment in New York.

Stories seem to fly to me and stick. They are always out there, coming in. We exist in a fabric of personal stories. All culture, all civilization is an artful web, a human puzzle, a colorful quilt patched together to lay over raw indifferent nature. So I never wonder whether, if a tree falls in the forest, will anyone hear it. Rather who will tell about it? —From the preface to *Sex and Death to the Age 14.*

151

Gita Panjabi: How do you choose the material that will appear in your monologues? What strikes you in particular when you sort through events?

Gray: That's hard. That's where the work is. Because if everything is grist for the mill, well, that's the old story: you either live a life or you tell it. You have to do a little of both to have stories to tell. And I find that I can keep a basic notebook and see patterns in the puzzle of my life. And those patterns are expressed in the form of personal stories.

What I do after an intense period—being in *The Killing Fields* was an intense period, so that already had its frames—is that I look back with an angle. With my new monologue, it's based on the interruptions in the novel I'm working on. Usually I start with what's driving me nuts. Because my monologues are always about coping, so the angle of interruptions is good. And I put the most interesting interruptions together, weaving in and out when I test them in front of the audience. Next I'd like to do a monologue about taxes in Washington. Or something like power spots in America. You know, political power spots versus so-called psychic power spots like Sodona, or Santa Fe. The interests are obsessional. They come on me in dreams. I can tell what I'm interested in by the books I pick up. And I can tell what I'm interested in by the stories I'm always testing out on friends in social situations.

G.P.: You'll just sit down with someone at a party and start telling her this story?

Gray: I can usually tell what's going to be a good story by the way people react to it in a social situation. Also, I'll work with phrasing and punch lines with people, to get the story right.

G.P.: So there the boundary between your life and your fiction is pretty tenuous.

Gray: It's completely fuzzed, interconnected. You know, it started out as a therapeutic form. I was first aware of the therapy of form when I was living with Elizabeth LeCompte in nineteen sixty-eight in New York. I was collecting unemployment, thirty-two dollars a week. There were four of us living in this little apartment on the Lower East Side, on Sixth Street and Avenue D. Two women in two bunks, and then Liz and I slept on a mattress we'd picked up on Tenth Street. I can't believe it. So, I would just walk the streets of New York. And I would come back, blown away by New York City. The way I

would cope with it would be to tell the story of my day. Not that we would sit in a circle, but while I was cooking chicken hearts I would rave about it. Luckily they were an excellent audience. They got a kick out of it. And I still do it. That's my way of coping — writing and speaking about an event. That's my way of making sense of it. I think this is common for every writer. I am very, very obsessive and neurotic and on-edge if I don't do some kind of writing every day, even if it's just a letter. You see?

G.P.: Yeah, I know what you mean. It's important to write, to have order...

Gray: It's ordering, yes. It's Wallace Stevens, you know: "Oh! Blessed rage for order." That's from my favorite poem — "The Idea of Order at Key West."

G.P.: So you cooked chicken hearts and monologued for the people you lived with in nineteen sixty-eight. Was this when you first discovered the monologue form?

Gray: Well, yes. The impulse was there when I first came to New York in nineteen sixty-seven. At the time, Joyce Aaron was doing a free, open theater workshop that I would go to. We would do an exercise where you would recollect an event in your life, like, tracing an average day in your week. If you got hung up, you were supposed to jam on it — "And I saw the guy and he had a knife, and he had the knife, and he had the knife" — until you came through to the next image. And I stood up and did a day in my life and didn't block once. At the end of it, Joyce Aaron asked me who wrote the monologue for me, meaning that I memorized it. I respected her enormously and was bowled over by this. But it never occurred to me at the time that it could be an art form. For a number of reasons.

One, I was very young, so there wasn't a whole history to draw on. I needed distance on myself as a character. Two, there was an enormous influence then of Artaud and Gertowsky in experimental theater, in which we were breaking down text, fragmenting text, and working with our bodies. So, it was really a grunt and groan period where a linear text was frowned upon. I finally joined that movement with Richard Schechner and the Performance group in nineteen seventy. I began working as an actor-slash-performer, which is what I thought I wanted to do. I had no concept of myself as author, because I had never written before, and I associated authorship with the written word.

When I went to Emerson College, I was completely oral-aural, just mouth and ears. I didn't read my Shakespeare in college; I took it out of the library on records and listened.

So, I was working with Richard Schechner, and things lead to things. I can remember when we were doing *Mother Courage,* probably it was nineteen seventy-three or -four, and there was a period of time when we weren't rehearsing, when Elizabeth LeCompte and I just started fooling around in the space with some of the people in the group. This evolved into the Wooster Group, which we founded and which did three very important plays.

G.P.: What were they called?

Gray: *Three Places in Rhode Island.* The first one was in nineteen seventy-five, that was called *Sakonnet Point.* I don't know if you've read my research on this, but it's certainly very available, so I want to skip the details, and say what's important about it.

G.P.: Of course. I can look it up.

Gray: The trilogy, *Three Places in Rhode Island,* was autobiographical, but all the pieces were very abstract. I concretized them by naming them after actual places in Rhode Island. The metaphor I see in this trilogy that's important for me is the metaphor of Pinocchio. Geppetto's workshop was originally Richard Schechner's Performing Garage. I came in as a dummy. Like many young, unconscious actors are, I came in, not with a strong sense of myself, but with a desire to be an actor. And then I found out, that really, you have to be a human being first. It was an enormous task, and I had neglected that. And Richard Schechner became the Geppetto, putting us through lots of psycho-physical exercise and encounter groups, to try to make us learn how to make the play out of ourselves. So he began to bring me into life. Then, working with Elizabeth LeCompte in *Three Places in Rhode Island* when we formed the Wooster Group, was coming into consciousness of the real, live boy. It started with *Sakonnet Point,* which was a dumb show—all movement. It was like the child; like recollections of childhood—lots of mood music, lights changing, laundry on the line, running in a bathing suit in hunting boots, Tchaikovsky's Piano Concerto Number One playing incessantly, over and over in a red tent.

The next piece, *Rumstick Road,* was based on a series of tapes I did with my family ten years after my mother's suicide to try to get a

many-faceted view of why different people thought she killed herself. Using those tapes, we improvised a theater piece that was the four of us reacting to the tapes, in a personal, surreal way. It was like a docudrama, or like a dreamscape with actual tapes as background. In that piece, I stepped forward and said to the audience, "I'm Spalding Gray. And this is my life." It was the first piece where I took the identity. It was very big. And I had light on my chest so that my face was covered. It was like what they do on a TV show where the person is trying to remain anonymous, and not be identified.

The third piece, *Nayatt School,* was an incredible artistic mourning for my mother, because I was in Mexico when she died and they couldn't reach me. So that was a great working-through for me. I took T.S. Eliot's *The Cocktail Party* as a metaphor for the articulation of insanity. So I used the idealized fantasy of Celia Coplestone as an image, especially her most important lines, when she comes to her psychiatrist and says, "I hope you can find something wrong with me, because if there isn't, then there's something wrong with the world. And that would be terrible, because that would be incurable."

We did a cut-up using *The Cocktail Party.* The audience was fifteen feet up, on bleachers, with a long, long thirty-foot long table in front of them. I was as close to the front of the audience as I am to you. The cast was sitting on either side of me; it was like the Last Supper. I played a crazy kind of schoolteacher-scientist that was doing an analysis of *The Cocktail Party,* which was being acted out by children below us. I was playing a combination of me, and a character that we were making up. Now, here's where the monologue form was seen for the first time.

I would open by—I had the *The Cocktail Party* on record, on old 78s—and I would open by talking about the play, and playing sections that I loved from it. While trying to condense the play, I would also tell stories. I'd digress and tell a story about a production we did in Albany, where we played it for a nunnery.

G.P.: So you incorporated a real-life story into an acting performance.

Gray: Yes. I would do it like that, adding personal stories that I had. And the Wooster Group would act as my audience. They would come in with a tape-recorder everyday and say, "Sit down, and tell that again. You know, tell those stories again." I'd say, "But you don't want

to hear them again." "Yes! We really like it." They were the first encouraging audience.

When we finished that piece, I felt that I had come to an end of working. I'd completed an artistic mourning for my mother. And somewhere inside of me — although I was unaware of it at the time — my deepest influence was Thomas Wolfe, with those sprawling, giant American autobiographic, confessional novels I read in boarding school. So, I knew I had to cut out from the Wooster Group; I had to do something very radical.

G.P.: Tell about the very first monologue. What was the process you used to create it?

Gray: I wrote only an outline, using key words to order my memory.

G.P.: So you had thought about what you were going to say before the first performance?

Gray: Yeah, I had sat down and written an outline, which is the way I do all my monologues. I imagined things and then made a structure. The way that I've always worked is that I use my memory, and the way that I remember as structure. Because, you see, it has to be connected to my memory and the way I think. It lives on my breath. I started with this idea when I decided to tell my stories instead of write them, which was in nineteen seventy-eight at University of Santa Cruz.

I was sitting in on a class called "Philosophy of Emotions" given by Amelie Rorty, who now teaches at Harvard. She could see I was a real primitive. I would sit in and ask these really naïve questions. We became friends and we used to go for walks around the campus and I told her that civilization as we know it was coming to an end. I didn't realize this at the time that that was an egocentric predicament. Because the group and all I'd known was coming to an end, I was equating that with the entire world.

I said, "I don't know what to do next." I'd been mulling this over, but she triggered it. She said, "You know, if you really feel like things are coming to an end, like they were in Rome . . . you should know the last artists in Rome were the chroniclers. They chronicled the decline and the fall." Bells went off inside of me. And I said right then, in the Santa Cruz hills, I am going to chronicle my life. Orally. Because to write it down would be in bad faith. It would, first of all, assume there

was going to be a future. And furthermore, I have nothing against pottery and books, but we have enough objects; I cannot bear the clutter. And I thought, this will live only on my breath. I had this really romantic idea that it would be an epitaph — at the end of each evening, I would complete myself. If there was another chance to do it the next night, I would.

So the first night, the monologue was maybe forty minutes long. And I tape-recorded it, and when I listened back and I went, "Oh! *(Snaps his fingers)* Just like psychoanalysis! Connection, connection, connection!" New outline: fifty minutes. Next night: sixty. New outline. Connection, connection, connection: hour-twenty. Suddenly, there's a full arc, all built in front of an audience, so that every night is a re-write, but not a rewrite. It's a wonderful paradox.

G.P.: In the introduction to *Swimming to Cambodia* [the book], Leverita talks about you being an epic chronicler, using an old form which asserts itself in a new way. What do you think about claims like that?

Gray: I love to hear them. They're rather academic to me, because I'm unaware of it. People are always trying to pin me down: "Oh, you must have had wonderful storytellers in your family..." No one told stories! It's a reaction to New England repression. I'm a Freudian, and I think that it has to do with this terrific need to — not sweep it under the rug — but to get it out. I mean, when I did *Rumstick Road* in Rhode Island, people were very shocked, because my mother's obituary included nothing about suicide. There were rumors she had died of cancer; no one ever knew. What happened to her? She vanished! The image I had of it when my father first told me was: I said, "How's Mom?" and he said, "She's gone." And I had this image of a dandelion being blown in the wind. It was a need to fill in my history and find out who I was, and to exist through storytelling. It was a therapeutic need that turned into an art form. I was able to do both. I was very, very lucky to be able to combine both. Therapists have told me this: "You've done a wonderful job compensating with what you had to work with."

G.P.: You've talked about your monologues being therapeutic for yourself, and this being a kind of important reworking. How do you see their role in affecting other people? Or don't you think about that?

Gray: I don't think about it when I'm composing something. Then

I think about myself. But then I hear feedback from people and I'm always curious. One thing that happens is that they begin to see clearly how interesting their personal history is. The monologues undercut what I consider the corporate star-system in America. Instead, they make for a kind of idiosyncratic creative gossip network...

G.P.: Wait! I have no idea what you mean.

Gray: Let me give you an example. It unifies a certain strata of Americans — the audience that comes to see me — by talking about immediate history. They begin to think about their lives. They think less about who Johnny Carson or David Letterman is going to have on that night and find that listening to each other talk is much more interesting. So they talk to one another. Stories feeding stories. Networking. When I say "creative gossip," I'm being frivolous, but also, I mean that. Stories that turn you on, entertain and give information.

G.P.: So, what's important about the relationship between you and the audience?

Gray: What's important is the recognition that I'm a fairly average man, and I try to stay that way. My new monologue is a little like *Eight and a Half* or *Stardust Memories,* in which I try to deal with this thing of fame, where people are always trying to kick you upstairs, and turn you into an image, inaccessible and above the audience. I'm trying to keep the balance, so that I'm speaking from that everyman position, and people can relate to me. I think that monologues are a form that is so ingrained in us, so basic to all of us, that all you have to do is shine a light on it. And you see it and you say, *(In a whisper)* "Oh, yes! All right! Yes, I understand that."

One of the most structurally interesting monologues I ever did was an audience participation piece, called "India and After (America)." All the stories were about a particularly turbulent time in my life in nineteen seventy-six when I was touring India with the Performance group and had a nervous breakdown coming back. It was reverse culture shock, or culture shock, which is reversed. I thought you were supposed to have it in the culture you're in, but it's when you come back to your culture after six months in India [that you have it]. It's unbelievable. I was grappling with that material, but it was too linear because I was too close to it. I wanted it fragmented, so it would be a metaphor for the nervous breakdown.

So, I had a time-keeper, who sat there with a dictionary. I had a

series of eight stories that had to be completed. They were still fragments, you see. She had a bell on the desk, and she'd open the dictionary — I chose a dictionary because at that time I was trying to increase my vocabulary. She'd supposedly choose the first word she came to. She would say the word, say, "albatross" — "a large bird that you hang around your neck." Thirty seconds. And I would take one of the six stories and use the first image which was provoked by the word "albatross." Without trying to illustrate it, I'd begin telling the story. When the bell rang, I would have to cut off the story. It was incredible. I had six stories in my head and she was giving me between fifteen seconds and seven minutes. Sometimes she'd cut me off at the most climatic parts and the whole audience would go, "Aw..." And when I picked it up again, they'd clap. While at certain times I'd be silent because nothing came. And at the end, the time-keeper read the words. That's a real meditation, because the words are so linked to the stories. It's like working with the I Ching. No one in the audience ever believed it was random...

G.P.: But that's incredible, because not only are you reliving the experiences of the breakdown, but also the process you had to go through to create it.

Gray: Yes. It creates the story in the room. I've never published it, because it was unpublishable. So I'm using it as a central piece in my novel. Now I'm far enough away from it to write it in a linear way. The book is called *Impossible Vacation* and it's about the way I — this particular character in the book — creates his own hells out of ... guilt, perhaps. It's an exploration of New England guilt. Creating the hells before they can catch up with him. Seeking the perfect moment.

G.P.: How did you decide to start writing the book, and not remain contented doing monologues?

Gray: Because I was tricked into it! I was offered a contract. When I first came to New York, in nineteen sixty, and I was nineteen, and I was visiting a friend of mine from boarding school. His father took us up to the top of the Riverside Cathedral. I had been reading all of Thomas Wolfe's books and I made a secret pledge to myself — I am coming to New York to be a writer. That was before the acting impulse. I never dreamed Knopf would offer me a hard-cover contract. I thought, God, that's like wanting to climb Mount Everest all your life and suddenly, you've got the pack horse going up it. I had to do it. I had

no idea how I was going to do it. I wrote it longhand, the entire thing. I've got an arthritic bunion; I can't write anymore.

The whole book is about a character who, when he has eyes on him — he does modeling for a life-drawing class — feels that much more alive. While writing, I felt myself disappearing, because of no audience. It was a terrifying experience. I had what you'd call writer's block about a year ago January and I had to go into therapy in Los Angeles. I was going three times a week, two hours a session to a psychoanalyst. I needed him as a witness, because I thought I was dying. I got too close to the story I was writing, about the fear of death. With an audience I can say almost anything.

G.P.: Why do you think that is?

Gray: I'm trying to come to that in my story, actually, without pop-psychologizing it. I think it has to do with Freud's theory of ineffectual mirroring. I don't want to incorporate psychology directly into my work. Instead I find a story that illustrates it. If someone asks me what I think of something, I usually tell them a story. That's my bottom line. That's how I think. I don't think abstractly, although I read abstract things, like philosophy. Right now I'm reading *The Philosophy of Sex* by Sartre. I am stimulated by not being able to read it. The great writers like Kundera do both. I really admire them, with that postmodern structure I didn't have room for in my book. I thought of saying, "Now wait a minute, here I am, and I'm going to tell you the real story starting now. This is just fiction, because I'm so insecure. What I really want to tell you is what happened." Raymond Carver came to that point in his poetry, and I think it's a wonderful quote above one of his poems in the new collection. It's by Robert Lowell — "Why not tell what really happened?" And this is what I always ask.

G.P.: I think this raises the question of fictional worlds, or realities. Do you feel the need to create a unique and consuming world in your book?

Gray: Sure. There are sections that I've read that are that. And it works when the writing's there. I have to be more descriptive, more literary, because my hands and face aren't there. That's the big task. I'm not there to illustrate it with my voice. I desperately want to read it out loud, but Renée [Shafransky] won't let me do it you. I will know what works and what doesn't just by having forty witnesses. They would be my editor.

G.P.: Right, but wouldn't you be influencing them by the way you read it?

Gray: Yes, I would hypnotize them and sell it to them; you're right.

G.P.: But what happens to the reader, then?

Gray: That's why I can't do it. I have to resist it. But I'm just craving to do it. But you're right; it has to live on the page now and that's not my métier. I'm going to try anyway. I'm half-way up the mountain, and I can't go back now.

G.P.: How long do you see yourself doing this?

Gray: I see it as an endless touchstone that I am going back to. Basically, it's my little neurotic touchstone. They want it by January. I work on one page in pencil for fifteen or twenty minutes, and I look at all the other pages, and I think: this is an analogue for my neuroses, the way I work on this book. And I think, maybe I'll never finish. *(Laughs)* It's that old thing again.

You have to stop your life to do it. The book — and you well know this — only takes on a reality when you've stopped the other reality, so that the book comes out of that emptiness. If your life is interesting, or cluttered — in most cases more cluttered than interesting — there's literally no gap for the gestalt to happen.

G.P.: But with your monologues, it's exactly the opposite. Were there the gap, there would be less material, or less impetus.

Gray: Right, right. The monologue is always happening; there's no end to it as long as I exist. It's always framing existence. I would like to think that I could chronicle my death through some medium. If anything terrifies me about death it's that I'll have to stop talking. But maybe I'll have exhausted myself by then.

Here's one last story, for what it's worth. I taught a workshop at Rheinbeck, New York, this summer, and before I went, Renée said, "Why do you want to go to that New Age place?" But it was incredible. I held workshops, and I was swept away by the pure form of the person speaking, saying, "This is what happened." You see, this is why I do "Interviewing the Audience," because it's a neutral place where you can talk about anything. You're not talking about stopping the bomb; you're not talking about AIDS; it's not a barroom where you're trying to pick someone up. You're just telling a story.

Toni Morrison
Sounding Language's Depths

Toni Morrison's characters soar through the air; they inhabit this world and the next; they laugh orchestrally; they cry heroicly; and Morrison misses them dearly when she finishes writing her books. They live so fully in her books and in her life because of the dominion she grants them. She maps out her novels, such as Song of Solomon *and* Sula, *in her mind first, and then, when she intimately knows the people and places, she sits down to write "impulsively."*

Born in Lorain, Ohio, in 1931, Toni Morrison received her B.A. from Howard University and an M.A. from Cornell. She once described her first foray into fiction as a "dirty habit." In the early sixties, during a period of great loneliness, she began The Bluest Eye *with "a brutal sense of irony, melancholy and a trembling respect for words." For over 20 years, she has also worked as an editor at Random House where she is "developing a canon of black work."*

Using a magic realism, which combines mythology with political critique, Morrison's novels brilliantly explore black women's experience. Critics and readers alike exult in the novels' innovative characterizations, poetic prose and depth of emotion. "I guess it's like going under water for me, the danger," Morrison has said of her writing. "Yet I'm certain I'm going to come up."

Brian Edwards spoke to Toni Morrison during her visit to Yale as a Chubb fellow in the winter of 1990. She meditates on issues of imagination and creativity especially as they relate to her latest novel, the Pulitzer Prize winner Beloved. *Of the interview Edwards wrote: "She speaks relatively free of gesticulation, the tone of her voice and its rolling volume punctuate and frame the way hands might. Her speech ebbs and flows, now with an intimacy, now with the great force of language's potential."*

Brian Edwards: I'd like to start out by asking how you name your characters, when you do that, if you find it particularly difficult?

Morrison: I sometimes know their names immediately. They sort of arrive with their names intact. Sometimes they don't. Sometimes one needs a character to explicate some idea, or to represent, or to par-

ticipate in some kind of event. And you can function sometimes with them nameless, and then you sort of supermarket-shop for a name. But what I have discovered is that if you don't choose wisely, you don't get much from the character. It's almost as though you have to introduce yourself. You really have to know somebody's name, even though they're just imagined characters. There's a feeling of satisfaction when you have chosen one. You feel as though you have access to the character, and therefore they will tell you things, reveal things, or make it possible for you to realize them.

B.E.: You've chosen some memorable names, and it's remarkable what you have done with the naming process. For example, how "crawling-already? baby" becomes the name of the child.

Morrison: Well, I am obsessive about it, I suppose, because among African-Americans the naming process is a little bit more fraught than an immigrant coming in and sort of liking one name. Saying, "Now, I want to be known as 'Cook'" or something and, "I don't want to be known as something-ich." That's one thing. That's, sort of, choice when you decide what your name is. You were not named back then [during slavery]. So having been named, it is an important thing to name yourself. Think of how much of the name comes from nicknames and some personal names that we get from some intimate gesture or some flaw, you know, like most nicknames are. And there are nicknames, as we say "personal" names, among all cultures. It's not something exclusive, but it just has additional weight for African-Americans because of the effort to separate all of them from their families. We [Morrison's literature class at Princeton] were looking this morning at something written by Poe, and accompanying [a character] was a man "called" Jupiter — that name is something in itself. But "called" in that sentence meaning literally — it isn't the point where he calls himself: *Je m'appelle* — because it is the business of branding, naming another. So you're taken out of your own context. So I guess in a funny way, one does get extraordinary names. You think of black musicians from the early part of this century with some incredible names: "Leadbelly," and so on. But for me the process of naming characters, I am aware of that. So not only am I interested as a writer in having the character have a name that I feel is the right name, it's also a question of reflecting events, this multiplicity of choices. And how if Baby Suggs has a funny name — a kind of discrediting, degrading name — in fact, it's a process

of choice. It's a way in which she identifies with the past; her husband used to call her "Baby"; his name was "Suggs." So what's written on the bill of sale is of no interest to her.

B.E.: She's surprised, isn't she, to see "Jenny" written on her bill of sale?

Morrison: Right. "Why do you keep calling me 'Jenny'?" Because that's not her real name. She didn't give it to herself; her mother didn't give it to her. You know, if I just start calling you "Ramone" from now on, you might not relate to that. That would be my choice as your owner. I could call you anything I want. I could call you "Two." So that's what they're resisting. And if I sell you—I put down "Ramone" and I sell you off—either at your age or much younger, you might say, "Okay, that's what I'm called."

B.E.: That makes me wonder about Sixo who stops speaking English because he says there's no future in it. And those characters who stop listening after a certain point or a certain word. I guess this moves away from language and includes being taught certain other things, like how Sixo doesn't want to be taught the arithmetic.

Morrison: Right. He's making these sort of—oh, what—not academic, but all those decisions. The language, English, betrays him. What people say to him they don't mean or they don't explain it. There's that interchange between himself and the master about stealing. Where he killed the little pig and ate it. He didn't say that, but he was trying to. So the whole system doesn't make any sense, in that the language cannot explain it. The language cannot explain it. We know that it can, ourselves, because of the work of Faulkner. I mean, all we see is how the language cannot deal with this repressed, hidden thing, but that's part of what he's saying in his manner. I mean, that would be the connection for me. In addition, he [Sixo] has a language, which only he speaks. His name Sixo, may have been given to him in jest, but he appropriates it. As he dies, he shouts "Seven-0!" That's another attempt to appropriate the language, and inscribe your own life instead of being written upon. And so when he says English has no future, I always thought that was very funny, not only because of the future tense business (*Laughs*); because there literally is no future in it for him. But then Halle, of course, is the entrepreneur. He's interested in reading and learning, and working extra and buying people out. He's very organized that way. He knows how to handle slavery. And had life gone on the

way it was with Mr. Garner, he would have done that. But the interesting thing about the institution was how whimsical it was. I mean, it looks like a solid institution with laws and things, and it did, but you just change masters or change anything, go thirty miles in any direction and it's a whole different ballgame. So all of this thinking it through, the way in which it was possible [the escape plan] with a fairly benign master, just didn't work [once schoolteacher took over]. All of a sudden: "What does he mean 'part-time labor,' 'extra labor'?" It doesn't mean anything if you were wholly owned.

B.E.: So in a sense, Halle's response, which comes through language that's being appropriated on him, is wrong. And Sixo, who avoids language, is right on?

Morrison: Yes. Sixo's right. He knew about the betrayal. Halle was alone among those men. They didn't want to learn to read because they didn't really trust the reading thing, they didn't trust the language. But also they thought, as many oral cultures do, that if you have to write something down, it's because you're stupid; you can't remember it. That really intelligent people can remember. You know, they come from this long line of Creoles, and so on, not knowing that there are a lot of things wrong with not being able to read a recorded text. But Halle understands how valuable that is. There's a phrase in there: "He learned to count on paper." And he is disappointed, destroyed. They both are destroyed as a matter of fact, but they both have children. So there's this question of what is reliable. That's just the indeterminate part, the feeling that one has about paper and language. On the other hand, I don't want to glorify and romanticize Sixo's attitude toward it, but it was, for those circumstances, right on the money.

B.E.: Let me bring in the passage at the end of the book, when the women from the community search for "the right combination, the key, the code, the sound that broke the back of words." Isn't that tough to do in a book when you're writing with words? Don't you feel the tension?

Morrison: Oh, indeed. That's part of the danger of writing at all. Which is what one likes. The danger of having this English, which is a wonderful, rich language. It's got so many possibilities. And at the same time you're moving into an area that is ineffable, in a sense. For this sort of oral culture, the language is so tonal. It means so much about what it sounds like rather than what it says. Vocabulary is not

all that important. It's how you say the words. You say "uh huh," and "uh uh," for "yes" and "no"; you can say them in a variety of ways. You can say them to mean just the opposite. Say "uh huh" and now mean "no" instead of "yes." So when you play constantly on the sound, it's musical in that sense. And there are other languages that are equally tonal when the information is like a score. Language is really like a score for many Africans. And so the way in which English was handled by early African-Americans . . . So when you have that, you are always tipping over the edge anyway. So I set myself up some obstacles by trying not to use adverbs to describe speech which forces me to craft the speech in a certain way so that I hope the reader can hear it. Although when I read it [aloud], everybody says: "I didn't hear that." I get something out of it.

B.E.: Are you saying that we are losing something by leaving behind an oral culture?

Morrison: I want the book to work silently for any reader who doesn't hear anything. But I think for the reader that can hear it, it has an additional accessibility.

B.E.: Are you influenced in this by listening to music?

Morrison: I think some of the texts are informed by a quality of sometimes spirituals, sometimes blues. More blues than not, because of that period, though I don't listen to it while I work; I don't have anything in mind. I invent songs when I want them in the book. Like when I make up the song for Paul D. based on his recent experience. Or in *Song of Solomon,* I invented that. Although what I was hearing in that song was a song that we used to sing in my own family. I was hearing that music, but just changing the words.

B.E.: Like in *Beloved,* when Beloved hums the song?

Morrison: And she [Sethe] says, "Oh I know that." Well, she thinks that, but that song could have come from anywhere.

B.E.: You said in an interview a couple of years back — one of those which compressed everything you had said during it into one page — you said that "Art is not an Anacin."

Morrison: It was sort of a negative thing. I meant, you don't read the book, like when you look at television, and then you feel good afterwards. And say, "Oh great! Now I don't have to bother with this event, or this epoch, or this kind of person." You know, you go to see a play about AIDS, you weep and you cry and then it's done; then you can go

home and go to bed. That's what I meant. Art isn't an Anacin. You don't do art and then the headache is gone. That's what I was trying to say.

B.E.: That's a lot more encouraging than with the stress on the word "art."

Morrison: Yeah, right. I'm saying it's serious. I'm saying it's complicated. I'm saying it's haunting, and it lasts.

B.E.: That's what they get by compressing their whole interview into one page.

Morrison: Yes. *(Laughs)*

B.E.: Which brings us to the crux of the tragedy of *Beloved,* the killing of the baby Beloved by Sethe. That's certainly not an Anacin.

Morrison: No, it's not. *(Laughs)*

B.E.: Was that as painful for you to write as it was for everyone to read?

Morrison: Yes. It was as painful for me to write as it was for everyone to read. And the only reason one does it is because she did it. And it was more painful for her. So it is sort of self-regarding of me, since all I had to do was to imagine it. She had to do it, you know, being an historical situation. But the pain comes in trying to project oneself into that position and the feeling of those characters. Secretly see. So that you can do justice to them. It has nothing to do with approval. I just want to do justice and bear accurate witness to something like that. So that you have to put yourself in that place, and that is someplace I'm not willing to go. Or if I do go, I certainly am not willing to stay there, but being the writer requires you to stay there and see that universe for years and years. So it's exhausting, that pain. So I'm not interested in your pain, really, because it lasted only as long as it took you to read it. For me, it was longer. Say four or five years. For her, it was something else. So it's a sort of hierarchy of pain. Anacin to Advil.

It's just that the material is explosive. So that what you try to do is to defang it in a certain way so that it's not overwhelming. But at the same time manage it so you can feed your reader: spoon feed him so that he can taste and really relish and swallow this material. Otherwise, particularly with something like slavery, it's so overwhelming that you lose the book, the art can't deal with it. It's like suppose I were writing about the Trail of Tears, or some aspect of the Holocaust, it moves in such ways—so that what you have to do is to assert some kind of control or authority or sovereignty. That's what's problematic.

B.E.: Other writers have spoken of a feeling of loss of company when they finished a book. You've said that this book was different for you once you had finished it. How?

Morrison: Well, it didn't end. I did. Which I did deliberately because I had something else in mind. You have to get rid of it, otherwise you'll write the book all over again. So you have to stop it. The characters would just like to never go away.

B.E.: Faulkner did it again with *Absalom, Absalom!*

Morrison: That's right, maybe I'll do it again. You know, I've had certain patterns that reemerge in books that obviously have been finished with. But I know how greedy characters in situations are, doing something. You cannot give them full reign because they can't write books. I write this book. You have to shut them up or move them away or cut them down. They'll take all of it because each one is convinced that his or her story is the real one. Except the art is the person who stands aside and puts them together. So some of the characters from *Beloved* are surfacing in the book I'm writing now. I will decide.

B.E.: Faulkner said that after a while he realized that it wasn't each individual work but his work as a whole that mattered. A unity between them all. Do you feel that?

Morrison: I think he's right. Some you do very well, some you don't do so well. And if you're permitted a career—writers aren't because they're supposed to hit it out of the ballpark each time; I don't know, maybe composers. It's like when you paint, every one is not a hit. You're thinking about changing, going through transformations, trying something new, putting it out there. You're not thinking of the galleries, so to speak. So that, for me, to have done five novels or six, or what have you, and that they sort of could work as a body would be wonderful. That's not the way one thinks of it while one is doing it. It's sort of hindsight. And he was realizing that he had carved out some universe all for himself. Except for *A Fable,* he pretty much stayed in that little world he had created, that country.

B.E.: And, retrospectively, he was so surprised at what he had done. When you look back at you work—?

Morrison: Yes. I can't believe I did it. *(Pause)* I just can't.

Sue Miller

Re-exploring the Territory of the Home

In her novels The Good Mother *and* Family Pictures, *Sue Miller has reclaimed the domain of the home from the 19th-century novel. In* Family Pictures, *she constructs the story of a home, of a family, in a collage of the multifarious perspectives and experiences of the different members of the Eberhardt family. The vanishing point at which these various perspectives converge is situated in the strange and almost magical figure of Randall, the autistic child of Lainey and David.*

Born in 1943, Miller grew up in Chicago, where her father taught Church History at the University of Chicago. At 17, she moved to Cambridge, Massachusetts, to attend Radcliffe College, where she earned her B.A. in English. For many years, she wrote while working at such varied jobs as modeling, waitressing and doing psychology research, and earning master's degrees in education, English and teaching. In 1979 Boston University awarded her a writing fellowship, which launched her career as a teacher and writer.

Polly LaBarre met Sue Miller at the Quiet Bar in Cambridge. She had just arrived from a counselling session with budding novelists in the third grade of the Chelsea school system: "We were talking about writer's block, which I guess they all suffer from."

Polly LaBarre: Do *you* suffer from writer's block?

Miller: I don't really think so. I'm slow, and I have periods of time when I'm not ready to write, but it seems a part of writing to sometimes have to *think* about it for a while. I do have long periods where I'm not writing, but I don't think of that as being blocked as opposed to people who are always writing.

P.L.: Do you have a routine or regimen to get yourself started with your writing?

Miller: No, I just make notes.

P.L.: At least two different reviews set your most recent book, *Family Pictures,* up against the classic American adventure of Huck

Finn's "lighting out for the territories." In your novels and stories, the "great adventure" of life seems to take place in the home, in the family. Is this the new territory of the American novel? How do home and family inform and inspire your writing?

Miller: Well, it certainly does seem to be *my territory*. I may, at some point, also light out for new territory myself. But the next book that I'm thinking about is also set in a domestic—more or less domestic—situation. But this is hardly new territory. It seems to me that the novel as a form really was a domestic artifact initially. It really had to do with manners and life at home. It was only more recently, especially in America, that it has become something other than that. I mean, there always was a picaresque novel and the novel of the voyage, but the great nineteenth-century novels are all about home.

P.L.: That's true...

Miller: I think there was a great turn away from that, particularly in American fiction, as it became dominated by men, it seems to me, from the time of the first World War. Someone like Updike, for instance, has always written domestic novels, and there are a lot of others we can think of, but there was a certain kind of interest in the novel of adventure that grew out of the nineteenth-century American novel and was picked up by people like Hemingway. There's a whole kind of tradition that's very male. But I think it's primarily an *American* tradition.

P.L.: There seemed to be a real adventure as well as a novelistic one...

Miller: Yes, and I think there's a kind of sense, or has been a sense for American writers that the domestic novel is the work of "pansies" or women, or something like that, but anyway, not something serious, male, like Bellow or Mailer. It's interesting to read those Cheever journals, to read of his despair, writing as domestically as he does, at reading Bellow, and thinking. "This guy writes with a scale, and with a sense of epic. I don't. I'm so little. I'm so small." I think that there's been too much of that feeling, that this is a better way to write than that, and not enough feeling that the domestic novel can also talk about all our lives.

P.L.: I agree, I don't think the home in your work is simply the hearth, the classic nurturing interior and insular setting ... I liken it to the version of the home of Freud—who is an important presence in

170

Family Pictures, and actually it is the kitchen where Freud appears in different forms — to Freud's version of the home and the whole idea of the uncanny, the *un-heimlich:* that really what's strange and what is terrifying to people is actually found in what is familiar and what is around you. And I think that informs the novel, that there is scale, profound emotions, deep love and deep alienation...

Miller: Well, I certainly wanted it to contain the universe as my generation grew up with it, to reflect the choices and the particular kinds of parents we had, and the sets of beliefs. It seems to me that people my age, or even younger, had very much a sense of a kind of moral commitment or a feeling of religion that somehow wasn't successfully passed on to us. So that we get the discomfort about certain things without the rationale, the deeply embraced rationale, for feeling that discomfort. And we have also the prevalence of Freudian thought which, in a way, sets itself up as opposite to that. It talks about cure and health, particularly in our culture — although that's far from what Freud intended, but that's the way it's gotten translated, essentially. At one point, I wanted to call the novel *Perfection,* and really saw it as a discussion of the degree to which perfection is possible, the degree to which one compromises and lives with the less than perfect, the degree to which one is *embracing* the less than perfect in embracing suffering.

P.L.: That seems to be what the family is all about, that it is "less than perfect," and the site of real suffering. And, actually, it is the *telling* of the story from the various perspectives that seems to create the scope of the novel. How do you shift between these points of view, how do you write these different, often male, perspectives?

Miller: Just by imagining a very specific person. I think that leap is a less enormous one in our universe than it was thirty or forty years ago. I think women really share much more of "men's" lives; sexually, their experiences are not so dissimilar; professionally, their experiences are not so dissimilar. They live, in some ways, lives that make them understand much more the male experience. But it was harder for me to imagine the specific sort of frame of mind of someone like David, the father in the book, in terms of sexual roles of that time; his unquestioning feeling of male superiority. But nonetheless, I wanted very much that sense that it was simply understood that women were a little bit like children. It was the male role to provide guidance, help in making important decisions. And I did, in fact, find wonderful examples of

that in first-person accounts I read in doing my research by parents of kids who were mentally damaged. I found a couple written by men in that period, and their tone towards their wives, even wives they respected enormously, is finally one of protection, confidence that their wives are incapable of making certain kinds of decisions. They feel that it is truly their responsibility and their *burden* to take that over. Not that they are pushing their wives aside; it is what they owe to the marriage, what they are responsible for — being decisive, taking control, making the decisions. That was the harder leap for me to make imaginatively, the leap to that time, that way of thinking. I really was helped a lot by the reading.

P.L.: That seems to be illustrated in David's [the father and psychoanalyst] journal in *Family Pictures.*

Miller: Yes, that was really the most direct expression of it — that there was no question in his mind that he was right. And he also felt very much the sense that he ought to have done a better job of controlling her [his wife] in some ways.

P.L.: Yet there are several small victories over that, you use the word "victory" several times in the novel, over the psychoanalytic authority, over David, the father. I think of Lainey's [the mother] "kitchen therapy" with Randall [her autistic son], or when Nina says "my little victory over all those Freudian processes" in describing her art, her photos. It seems that throughout the novel this feeling-oriented, usually classified "female" emotion, is prevalent, seems to be very important.

Miller: Yes, to a degree. I think, for instance, Nina is enormously helped by therapy, and I think that Lainey is — well, in my own way of thinking, it may have been a mistake to keep Randall at home. It certainly was very damaging for Mack, he was really hurt in a permanent sense, and I meant for that to happen, I was very conscious of that. I very much feel that the psychologically-based blaming of the mother in those situations was terrible; and that judgement was meant to be there. It was really a terrible mistake that the psychiatric community made at a certain period, and not one for which they have ever truly acknowledged responsibility, Bettleheim in particular. But I did also want there to be some validity to that perspective. For instance, when David says that Lainey really wasn't able to live on a more *human* scale. I think that's true. And I think in a way she really needed to enlarge everything,

that she was a person *meant* for the disaster that befell her. She rose to it in a certain way, but in a way that was difficult for everyone around her. I meant the argument to be very open, that neither perspective fully worked.

P.L.: How does that help you resolve these issues? Does it lead you to confusion or clarity?

Miller: I don't think that it's confusion to say there's not an answer. I suppose in a certain sense, to imagine ways in which that impossibility is depicted makes me more willing to accept the ambiguity of everything. It seems to me that's one service that fiction performs: to honor the ambiguity in life and to make people work hard before they embrace the great certainties. I think most programmatic answers to human dilemmas or emotional situations are inadequate.

P.L.: What about the autistic child, Randall, and the power of his figure in the novel? It's interesting that someone who never utters a word, who is completely insular and disconnected, really, from the people around him, does have so much pull and power. He speaks to the members of his family and colors the way they think about themselves and the way they each configure and compose their own pictures of the family. How did you see his role in these "pictures"?

Miller: Well, he's the presence which is absent and the figure who lives by some sort of grace alone. He really can do nothing for himself; he has a kind of life utterly determined and dictated by the response of other people. It seems to me a situation in which that response is finally . . . that the kind of answer that people give is very important and really defines them. He [Randall] seemed to me to be a fictional opportunity to push people to the corners that they might not ever go back into otherwise, but that were there behind them all the time. And then once the parents have been pushed, the children make decisions about which idea of human life they owe their allegiance to.

P.L.: You seem to travel that path in terms of Lainey's collage of pictures — her versions of Freud and the two pictures of the Annunciation — and the final picture puzzle that Nina constructs and deciphers. That would seem to represent the journey from a mother feeding some version of the world to her child to Nina figuring it out, interpreting it for herself.

Miller: Yes. But I think Nina's own recognition is that anyone else would have made some other final reading, that hers is only hers.

P.L.: And the pictures in the novel tell us about the family, but they also seem to be the family's way of telling. Nina at one point says that none of the typical photos of a wedding or a party could be really good pictures, but that the stolen pictures, those taken at secret moments, of sorrow, of pain, or of feelings that people normally hide were the important pictures. *Those* seem to be the pictures that you present in *Family Pictures.*

Miller: Yes, I was always trying to take a family scene and then just turn it slightly to show something that lay under one of the characters or another that was challenging or difficult or even excruciating. I tried for a kind of density of detail — exposing really, how it all works, but at the same time showing what lies under. That was very difficult for me. Sometimes I pushed too hard. Actually my husband helped me cut about one hundred pages from the final manuscript. Even so, some critics said that the weight of detail was just too much, that the book couldn't stand up under it. One of my reviews compared the book to *Moby Dick* in its density of detail. And I think of all that information. Of course it may seem excessive to someone not interested in whaling. But I did want that sense of the warp and weave, that texture to be present. I wanted to show how this family worked, I wanted the book to feel *weighted* by that.

P.L.: I definitely got a sense of that texture. I think if the opening of the book, where Nina presents the picture of Mack's birthday party and says, "this is the way I remember it. But I'm wrong." After reading the novel, I see how much that phrase informs it, that Nina's picture isn't "wrong," but a perspective that forms her overall picture of the family. When you speak of the family you speak of "freedom," a freedom that some of the children achieve very easily, and that Nina achieves in telling the story. How do you equate stepping away from the family with freedom?

Miller: Well, in Western culture anyway, it's the essential step. Particularly in our culture — oh, all this language we have: the "dysfunctional family," the need to "resolve" one's childhood, these various kinds of therapies. It seems to me that particularly in a family like this that there simply wasn't enough to go around. I think there is a sense in which it's harder to move on, it's harder to really resolve the feeling that "I didn't get enough," under those circumstances. But that's the way it is. I wanted it to be Nina's conscious account of making that

decison—that what is given is given, that is all you have. And that is somehow the way it will be for her with the child that she is willing now to have, no matter who it may be. It's that risk of having a child, it's the obverse anyway of the risk of being born.

P.L.: Mothers are persistent figures in your work, the voice of the mother recurs in your novels and short stories in different ways. Someone like Anna in *The Good Mother* who dreams of and explores the idea of passion and finally isn't able to reconcile it with her role as a mother which seems to come first, to take over, at the expense of that passion that is involved with sexuality and a certain kind of drama; or the mother in the story *Inventing the Abbots* who summarizes her existence with the phrase, "in the end, a pinched life"; and, then someone like Lainey who incorporates all that passion and drama in her life as a mother, in fact as a mother, her sexuality blossoms, coincides with the birth of her children.... Are these compatible visions of motherhood, or are they mutually exclusive?

Miller: I don't think they're mutually exclusive. I felt in a way that *The Good Mother* was misserved by the promotional blurbs that accompanied it: "A woman forced to choose between maternity and..." I mean, I didn't really see the book that way at all and I don't see that choice as a necessary choice at all either. In fact, if you read a lot of female psychology, there are innumerable accounts of women who don't really feel sexually alive until after they have had children. Although, the simple demands of raising young children often mean you don't have a lot of energy, or simply, a lot of time for that life. But I think raising that issue is a mis-reading of my work. I felt I posed a particular situation for Anna. I don't feel that I was shaking my finger at female readers and saying, "If you're not a very austere single parent, you're going to be in big trouble"; or that you can't have it both ways.

P.L.: Right, although the difficulties of trying to raise a child as a single mother while embarking on new relationships seems to endlessly complicate that role. And, there is a double standard—Brian [Anna's husband] does not suffer in this situation, while Anna suffers for her new life, her risk-taking. You mention these risks often, you characterized that family as constituted by a "reckless courage" and a "loving carelessness." That seems apt in this situation where there is no clear choice...

Miller: Yes, when one is pregnant, there's this tremendous sort of wild card possibility, you just don't know, you just don't know who this child will be. An autistic child is one extreme, but there are all kinds of other ... you just have to make room for another human being who comes with a certain personality, a certain temperament, although you have some control over that development. There is something terribly exciting about family life. There is the emergence of a new person whose life comes back at you, whom you never can escape from ever again as a parent. It's most terrifying and at the same time quite magical. I mean, I do think it is the "great adventure," the *greatest* adventure we embark on.

P.L.: And that's how you end *Family Pictures*—the daughter's version of her parents' great adventure. That seems very hopeful, the child finally *comprehending* the life of the parents...

Miller: Right. Although to me it seemed implicit that Nina imagined the whole book. But for her to imagine that moment of her parents' is to give them a real gift. I meant Nina's being able to see them as young and happy, and wildly excited by the very thing that in the end pulled them apart, as her understanding of *all of it*—that they could have had that moment, that they *ought* to have had it.

P.L.: You mentioned the publicity for *The Good Mother,* what's your reaction to the film version?

Miller: I didn't see the film version. I sold it to them because I wanted them to give me the money they gave me so I could go on and write. I think very few writers want to see a film version of their work. I feel very *uninterested,* finally. The people who made the film were very pleasant to me and civil and so forth, and I have no bad words to say about that. But I think that the history of film translations of books is very bad indeed.

P.L.: I think it's necessarily reductive, to say the least.

Miller: Yes, and they've often been, beyond that, ludicrous. My understanding was that this was not a ludicrous film. But I think the history of writers who get involved in the film versions of their books is very sad. And it was a conscious choice on my part to say, "I sold it to you and thanks for the money...."

P.L.: So, it doesn't seem like screenwriting is an option for you...

Miller: It isn't, no. It's a whole different technique. It might be something I'd be interested in doing from scratch. But it would be very

difficult to imagine taking a book that you cared enormously about and reducing it. And it is *reducing*. And then knowing that even beyond that, when you handed it over to someone else, it would turn into a collaborative effort.

P.L.: It seems that a translation of a *novel* in particular, because of its scope, to film is bound to be difficult.

Miller: It seems to me they should work from short stories...

P.L.: Is it hard for you to put your pen down and have done with these people, are you finished with them?

Miller: Yes, I am. This book was very hard for me to write, so there was a certain sense of relief to have finished it in a way. There was an excitement in working with them and in feeling their reality. That's one of the pleasures in writing for a writer like me whose work is so oriented towards characters. My aim is really to make you believe these people lived and to make you enter their lives in one way or another. There are a lot of ways in which I'm a very old-fashioned kind of writer. The result of that for me is that I get very involved in the life of the book, and walk around thinking about what they could say, might say: "Oh, no, no, no. He would do *this*..." And really, during the time I'm working on a book, I'm living in that world, or can just step over very easily into it. But I was very tired of them also. And there's a lot of anxiety that maybe these people won't be interesting, that's always at work too. And almost as soon as I was finished, I began to venture into another situation. It's not like having children where you have one and then you have another and you still love the first one. Instead, you have one and as soon as you begin to have another, you sort of forget about the earlier one.

Wendy Wasserstein
Different Textures to Different Lives

Wendy Wasserstein has written three major plays that have been per-
formed on and off Broadway in New York. Her first, Uncommon Women, *was*
written in 1977 while Wasserstein was at the Yale School of Drama. Uncom-
mon Women *consists of an all female cast of characters, all struggling to define*
their identities as women in era when new choices abound. Wasserstein got the
idea for Uncommon Women *with an original image of an "all female curtain*
call" that illuminated her imagination. In 1983 she wrote Isn't It Romantic,
which centered around two recent Harvard grads, Janie Blumberg and Harriet
Cornwall, a struggling Jewish artist with nosy parents and a WASP business
executive, respectively. Both are looking to "have it all"—jobs, husbands,
families, personal success.

Wasserstein centers her plays around women and their choices, an issue
that reaches full fruition in her most recent play, The Heidi Chronicles. *When*
The Heidi Chronicles *won the Tony Award for "Best Play" in 1989, Wasser-*
stein became the first woman to take home the theater community's most
prestigious prize. She is thus also the only woman of a small handful of
playwrights to win both the Tony and the Pulitzer Prize for writing, at the same
time.

Benjamin Feldman met Wasserstein in her cozy New York apartment in
the spring of 1989. Wasserstein served herbal tea and seemed eager to talk.
Feldman found her reflections upon her generation especially insightful. Her
colorful wit seemed to flow without effort or intention.

"Even during the hour I spent with her," said Feldman, "friends—
members of what Wasserstein calls her generation's version of the family—
would call her and Wendy would make plans to get together, promising to
bring Ginger, her cat. At one point she picked Ginger up and announced,
'Ginger and I always call together.'"

Benjamin Feldman: Tell me about how you got into playwrighting. All I know is that you were at Mount Holyoke when you started, and you were a senior...

Wasserstein: No, it was my junior year and I was studying to be a congressional intern ... but I kept falling asleep on the Congressional

Digest in the Mount Holyoke library, and finally my friend Ruth said to me "Why are you killing yourself like this, when you could be taking playwrighting [classes] at Smith and then we can go shopping [there were better stores near Smith]!" So she sort of said the magic word. So I first took playwrighting my junior year at Smith College. And it was the first time I realized that you could get credit in life for something that you liked to do.

B.F.: Now, did you think of writing plays before that?

Wasserstein: I grew up in New York. I grew up going to the June Taylor Dancing School . . . which was the home of the Jackie Gleason Dancers . . . and my mom's a dancer, and we used to go to Broadway shows . . . so I always loved the theater — much more than movies. And when I was in high school I used to write something called the "Mother Daughter Fashion Show" . . . and the reason why I wrote the shows was because they let me out of gym to do it. But I never thought I'd grow up to be a writer; I thought I'd be a lawyer. Because you know, especially with girls, you didn't turn to your parents and say, "You know what I really want to do is write Off Broadway plays."

B.F.: You mean it was more common to say you'd be a lawyer?

Wasserstein: Well, from my background it was. I was from a Jewish family in New York. I was graduated from school in seventy-one so it was just at that cusp of the women's movement which was changing our ideas — I mean my folks sent me to Holyoke because there was that old saying that "Smith is to bed and Holyoke is to wed" and, well, they wanted me to wed. But then, when the changes started to come in, instead of having a teacher's degree under your belt you could now have a lawyer's degree under your belt, and still marry well . . . and work part-time and have your children. I credit the women's movement for a lot. Perhaps even for my becoming a playwright. You know, it's funny, I had an interviewer here the other day who asked me if I went to Yale because I thought I'd meet a husband or find a mate —

B.F.: To the Yale drama school, you mean?

Wasserstein: Yes, well, just to Yale University — when I was twenty-three — and she asked me if that was on my mind and I said no, really, what was on my mind was becoming a person. To give myself a sense of self was very important to me . . . and I think a lot of the women of my generation felt that, in terms of finding a sense of self — that had a lot to do with the work of the women's movement.

B.F.: So you were taking the class in your junior year—

Wasserstein: Yes ... and the teacher was very supportive of my work, and he said to me, "Look, maybe you should think about the Yale School of Drama."

B.F.: What kind of plays did you write that junior year?

Wasserstein: I wrote one called *You Bet Your Life,* about the draft, and the lottery when everyone found out that their number was called ... and because I was at Amherst at the time [Wasserstein spent a year of college at Amherst], which was predominantly a boy's school, everyone was screaming about their lottery number. Then, senior year, I took an independent project to write a play about my mother.

B.F.: That's what my play's about.

Wasserstein: Yes, well, mothers are great; mothers will feed you for life. But anyway, I wasn't really a theater person; theater people were, you know, the girls had long, Pre-Raphaelite hair and thin fingers; they were very artistic looking—I was never artistic looking. You know, I wasn't a girl about whom someone would say, "Oh, she's very artsy, she wears the shawls and the sandals and the silver earrings." This was never me. I never thought of myself as artsy. If anything I thought, "Oh, I'll get out of school and write for the 'Mary Tyler Moore Show.'" But then I started acting, doing plays. Then I went to New York. My friends (from the acting community at school) and I all did odd jobs; I took inventory for the board of higher education. I measured desks. We all took writing classes at City College with Israel Horowitz.

B.F.: Are you also writing a play at this point?

Wasserstein: Yes, I wrote a play called *Any Women Can't* for the class. And what happened was my mother ran into this woman named Louise Roberts on the street, who was the receptionist for the June Taylor School for Dance, and Louise said, "What's Wendy doing?" and my mother started hyperventilating and said, "Wendy! She isn't a lawyer, she isn't married to a lawyer, and now she's writing plays!" and this woman, to make my mother stop screaming at her, said, "Give me Wendy's play because I [now] run the dancing school that's across the hall from the theater school at Playwrights Horizons [New York's top Off Broadway Theater]. . ." And my second year of writing school, when I was taking those writing classes, I applied to the Yale School of Drama and Columbia Business School.

B.F.: To both?

Wasserstein: Yes, and I don't know how (I got into both)—I got about a four hundred on that business school thing—but I'm sure I was the only girl who applied that year who wrote that she wanted to be a playwright.

B.F.: That's funny that you applied to both—

Wasserstein: Oh yeah—

B.F.: It's like something from one of your plays.

Wasserstein: Yeah, so ... I was amazed that I got into Yale, just amazed. I submitted *Any Woman Can't* (for my application). And *Any Woman Can't*—I mean the first scene is all these men following a woman around screaming, *(Makes a kissing sound)* "Hiya Honey! Hiya Honey!" Hahaha! The first scenes are sort of really dark!

B.F.: Uh huh.

Wasserstein: It's funny because Chris Durang remembers coming across that script—he worked in the registrar's office at Yale and he said to himself, "Who is this woman?"

B.F.: He was already at the drama school—

Wasserstein: Yes. And he said, "This play—who is this?" And I took my pictures at a Woolworth's for twenty five cents and I was wearing this T-shirt and dark eyes—this terrible looking picture—he said I looked like Patti Smith. And then this sort of rolling girl showed up, he was just shocked.

B.F.: So you were only two years out of school and then you went right back.

Wasserstein: Yeah. But you know ... I think when you get out of school is a very confusing time because you don't know what's going to happen to you and when your friends are going off to become doctors and lawyers, they're on a path, and you feel especially from places like Yale and stuff that there's this path and you should stay on it. It's harder to start a life outside of graduate school. I know people who at twenty-seven come up with ideas for TV shows and make millions of dollars by the time they're twenty-eight. One of the reasons that I think I didn't wind up to be a television writer was when I got out of college I went to California for a summer—I went to Long Beach State to a dance program—and I thought I'd stay in L.A. and then I'd land a job in television. But then, I just didn't—I don't drive. I grew up in New York, and I just didn't like California. . . . The theater is more native to me,

that's all ... but TV is ... dialogue and character, which is what I can do ... I don't understand how people can sort of grow up to write certain things and not certain things.

B.F.: TV always seems like a good option (for a writer) ... especially if you want to survive...

Wasserstein: Well, not only if you want to survive but if you want to impact forty million people, I mean if you want to change the image of women...

B.F.: But TV seems like politically it wouldn't accommodate many ... much change.

Wasserstein: Well, it's masked, though. You know, I always think it's like it's Melita Drip [coffee makers] like the same ideas but they're filtered down...

B.F.: O.K. So you got into the Yale drama school, and then you wrote *Uncommon Women* there.

Wasserstein: Well, yeah, I was there a few years; I didn't just walk in and start writing. You know that was a very difficult time. I was there when Chris Durang was there and Albert Innaurato and Meryl [Streep] and Sigourney [Weaver]...

B.F.: What a crowd!

Wasserstein: It was a hard time because you know you had so many talented people ... I felt like I was in a Jiffy Popper that never popped because you have all these talented people and you don't know what's going to become of you ... it's a three-year program, and the people from the law school come out and have a job and you don't know! You have no idea what's going to happen to you.

B.F.: You and Christopher Durang ... It must have been such a funny...

Wasserstein: He's a wonderful man. I mean I owe a great deal to Christopher. Chris was my best friend there. He always thought I was very funny. He made me feel like I belonged somewhere. I mean he was the first person I met who I thought, "I see; I want to be in his company." While I admired those women at Mount Holyoke who were so curious and hard working and smart, I wasn't them, and so, Christopher, there was something about him — his intelligence and his brightness — I never tired of his company. We'd go to dinner at the dining halls — What's the college across from the drama school on York Street?

B.F.: ...Branford

Wasserstein: We used to go to Branford dining room and sit there for hours and tell each other stories about our families. And my mother Lola has stories to tell. That was wonderful, and we watched a lot of television. And we used to stay in New Haven over the summers because—I think I was in a period of defining myself and also feeling embarrassed about myself. I had a lot of conflicting feelings. That's really why I wrote *Uncommon Women.*

B.F.: What were the conflicting feelings?

Wasserstein: I think because ... I didn't know how good I was, I didn't know what would happen ... I didn't feel I was ... I just didn't know ... I felt I had my foot half in theater and then half was this nice girl from New York who should be marrying a lawyer. And that was hard for me.

B.F.: You didn't ever think, "God, I think I'm good"?

Wasserstein: I always thought I was funny. I don't know. I don't know how good I thought I was.

B.F.: How do you go about writing? What do you do? Do you get a vision, or...

Wasserstein: I tend to handwrite in a notebook. And I go to libraries a lot. Because my phone rings all the time. Also if I'm home alone, I'll write for two minutes then I'll get up and make a phone call, I'll eat something, I'll walk around, I mean, I'm just terrible. I love libraries. All the other people are working there so I work too. I'm very familiar at Yale with the um ... the new library...

B.F.: C.C.L.?

Wasserstein: C.C.L. Where they have all the films of Katherine Hepburn, and the "Films of Lana Turner" section. I used to go there all the time! At Amherst they used to have the "best plays" section. I used to sit there for hours looking through the best plays.

B.F.: But what gives you the idea, I mean—

Wasserstein: Ideas for plays come to me ... they tend to be ideas I've been thinking about for a long time. Something that's been on my mind.

B.F.: With *Heidi Chronicles,* what is it you were thinking about for a long time?

Wasserstein: I wrote the first scene of *The Heidi Chronicles* in nineteen eighty-two, eighty-three. I wrote it before I went and rewrote *Isn't It Romantic.* I wanted to write something about the women's movement.

B.F.: That's what was on your mind, the women's movement?

Wasserstein: Kind of yeah ... the issue of sadness ... and then writing about the two men just interested me ... I didn't want to write just about the women's movement.

B.F.: Well, were you sad?

Wasserstein: I have a tendency towards melancholia. Anyone who's funny has a tendency towards melancholia.

B.F.: Are these two men men you know?

Wasserstein: Amalgamations of men I know.

B.F.: The homosexual friend, Pete, is such a sympathetic yet unsyrupy portyal of a homosexual.

Wasserstein: That came out of a lot of friendships that I have, and a lot of true feelings of love that I have. Also a friend of mine got sick, as I was writing this play ... and that really affected the writing.

B.F.: Is it fair to say that with him you were trying to make a connection between the women's movement and the gay right's movement?

Wasserstein: No, I was just trying to make connections between the generation, you know, because there would be this land sweep for Bush, you know, and I would wonder, "How is this happening?" I try to connect a lot of things. Rita says that in *Uncommon Women* when she's trying to make a connection between past and present. My major was history. And it's interesting that Heidi's an art historian ... Heidi remembers everything ... I always try to make some connection between the "wait a minute you said this yesterday, so how can you say this today?" Then there's other people who just say what they say! Move on and say it!

B.F.: Art ... [Heidi is an art historian/professor] is a big thematic strain in *The Heidi Chronicles* — the progression of the representation of women in art ... were you trying to make a connection between the representation of women in art and the women's movement in general —

Wasserstein: It's interesting how you write plays because you often don't write them as a critic would approach them. Interestingly enough, *The Heidi Chronicles* follows the structure of the Book *Heidi*, which I didn't even know! Well, I started out writing about an art historian because we read this book in college [by] Kenneth Brooke, and he divided people into participants, spectators and observers, and

how they looked at the world, and I thought I wanted to write about someone who wasn't a participant but wasn't just an observer, who was a spectator. And she calls herself spectator. Because she's involved and then she's watching. Like a historian. Then I thought, how can I do this, what can this girl be? Then I thought, oh, an art historian. The art history lectures were not originally in the play. It began with the dance ... but then Dan Sullivan, my director, said "Wendy, you can't start the show with thirty-five-year-old women playing sixteen-year-olds, we don't know its a flashback ... they're gonna think we just don't have enough money" ... so then we came up with the idea of the art history lectures...

B.F.: So it sounds like it was a structural choice.

Wasserstein: It was a structural choice. Then ... an art historian in New York told me that there were no women in Janson's *History of Art* until nineteen seventy-six. I thought, "This is unbelievable," and then I remembered sitting at Mount Holyoke and they never taught us about any women artists — there were no women in that book, and it is called from the dawn of whatever time to the present. That just shocked me. And then I started doing all this research about women artists, and I went down to the women's museum in Washington. It was amazing. You'd see these paintings by Clara Peters; here was this painter from sixteen whatever and I thought, I didn't even know women were painting. Then I chose some paintings I just liked — I don't know that much about art history — I picked one by Lilla Cabot [Perry] because I liked it. I took them to an art historian and he told me that Clara Peters was an artist who was known, in her time; I thought, "This is unbelievable! And no-one has heard of this woman." So it's sort of all connected, in a way.

B.F.: The art really adds a lot to the play.

Wasserstein: Yeah, it does. And also cause I've taught, too, so it was sort of that idea of teaching. My director knew ... a great teacher ... so I talked to her. Things begin to collect.

B.F.: I wanted to ask you about these yuppified female characters in your plays, the ones who choose a maintrack existence, like Susan in *The Heidi Chronicles*...

Wasserstein: You know what's interesting about *The Heidi Chronicles* is that it's not about the yuppie generation. We're a little older than that; it's really baby boomers. Susan is not a yuppie. Susan is a fascinating person ... she tells Heidi, "Honey, I've been so many people

I don't know who I am, and I don't care." The interesting thing about people my age is that if you talk to them they'll tell you "Oh, yeah, I was on this commune, and then I took like all these drugs, and then, I don't know, like then, I went to Columbia Business School for two years, then, like I became president of Paramount Pictures, and now, like I'm really into motherhood." The yuppie thing is planning a career track; these people don't know who they are.

B.F.: I think that's why I didn't like Susan; I couldn't believe she didn't realize how much she had changed.

Wasserstein: Susan isn't a bad person; she has tremendous energy; she can move on a dime. Someone like Heidi, or someone like me, can sit and sit, or think and think. I'm like Holly in *Uncommon Women*. I have sympathy with everyone's point of view. I can see any problem from six different points of view. My characters are either like that or they can be more moralistic and prissy ... [with a definite sense of] right and wrong.

B.F.: A lot of your plays end with an image of women alone on stage. *Heidi Chronicles* ends with Heidi and her baby, *Uncommon Women* doesn't have any men, and *Isn't It Romantic* ends with the single woman [Janie] dancing alone after she refuses to be in a relationship. Is this a coincidence?

Wasserstein: You know who wrote a really good review for *The Heidi Chronicles?* James Dooly for *Seven Days,* and he talks about the connection between *Isn't It Romantic* and *The Heidi Chronicles.* He talks about the energy that Janie has and the excitement of dancing alone, and asks the question: "Years later, what it's like for the person who dances?"

B.F.: And that's *The Heidi Chronicles.*

Wasserstein: Yeah.

B.F.: One of the things I loved about *The Heidi Chronicles* was that, while it was funny, it also had a lot of social import. One can almost read it as an historical text, or as a document that can tell us something about the time in which it was written. If people read it like this, what do you want them to get from it?

Wasserstein: It's not like there was this Betty Friedan book that changed our lives, but there was this time that changed people's lives ... The women's movement, the gay movement, all those things changed people's lives. In terms of women, and careers that you can do this and

that, it's better. A lot has improved. But there are also personal things going on, too.

B.F.: Like what?

Wasserstein: Well, I think the whole idea of "you can have it all" is a hard one. Scoop Rosenbloom [a character in *Heidi*] talks about the women who opened the doors ... And there *was* a generation that opened the doors ... which made it possible for us to get women who can say "I have my job, I have my baby, I have my husband"—There was a certain point when on a scale of one to ten you had to do things ten ... but you can't do everything ten.

B.F.: Do you mean that with all the choices available some things are lost?

Wasserstein: Well, there's different textures to different lives...

B.F.: But, what's upsetting about all this?

Wasserstein: What's upsetting is like what Heidi says, "We're all in this together." There was this feeling of "we" that went away. And that was upsetting.

B.F.: What has it been replaced by?

Wasserstein: I don't know what it has been replaced by. Rampant individualism.

B.F.: Is that connected to the "sadness" of *The Heidi Chronicles?* You said at Yale that the play was about a woman who becomes sad.

Wasserstein: You know, as you become older in life—like Heidi is forty by the end of the play—you've made certain choices. That's the sadness in a Chekov play or in a Wendy play or in anybody else's play. You know, that this is who you've become. And the energy of those years and the energy of social movements is "curtain up, light the lights." And when you see who you've become there are certain ways in which overall it was good. But there are certain ... back tracks ... too.

B.F.: And that's what *Heidi Chronicles* kind of chronicles.

Wasserstein: I think so, and I think it's a chronicle of a certain generation of people, though not all people. For the Heidis of the world, their friends are their families. Which is very different ... from the people who grew up in the fifties with "Father Knows Best."

B.F.: Now that you have such a powerful voice in terms of representing women or actuating change in terms of how we receive certain groups, do you think you have a responsibility at this point to

maybe make references to or write about women who aren't upper class white heterosexuals?

Wasserstein: I think about that a lot, actually. I do. The problem is you want to do what you do well. You don't want it to be forced ... I mean what I think is good about *The Heidi Chronicles* is that I believe those people. You don't want to do something where one does not believe those people. Although, you should try ... it's just like I was scared of writing the [gay male] doctor. I thought, "oy, yoy, if I don't do this well..." So ... It's something to think about.

About the Interviewers

Melissa Biggs Yale '89 (*Vernacular Founder and Editor '87-'89*) works as a free-lance writer and researcher while earning her M.F.A. in fiction writing at Columbia University.

Brigid Clark Yale '87 (*Vernacular Contributor '87*), when last heard from, she was headed to a fiction writing program and to the altar.

Brian Edwards Yale '90 (*Vernacular Managing Editor '89-'90*) currently works at a publishing house in New York, while not writing and directing his plays.

Benjamin Feldman Yale '90 (*Vernacular Staff '87-'90*) after penning his classes commencement musical, he moved to New York where he continues to write plays and musicals.

Holly Finn Yale '90 (*Vernacular Managing Editor '88-'89*) after a short stint at a consulting firm in New York, she fled to the beach where she writes for the *Fire Island News*.

Polly LaBarre Yale '92 (*Vernacular Editor '91-'92*) has moved from Interviews Editor at *The Vernacular* to editor. She is currently at the magazine's helm steering it safely into the future.

Gita Panjabi Yale '90 (*Vernacular Editor '89-'90*) currently lives between New York and Connecticut as she writes her second screenplay.

Liesl Schillinger Yale '88 (*Vernacular Staff '87-'88*) is currently busy as a preeminent fact-checker at *The New Yorker,* when not frequenting foreign locales.

Margo Schlanger Yale '89 (*Vernacular Contributor '89*) when last heard from, she was on her way to Yale Law School.

Elyse Singer Yale '89 (*Vernacular Art Editor '87–'89*) currently lives in New York's East Village and moves between the publishing and theater worlds.

Matthew Wilder Yale '89 (*Vernacular Contributor '88*) studies theater at U.C.L.A., but keeps in close touch with his interviewee Peter Sellars.

Jonathan Wright Yale '87 (*Vernacular Staff '87–'88*) when last heard from was back in New Haven, but not for long.

Index

Index